# PAULA REGO

John McEwen

## 2nd EDITION

In memory of Victor Willing (1928–88)

*Acknowledgements*

My thanks to Paula for all her help, time and encouragement and for making the pictures, without which there would be no book. All unfootnoted quotations in the text are from our conversations and correspondence. My thanks also to her family – Maria, Caroline and Ron, Victoria, Nicholas and Manuela – for their many insights and the loan of their photographs; to Alberto de Lacerda for introducing me to Paula and Vic, for being such a generous friend and for reading and translating the manuscript; to the many people from whom I solicited information, particularly Eduardo Batarda, Teresa Black, Paul Coldwell, Dr John Mills, Rudolf Nassauer, João Penalva, Ruth Rosengarten, Patrick Sarsfield, Edward Totah, Colin Wiggins and Professor Hellmut Wohl; to London Weekend Television for permission to quote from the interviews for Melissa Raimes's film 'Paula Rego'; to the authors and publishers from whose works I have quoted; to John Erle-Drax and Marlborough Fine Art; and to my editor, Robyn Ayers, and Phaidon Press Limited.

All works are in private collections unless otherwise stated.

Phaidon Press Limited
Regent's Wharf
All Saints Street
London N1 9PA

First published 1992
© 1992 and 1997 Phaidon Press Limited
First paperback edition 1993
Second edition 1997
Reprinted 1997

ISBN 0 7148 3622 2

A CIP catalogue record for this book is available from the British Library

FRONTISPIECE
1   Victor Willing: *Portrait of Paula Rego*, 1975. Crayon and pencil on paper, 35.5 x 26 cm.

Text set in Monotype Garamond 11 on 15 pt
Printed in Hong Kong

# Contents

# THE BOGEYMAN

*A traditional Portuguese folk story
told by Paula Rego in her own words.*

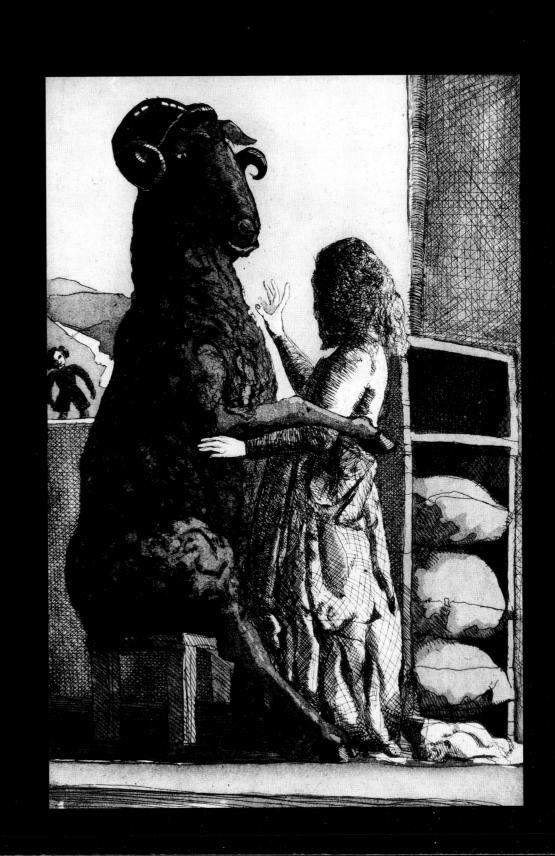

Once upon a time there was an old man who lived in a cottage with his old wife and his granddaughter, who was a little girl, and a faithful old dog who was littler still.

One night a band of Bogeymen passed by and one of them said to the others: 'Brother Bogeymen, this is the house. Let us crash in through the roof, eat up the old man, eat up the old woman and carry away the little girl.'

But the faithful old dog heard them and barked so hard that the Bogeymen ran away. And the old man, suspecting nothing, turned to the old woman and said: 'Darned dog for waking me up. Tomorrow I shall cut off his tail!' And the next day the old man got up at dawn and cut off the old faithful dog's tail.

That night the Bogeymen returned and one of them said to the others: 'Brother Bogeymen, this is the house. Let us make a hole in the roof, climb in and eat up the old man, eat up the old woman and carry away the little girl.'

This went on every night until the old man got so exasperated he cut off the old faithful dog's head. So there was no more barking.

And on that night the Bogeymen came and they made a hole in the roof and they climbed into the house and they ate up the old man. They ate up the old woman. And they took away the little girl in a sack.

And when the Bogeymen arrived home they threw the sack on the floor and each one patted it and said 'We shall see to you later', then they went to bed to sleep until night-time, because Bogeymen only sleep by day.

The little girl heard them snoring and she screamed and screamed. She screamed so much that a man with a big dog came to her rescue. And she told him what had happened. The man put his dog in the sack and took the little girl away.

That night the Bogeymen woke up. They went to the sack and each one patted it, saying 'Let us get to work!' They opened the sack and the big dog jumped out and he ate up all the Bogeymen. And the little girl lived happily ever after.

2   Previous page: *Baa Baa Black Sheep*, 1989. Etching, 52 x 38 cm.

3   *The Baker's Wife*, 1989. Hand-coloured etching and aquatint, 11.5 x 16.6 cm.

4   *Little Miss Muffet (1)*, 1989. Etching, 52 x 38 cm.

5  *Hey Diddle Diddle*, 1989.
Etching, 52 x 38 cm.

6  *Aberystwyth*, 1987.
Etching, 25.5 x 37.9 cm.

7  *The Encampment*, 1989.
Etching and aquatint, 52 x 38 cm.

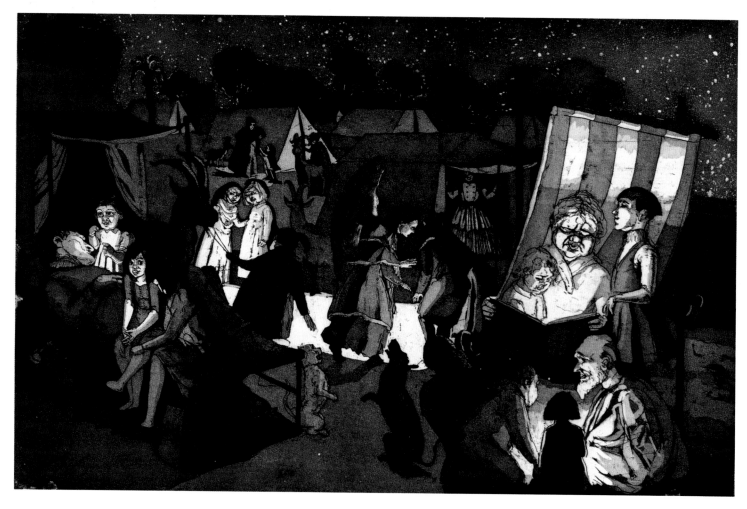

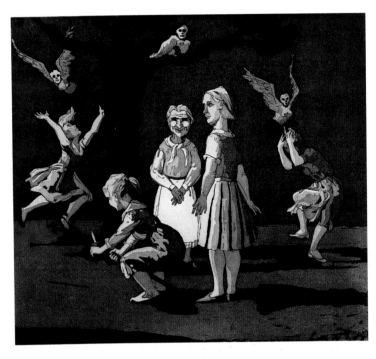

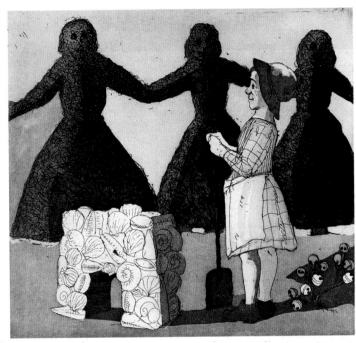

8   *Tilly in Kensington Gardens*, 1988. Etching.

9   *Mary, Mary, Quite Contrary*, 1989. Etching, 52 x 38 cm.

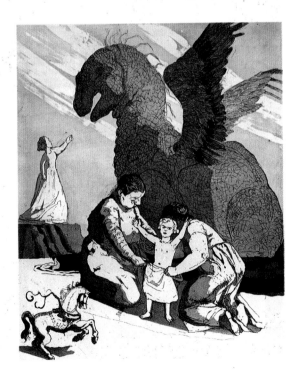

10   *Andromeda*, 1990.
Etching and aquatint, 29.5 x 24.5 cm.

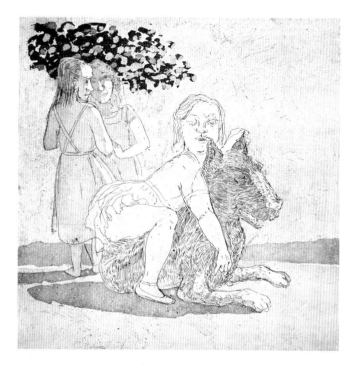

11 (above left) *Girl sitting on a Dog*, 1987.
Etching, 25 x 25.1 cm.

12 (left) *Girl with a Little Man and Dog*, 1987.
Etching, 25 x 25 cm.

13 (above) *Old Mother Goose*, 1989. Etching and aquatint,
52 x 38 cm.

14 (opposite) *Polly Put the Kettle On*, 1989.
Etching and aquatint, 52 x 38 cm.

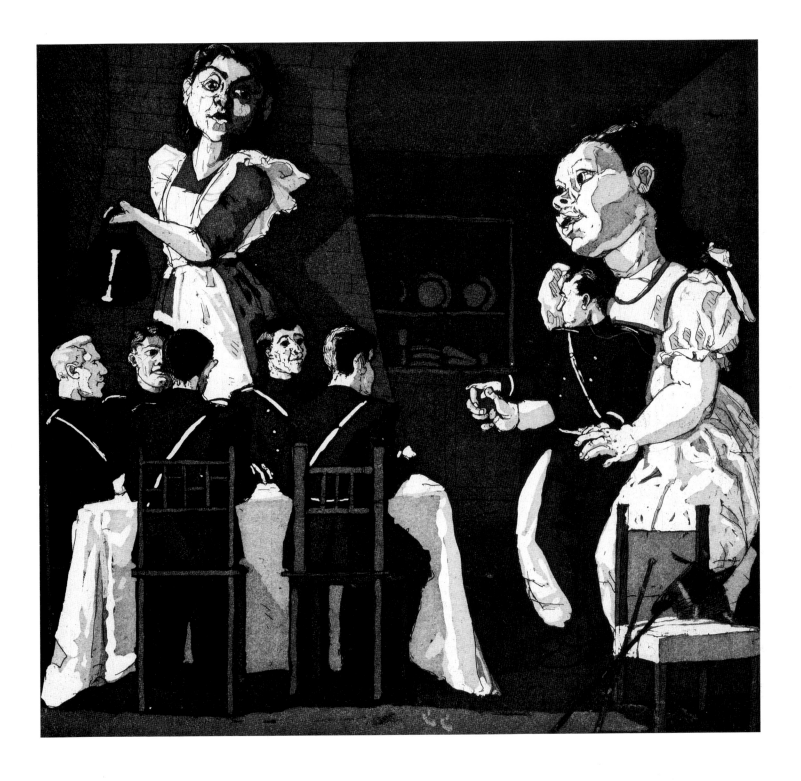

# ONCE UPON A TIME

To paint, Paula Rego must have a story; and her favourite way of telling a story is to paint. Storytelling is indeed a primal gift, integral to primal states of life – to the old world before books, to oral, non-literate societies today, and therefore to childhood forever.

Portugal during Paula's childhood was still in touch with this immemorial world; still rural enough to have a living folklore. To a large degree this lack of change had been artificially maintained and at some cost. António de Oliveira Salazar had become Prime Minister in 1932 and ruled as the self-appointed leader through four decades. His dictatorial hold on power demonstrates his political skill, a skill which stood his countrymen in good stead when he saved Portugal from involvement in the Spanish Civil War and preserved its neutrality throughout the Second World War. But there was a price to pay in economic and cultural terms for his puritanical rule. In matters of social and technological improvement the majority of the population benefited very little. Bestial poverty was still a way of life for many, even in the 1960s. Paula herself remembers visiting a remote village in the north of the country on a New Year holiday in 1966 and seeing men walking barefoot in the snow.[1] Religious prohibitions, class stratifications, sexual discrimination, bourgeois observances lay undisturbed. Television was almost unknown; Americanization would not begin until the 1960s. But this also meant that the rude variety of a more rustic way of life survived much longer than in other non-communist European countries, with the possible exception of Ireland.

Maria Paula Figueiroa Rego was born on 26 January 1935, the only child of José Fernandes and Maria de S. José Avanti Quaresma Paiva Figueiroa Rego. José Rego was an electronics engineer, who later had his own factory in Lisbon making precision instruments. He was an Anglophile, in marked contrast to the Government's sympathy with Hitler's Germany; while Maria, his wife, was brought up within Portugal's Francophile tradition. In 1936, the year after Paula was born, her parents moved to England for a year and a half, during which her father completed his training at the Marconi works in Chelmsford, Essex. Paula was left behind under the shared guardianship of her grandparents and an old aunt of her mother, her time divided between them in their respective Lisbon apartments week by alternate week. Her grandparents doted on her and were convivial company. They lived in

15 Previous page: Paula aged three.

16 Paula aged eighteen months.

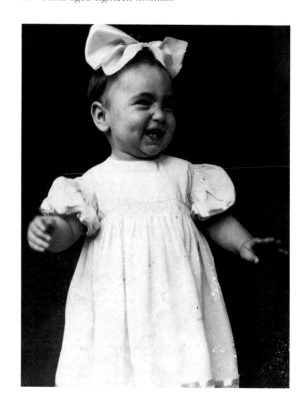

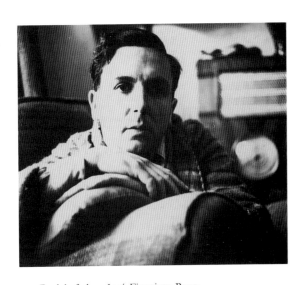

17  Paula's father, José Figueiroa Rego.

18  Paula's mother, Maria Figueiroa Rego (left), in England, 1936.

a ground-floor apartment, with a garden where they kept chickens. Her grandmother, who took an active part in household affairs, helped with the cooking and encouraged her to share in the fun-and-games of the kitchen. In fact Paula enjoyed a freedom with them that was denied her anywhere else in her childhood.

By contrast, life with her aunt could hardly have been more gloomy. She was already an old woman, disappointed in her marriage to the point of manic depression. Her apartment seemed to reflect this mood, being large, gloomy and several floors up. There she would sit all day long, in silence, in the same armchair. She had good reason for her black moods. Of course at the time Paula longed to spend every minute with her grandparents and she dreaded the weekly move; but now that the arrangement had been made her mother insisted on it.

It was a perplexing situation for a little girl, and Paula adapted to it by trying to please all concerned; a solution whose ill-effects have – she is certain – had a considerable impact on her art. A frequent theme of Paula's work is the struggle between outward good manners and inward revolt, the one subverting the other. As she says:

The greatest problem all my life has been the inability to speak my mind – to speak the truth. Adults were always right, never answer back. To answer back felt like death, like being in a sudden huge void. I'll never get over this fear; so I've hidden in childish guises – or female guises. Little girl, pretty girl, attractive woman. Therefore the flight into storytelling. You paint to fight injustice.

Most of us will recognize this confusion, and know what it is to suffer moral and physical cowardice. It is the great appeal of Paula's art that she reveals us to our most shameful selves in this way and, more particularly, how she reveals women to themselves, for she depicts the 'human comedy' from a female point of view. She answers back, she tells the truth – sometimes the unpleasant truth – in her art. Many female writers and poets have done this; but perhaps, until Paula, no female painter has explored it so profoundly.[2]

In 1938 Paula, then aged four, was diagnosed as having incipient tuberculosis, so her parents moved up the coast to the more healthy seaside resort of Estoril. Here they settled, moving into a villa designed to their own specifications with a fine view over the town to the Atlantic. This was the house where she was to live until she left at the age of sixteen for finishing

school in London; it is the house in which her mother still lives today. Full of charming period touches, it has a grand staircase designed for showy descents and a vestibule ceiling in the moulded form of an eye. Paula's bedroom was directly above, a place of sanctuary for an only child. It was very different from her grandparents' bustling home, where she was allowed in the kitchen, and in which her grandmother even did some of the cooking. For Paula, life with her parents was very formal. They led a quiet life and she was discouraged from mixing with the servants. Television had not yet arrived, and children had to entertain themselves more than is usual today. Paula's chief consolation was to play with her toys, in particular the Spanish theatre that had once belonged to her father. And drawing; drawing above all. As her mother remembers:

> All the time she was doing this – hm, hm, hm – in her room, like that – hm, hm, hm – my God, all the time. And it was a relief for me to hear this always, because I knew – ah, Paula's happy. She's drawing. She's happy. And you know she still makes the same noise – roo, roo, roo – and she still draws on the floor – even now after all these years, just the same.

Making art is a solitary profession, and Paula remains grateful for the solitude of her life as a single child: 'That kind of childhood, where you're stuck in a room all day, is the best training for a painter.' But it was not only art that kept her happily employed in her room. 'At Estoril I first was aware of the outdoors, a world beyond the house, and I was absolutely terrified. My mother tells me I was afraid of the flies, but I remember being afraid of everything. I was even afraid of other children. I just couldn't bear to be put outside. Oh God, it was awful. It was just terror, terror.' Thankfully, this did not apply to the beach, which she treated as an outdoor playroom.

Paula's artistic talent owed, no doubt, something to her mother; and it is through her mother's family that she can claim to be a distant cousin of Vieira da Silva, the most famous contemporary Portuguese artist, at home and abroad, but one who was also a woman. Today Paula's mother is scornful of her own efforts as a painter, but in Lisbon as a girl she attended art school – then a more conventional practice in Portugal than in England – and continued to dabble in oils long after she married. Luzia Pires, Paula's former nanny, has a small painting of a chair by Maria, which shows competence and sensibility; and Paula admires her mother's eye and listens to her

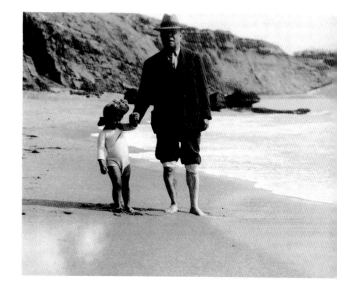

19   Paula aged two, with her grandfather on the beach at Ericeira.

views on art to this day. As Paula says, 'she knows about art really with a big A'.[3] In addition, Maria was a chic woman, who liked clothes and dressing well – an extrovert side no doubt encouraged in childhood by the private theatre in her cousins' house in the fishing-village of Ericeira, north of Estoril. She enjoyed having the latest Parisian fashions copied; this surely encouraged Paula's early passion for dressing up.

Nonetheless, Paula's upbringing was strict, with great stress laid on etiquette and good manners; being properly turned out for the drawing-room (white gloves, hair brushed) was a major concern. A particular treat was to sit with her father on the sofa and look at picture books. Her favourite was a fine edition of Dante's *Inferno*, illustrated with engravings by Gustave Doré, **20**: 'It was a heavy book and as he turned the pages I'd have a peek – just enough to send the shivers down my spine and make me run off – and then I'd creep back for another go', Paula remembers. She still has this book, and remains just as excited by it:

> Look at this illustration to Canto 28 with that tummy being ripped out! And Canto 32 – it's really horrible, with all of them stuck in the ice. Look, that one's eating his hand. I suppose if it's frozen it won't go off. Even at art school they could still send shivers through me. I've never understood why 'illustration' is used dismissively in the art world. I mean Doré had to imagine these things. The power comes from the invention – the drama and variety of scale. What they really are is a series of brilliantly expressed phobias. To dismiss them because they are in a book is ridiculous. It's that stupid old 'fine art' snobbery again.

Summer holidays were passed at Ericeira with her paternal grandparents, her mother's parents having died long before. Her grandfather, José, was an extrovert, an entrepreneur whose success had afforded him the luxury to build a villa on the edge of the village. His money mainly derived from dealing in the property market but he speculated in all manner of things, including the Portuguese railway, for which he held the right to print the tickets – a lucrative monopoly that benefited the family for many years after his death. It was characteristic of his generosity as well as of his taste for gambling that he should also have been bankrupted twice in his career, setbacks that proved only temporary.

The villa at Ericeira was José's stage, where he liked to give lavish shooting-parties. It was a male world of thirteen-course lunches and drinking to

20   Gustave Doré: Dante's *Inferno*, Canto X. Engraving.

21 Paula's grandfather, José Figueiroa Rego.

match, with *fado* singers providing the entertainment. On one occasion Paula remembers the famous Benfica football team coming; her grandfather was one of the Club's founding directors. On these male occasions it seemed to be understood that her grandmother, Gertrude, would stay away in Lisbon.

Gertrude had been born in the village, and before she was rescued by a true fairy godmother who returned from Brazil and adopted her, she had known real poverty. Gertrude was a kind woman, but she was brutally unself-pitying and hard-working. Her belief that wives should defer to their husbands was absolute. There were servants, but she would also help with the cooking, getting up at five in the morning if she was making one of her celebrated rice-puddings. She also loved animals and surrounded herself with chickens, rabbits, geese and the rest. Paula remembers her grandmother's pockets always full of chicks. She admired her greatly.

The villa at Ericeira was to be an enchanted place for Paula, and one she eventually inherited. As far as playmates were concerned, she might just as well have been alone; so for company she passed her time in the kitchen – a jovial and active place, quite unlike the more sedate and grown-up world of the drawing-room. 'There were dead chickens and cooking and people ironing and . . .', she says, the images multiplying beyond control, 'just all the good things – and my grandmother, of course, if she was at home.' In the kitchen bourgeois distinctions went by the board, and so did the luxury of sentimentality. The maid who had been ironing an immaculate shirt one minute might be wringing the neck of a chicken the next; and the chicken itself might have been a household pet only seconds before its brisk despatch. 'The Portuguese are keenly aware of the fragility of hierarchies and the comedy which derives from their disruption', Victor Willing, Paula's future husband, was later to write.[4]

22 Paula's grandmother, Gertrude Figueiroa Rego.

It was during these formative years that Paula's talent for storytelling was fostered by the example of several of those dearest to her. This is the key to understanding all her art, from first to last; and it derived not from books but from being told stories, in ways no doubt unchanged for many generations. Books for her came later. Not the least of these storytellers was her mother, who can still beguile her great-grandchildren from their computer games. 'I can't really describe it', her granddaughter Caroline explains, 'but she has a different voice for telling stories. It's a sort of cooing, but with an

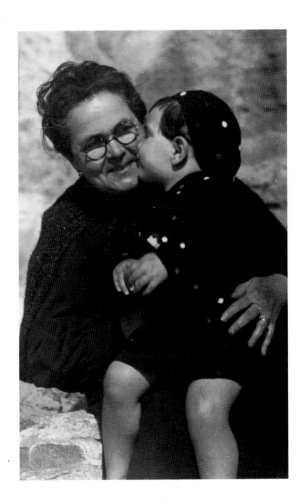

23    Paula aged three, with her grandmother.

edge to it, a throaty roughness. It has a hypnotic effect – all part of the gift I suppose.' Victoria Willing remembers her grandfather's stories being even more vivid. '"BaBa" (Maria Rego) tells very good stories but gentler ones, full of gossip about the lives of lizards, things like that – lizard soaps. But "VôVô" (José Rego) told horrific ones – more horrible even than Paula's, which were bad enough. He'd speak of things coming alive in the dark and creeping through windows – so terrifyingly that Caroline and I would lie awake after he'd gone, not daring to go to sleep.'

But no-one was quite the match of Aunt Ludgera, José Rego's sister, who always came to stay at the villa for part of the summer holidays. Every afternoon in the siesta hour she entertained Paula with her wonderful and fantastic elaborations. She never failed to encourage her to make her own contributions to the tale as it unfolded, incorporating her ideas. But even more fantastic than this were the other times when, without warning, she would suddenly make her stories real, super-real, by adopting frightening disguises. One of these was a character called *Piolho* or 'The Louse' – a hideous tramp who might appear at any time, cursing and brandishing a bottle. Paula would know that it must be Aunt Ludgera, but the performance was so unexpected and convincing that she could never quite be sure until her aunt laughingly revealed herself. Aunt Ludgera's own life had been sad, but Paula loved her for her unfailing curiosity. As a black-dressed and benign presence she was depicted in old age by the painter Peter Snow, who was once a student with Paula at the Slade School of Art in London, and who came to stay with them for a holiday. His picture shows Aunt Ludgera sitting watchfully over the latest addition to the family at that time – Paula's second child, Victoria, as she lay in her playpen on the glaring white terrace at Ericeira.

The roots of Paula's art lie in this immemorial tradition of storytelling, learned in childhood and imitated by her as a child in her private games and endless drawing. It is a world she re-enters every time she kneels (her favourite position for drawing to this day) to begin another picture:

There was also my grandmother; and an old servant of my mother's, Jacinta, who used to come and sit in my bedroom at night because I was afraid of the dark, and tell me stories from her country – the country place she came from – till I fell asleep. They'd be about animals – the ant eats the belly of the goat, the rabbit's revenge. She was very, very old, maybe ninety, and I loved her stories as well.

Chapter 2

# FIRST CONCLUSIONS

It might be assumed that, living in Portugal, Paula would have been raised within the Roman Catholic Church, but she was not; or, at least, not by her father. He had been brought up a staunch republican and democrat and was thus opposed to the clerical hierarchy. They sided with the autocracy, whether this took the political form of a monarchy, as was the case in Portugal in the earlier part of the century, or Salazar's dictatorship, which lasted from the early 1930s to 1970, and which was followed, four years later, by the Revolution. According to Paula, her father did not approve of priests:

> He thought they were dreadful people and that they were oppressive and oppressed through the Mass. He was right, of course, in the case of Portugal, because priests were really ignorant people on the whole, extremely ignorant, and they liked to keep people more ignorant than they were, so that they could tell them what to do, you see. They were really bullies, priests were.[5]

Nevertheless his politics were much milder than his father's, in keeping with his altogether more introverted nature. José was a liberal, whereas José senior displayed revolutionary tendencies, and may well have been involved in the assassination, in 1908, of King Carlos I; he never admitted to having been party to it, but he was suspiciously absent from home on the day of the assassination. The story goes that he did not return until after breakfast the next morning, in evening-dress and loudly celebrating the King's death, together with some cronies. The incident is commemorated in Paula's collage *Regicide* (1965), in which the assassins, one of whom was killed on the spot, are clearly visible at bottom-right.

Paula's father was equally, if less murderously, opposed to Salazar who, like the Portuguese royal family, upheld the Church. The Church in Portugal had been fired with renewed and puritanical zeal by the apparition of Our Lady to the children at Fátima in 1917, apparently in answer to the atheistic menace posed by the triumph of revolutionary Communism in Russia. Although Portugal today is a democratic state, and thus very different from what it was twenty years ago, some of that Fátima-inflamed religious fervour persists. In one of its moving rituals the congregation stands after communion until the exposed host is returned to the tabernacle – like people on a shore watching a boat carrying all their hopes pass out of sight at sea.

24  Previous page: *Manifesto*, 1965.
Collage and acrylic on canvas, 183 x 152 cm.
Gulbenkian Foundation, Lisbon.

25 *Regicide*, 1965. Collage and oil on canvas, 150 x 200 cm.

Paula's father forbade her to take the sacraments, so she did not make her first confession and Holy Communion until she was fourteen, when she rectified the loss in a short-lived fit of religious zeal. Nevertheless, Catholicism inevitably played a profound role during her upbringing. It would have been impossible in Portugal not to have been, in Paula's words, 'some sort of Catholic'. And if her father was not religious himself, then he was an exception. Paula's great-grandfather, for example, who lived in her grandparents' flat in Lisbon, had been a lay preacher and was extremely devout. His room had an enormous cupboard full of statues of the saints, and there he would sit all day praying and composing prayers in a mist of incense. Her mother too, a devout believer, remains punctilious in her religious duties, in common with all the women of her generation in the family. Occasionally Paula would accompany her to church.

26   Paula with her parents at Estoril, 1943.

But beyond that, there was the wider cultural influence. Wherever Paula turned there were signs of this collective belief. Even her anti-clerical grandfather insisted on decorating the outside of the villa at Ericeira with the story of St Gertrude the Great, who was a model of holy virginity. And still today there is a curtained shrine to Our Lady in the bedroom Paula's mother uses; while in the hallway of the cottage her old nanny Luzia still has at Ericeira (always the place Paula regards as her true home) pride of place is given to a faded print of *The First Mass in Brazil*, showing a priest at a makeshift altar raising the host in the wondering presence of half-naked Indians. As for formal religious instruction, that was imposed by attendance at the local kindergarten, where Paula, like any other Portuguese child, learned her catechism. The images in this booklet, in which Christian doctrine is presented in the form of questions and answers, made a lasting impression:

348. Which are the enemies we must fight against all the days of our life? The enemies which we must fight against all the days of our life are the devil, the world and the flesh.

349. What do you mean by the devil? By the devil I mean Satan and all his wicked angels, who are ever seeking to draw us into sin, that we may be damned by them. [6]

The idea of the devil was especially terrifying: 'The worst nightmare I've ever had in my life was because I imagined that if you left the door half-

open the devil would come and get you in the night . . . . So religion to me was scary. Catholicism is ridden with guilt. The back of the churches in Portugal are full of confessionals.' The religious presents Paula was frequently given – rosaries, statuettes and medals relating to Our Lady of Fátima, pressed upon her by well-meaning grown-ups – were stored away by her in her bedside table to ward off the threat of nocturnal attack. It was not the least of her grandmother's kindnesses that she used to let Paula sleep with a light on.

Fear, as the Surrealists knew, drops its victim straight into the pool of the subconscious, and fear is, therefore, a highly desirable state of mind for some artists. Terror has doubtless been of inestimable value in making Paula's art what it is. Art for her has exorcized fear: 'In my art I try to give fear a face', she has said. Primal states, or what she characteristically calls 'raw' states, make us all the slave of fear. The more so for her, child as she was of a fearful time and place – her terror of flies and agoraphobia existing in a world made uneasy by war. It is this artistic acknowledgement of her 'raw', unspoken self that continues to make Paula more of a surrealist than anything else. When Paula's father gave her her first contemporary art book, Alfred Barr's *Fantastic Art: Dada and Surrealism*, as a present on her fourteenth birthday, she was delighted not so much by its novelty as by its familiarity.

This, of course, did not prevent her from having occasional outbursts of misbehaviour. Still, considering her outward desire to please, what electrifying wickedness it must have been when (aged about five) she one day took her latest doll – 'just like a real baby, made of fleshy rubber' – and snipped off its fingers with a pair of scissors, one by one, starting with the thumbs. To this day she is not sure exactly why she did it. Possibly, she suggests, because it was so tantalizingly like the real thing; possibly because it was a boy and she was a girl, which had initially disappointed her son-seeking father. All she knows is that the thrill of revolt remained within her, and was artistically realized in the early 1960s when she first cut up her drawings and rearranged them as collages.

The fleshy doll had been given to her by her grandparents, and indeed it is with them that she associates many of her childhood presents. Her grandparents' visits were always a treat, and one of the happiest memories of

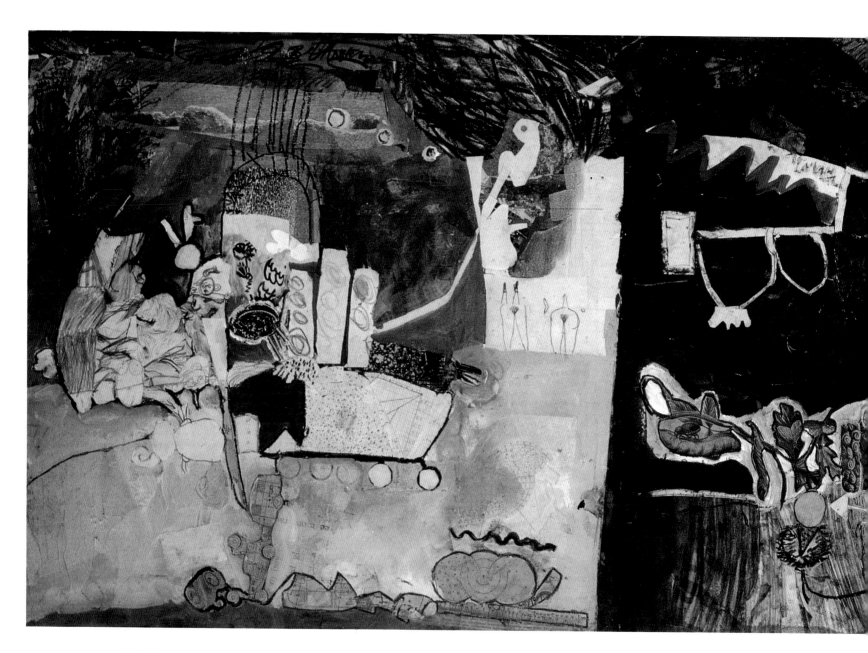

27  *When We Had a House in the Country*, 1961. Collage and oil on canvas, 49.5 x 244.5 cm.

her home in Estoril is the sight of them struggling up the short walk to the house laden with the latest load of surprises. On one particularly memorable occasion, when she was still quite small, her grandfather presented her with a whole boxful of swimsuits – 'Obviously "fallen off the back of a lorry"', as she now wrily observes – one for every day of the week. She remembers one of them with special affection: based on a motif of butterflies, it eventually found its pictorial place as a costume in her *Vivian Girls* series of paintings of 1984.

Another year her grandfather began sending postcards in the form of clues to the identity of a forthcoming Christmas present. Postcards were arriving on a daily basis for several weeks, gradually building up a composite picture through such clues as: 'Red as the legs of a partridge'; 'Good – but only for dancing'. These postcards excited Paula's expectations to fever pitch; and when the great day finally came she was not disappointed to find herself the possessor of her first pair of grown-up shoes – hand-made, scarlet, and in the latest platform style. 'I'm a bit of a shoe fetishist', she admits.

But the greatest treat was to go to the cinema with her grandmother and Luzia. The three of them would make a day of it, taking a box and bringing a picnic tea, which always included her favourite Berlin Balls, a sort of super doughnut.[7] In these blissful circumstances she saw her first Walt Disney film, *Snow White and the Seven Dwarfs*, an experience she describes as 'the discovery of a new world'. The way the branches of the trees turned into grabbing hands particularly thrilled and terrified her. It is from that moment that she dates her agoraphobia, something she has learned to cope with, but which she still experiences out-of-doors as a disquieting sense of being followed.

*Pinocchio* soon vied with *Snow White* as her favourite film, and it still does; the only film-maker to match the surreal Disney in her adult estimation is Luis Buñuel. The stars made their mark too – the Brazilian Carmen Miranda with her cornucopian head-dresses, a particular favourite in Portugal; Fred Astaire and Ginger Rogers; Judy Garland and those famous red shoes. To this day Paula prefers the cinema to any other form of entertainment. Her love of films was partly nurtured by her father. He made films for his own amusement and that of his friends, and showed them and his collection of

commercial reels in a little cinema in the basement of her grandparents' flat – the first private cinema in the country. It had proper cinema seats and was, she feels, like a toy for him. Here she saw all the early Charlie Chaplin and Disney films, with Mickey Mouse quickly establishing himself as her particular favourite. The most surprising aspect in all this is that her father never took Paula to the cinema.

But films did not exclude more traditional forms of entertainment, notably books. Paula denies that she read, or was read to, as a child, and yet when Marina Warner suggested in a radio interview that the stories of the nineteenth-century writer the Comtesse de Ségur might have been one of her influences,[8] Paula's reaction was one of shocked but gratified surprise, as if relieved that a secret had been found out. It transpired that she had been brought up on the Comtesse's *Les Malheurs de Sophie* and *Les Petites Filles Modèles*, books in which the prim and proper heroines are less docile than they pretend. This behaviour approximated with Paula's own experience, in which demure obedience sometimes hid the most wicked thoughts, as is the case with so many children. Good manners may have been a way of dealing with social life, but Paula's imagination was her own. In this she agrees with Gabriel García Marquez that 'everyone has a public world, a private world and a secret world'. The imaginative freedom to express these innermost worlds was exhilarating.

Portugal remained neutral throughout World War II; but the conflict inevitably cast a shadow that even a child would have noticed. Her mother knitted endless balaclava helmets for the war effort, and, for the first time, Paula became aware of her father's depressions. He would return from his office, pour himself a whisky, climb the stairs and brood for an hour or so in the falling darkness in an armchair on the landing. This routine sometimes went on for weeks, ending as suddenly as it had begun, usually with a celebratory lunch in Lisbon with his male friends. Paula's father found it impossible to discuss his business problems; and the onset of the war cannot have helped. But at nine o'clock each evening, however downcast he was, he would listen without fail to the news from London on the BBC World Service. For Paula the well-known signature tune that preceded the news would always spell happiness, instantaneously recalling the security of her bedroom and the assurance of hope.

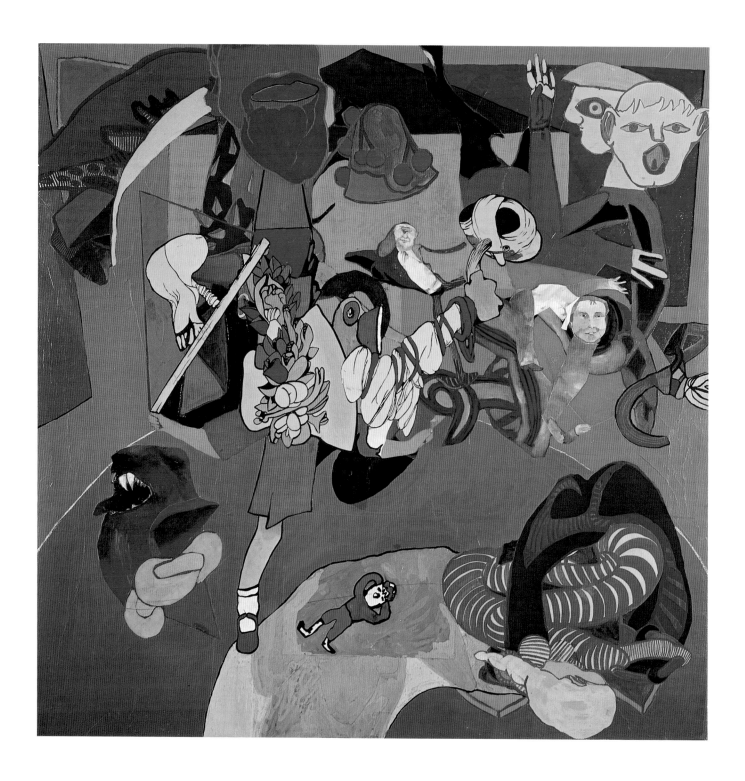

28  *The Punishment Room*, 1969. Mixed media on canvas, 120 x 120 cm.

Paula's art may always depend for its ignition on personal experience, but through formal, or therapeutic means she has assiduously placed it at one remove from her life. At various times this has been achieved through abstraction, anthropomorphism or even, in the most recent figurative paintings, by setting her pictures in the past. Nicholas Willing, her son, viewing his mother's art from the perspective of the film director he now is, sees the advantage of such mediation:

Her art is principally to do with experiences of her childhood. I think that's where she's drawing most of her sources, because her emotions were more polarised then. And so the faces and figures and clothes are those of her childhood. In the picture of *Joseph's Dream* she told me she needed to put something in the foreground. I suggested an old vacuum cleaner, which she thought was a very good idea. So she painted in a vacuum cleaner, but immediately she had to paint it out because she said it made the picture look kitsch. And that's the problem with putting in modern things, because her world is timeless – well not timeless, but the world of her past, of her childhood, is lost in time. That is part of her pictures' enchantment, of their power. One of the things Jiri Menzel, the famous Czech film-maker, said about the strengths of setting films in the past – which is of particular relevance in England because English movies always are set in the past – was that it makes a film more magical, more surreal in a way, because there are fewer points of reference to your own life. I think that's true.

29  Paula aged three.

Chapter 3

# SCHOOL

For her secondary education, which began at the age of ten, it was decided that Paula should go to St Julian's, an Anglican English school near Estoril. Her father insisted on this because he wanted her to gain an English School Certificate, so that she could have the option of pursuing her higher education in Britain. Extra tuition was required if she was to pass her entrance exam, and to this end a teacher, Dona Violeta, was hired to give her lessons three afternoons a week over a period of two and a half years in the run-up to the ordeal. Dona Violeta had a sallow complexion and, in Paula's memory, always wore a lilac Angorra sweater, a garment which for Paula came to be symbolic of dread. Dona Violeta turned out to be far more associated with violence than with violets:

I loathed her. She was rough and cruel and used to hit me. I used to be literally sick from fear of her. She'd say: 'You can't draw. You'll never be able to draw.' But being a child I never told my mother, because that was how I thought it was meant to be, even though when she popped her head round the door I'd be thinking: 'Please stay! Please stay!' But I was very well brought up and always did what I was told. Scaredy cat! I still am, I'm very careful in real life. You have to survive, don't you. But this is always what I tell students – in paintings we have the freedom to do what we like. Total freedom. That's where I take my risks.

Paula's parents never learned of the wickedness of this teacher; parents rarely do. The poisonous envy and disappointed revenges of adulthood have to be borne by children in silence. It is an unspoken, sometimes even a conscious, conspiracy, a deadly pact, as all pacts are between the victim and the persecutor. But Dona Violeta was strict, and even effective in her own savage way. Paula passed her exams.

St Julian's, a seventeenth-century building just visible from the coastal road between Lisbon and Estoril, still exists. In Paula's day a picturesque wood of mimosa and pine screened it from view. The English artist Patrick Sarsfield was one of her art teachers there, and remembers the place well. One evening while Sarsfield was strolling near the main gate, a black, chauffeur-driven limousine drew up. In the back was a little man. The chauffeur descended. He took a deck-chair from the boot and set it up in the grounds where there was a view of the sea. He then carried the little man there from the car. The little man proceeded to dismiss Sarsfield's accusations of trespass, placed a bowler hat on his head, removed his shoes and

31 Paula aged 15.

socks and sat contemplating the view. The chauffeur, meanwhile, stood guard. It transpired this was none other than Calouste Gulbenkian, the richest man in Portugal and founder of the Gulbenkian Foundation, the famous cultural charity. Apparently Gulbenkian considered St Julian's his by right since he had a British passport and St Julian's represented British territory. Sarsfield remembers on another occasion the bizarre sight of Admiral Horthy Miklós, ex-Regent of Hungary and ally of Hitler, holding the finishing tape at a St Julian's sports day along with the Arch-Duke of Austria. On Sundays Horthy Miklós, a Protestant, was to be heard in the Anglican church, lending his voice to lusty renditions of 'Onward Christian Soldiers'.

Paula's first art teacher on arrival at St Julian's was Margaret Turnbull, whose influence on her work is still discernible. Turnbull was a Bloomsbury type with an unfashionably male haircut and a taste for voluminous blouses. Her own work, made in Indian inks, with the figures starkly realized like cut-outs in illustrated books, made a deep impression on Paula. The first professional artist to recognize Paula's talent, Turnbull insisted she have a box of oil paints, and took the trouble to teach her the techniques of this medium, advising her to be as frugal as possible. This lesson was never forgotten, though today Paula avoids painting in oils because the smell of turpentine makes her feel queasy.

A favourite method of Turnbull's teaching involved setting up still-life arrangements for her pupils to copy. These were not banal assortments of bottles or fruit, but included such novelties as toys, including a figurine of a bull – just the sort of 'prop' Paula has included as a symbolic dimension to her post-1985 pictures. Turnbull also made her pupils copy the works of the Masters, even quite up-to-date ones by the usual school standards of the time. Paula did several, including one after Degas, although none survives.

Margaret Turnbull was succeeded by Patrick Sarsfield, who was equally impressed by Paula's talent:

She was absolutely outstanding – the boldness of the line, the strength of colour; to tell the truth it didn't look like the work of a girl at all, or a child come to that. She had this absolutely natural talent for composition. I've never seen it before or since in anyone so young. Her drawing might not have been absolutely correct in terms of foreshortening or what-have-you, but the composition was so good and the line so bold it

didn't matter. She says very sweetly that I taught her – let me say I did nothing of the kind. I didn't have to. There was nothing for her to learn. In fact I remember when I left I asked her for a drawing and she very kindly gave me this picture of a man lying drowned on a beach surrounded by standing figures. Alas, when I got back to London it was thrown away with some of my own work by a charlady; but I often think of it. In her recent work, which I admire more than anything she's done, and which is very similar in spirit to the way she drew at St Julian's, she invariably depicts a man in the role of a victim. Now I sometimes wonder if that drowned man on the beach was the first of these, a forerunner if you like. Of course, as she was a girl, I never thought she would be allowed to become an artist. I thought she would probably be doomed to make a rich marriage and settle down to family life. But I do remember telling her to try and go on with her art; so it was a great thrill to me when I opened *The Times* one day, thirty years later, and saw her name. It rang a faint bell and then I put two and two together and wrote a letter and sure enough it turned out to be her. I was delighted. And not in the least surprised; except, of course, that she'd stuck at it.

Paula liked her teachers and benefited from their encouragement. St Julian's was markedly liberal, as perhaps it needed to be with pupils of twenty-three nationalities. She was good at every subject except geography, and enjoyed dancing and sports; it goes without saying that she always won the art prize as a matter of course, or, in her opinion, by right. The damage done by Dona Violeta was repaired. As her mother recalls:

One day she came to me and said: 'I'm going to win the art prize.' She must have been about eleven. But I said 'Paula, maybe you don't win this prize. Perhaps there are children better than you.' Because children always think they are so special, which is good, but it can be disappointing later when they find they are like everyone else. Anyway, one month later she came to me and said 'I've won the prize.' Well, I wasn't proud. I was relieved, because it meant she would be calm. If she hadn't won the prize – my God ...! She is very like her father in this. He was always very determined, very hard with himself. And I think this is true of Paula. Of course today she is a good painter, that we can see; but it was always as if she was meant to be a painter, an artist – something she couldn't control. She was happiest doing this. No, I wouldn't say it was a vocation. That is too romantic. It was an obligation. She was obliged to do it by her personality.

The Portuguese tradition of tile-painting, everywhere to be seen, was perhaps Paula's most persistent influence. Decorative tiles in Portugal are used both inside and outside buildings, and the villa at Ericeira was no exception. In the panel to St Gertrude on its façade, for example, the face

of the Saint is actually a portrait of Paula's grandmother. Paula still finds it absurd that her grandfather, whose moral probity she doubts, should have had the nerve to treat his wife in this patronizing way; but the point – that real people could model for saints – was not lost. Her debt to this insight, and to tile painting in general, is specifically celebrated in *Crivelli's Garden*, Paula's tile-like mural of 1991 on the theme of the lives of the saints (whose appearances also derive from real people) for the brasserie of the new Sainsbury Wing at the National Gallery in London.

Paula's imagination was no less stimulated by her love of picture-books, a taste amply satisfied by the library of illustrated books left by her grandfather. Two particular favourites were bound volumes of the popular turn-of-the-century Spanish magazines, *Pluma y Lapis* and *Blanco y Negro*. The pages are full of drawings on every conceivable subject, from humorous stories to romantic ones, the latter apparently their principal stock-in-trade. She takes as much pleasure in them today as ever she did, but with the passage of time they seem to have become more essential to her as good-luck charms than as references. Certainly no studio of hers would be conceivable without them taking pride of place on the bookshelf. Other lasting favourites among illustrators include the eighteenth-century English caricaturists James Gillray and Thomas Rowlandson; 'all the Victorians, because they drew so well'; and in particular, Sir John Tenniel of *Alice in Wonderland* renown, Gustave Doré, Arthur Rackham and Benjamin Rabier, best known for his 'La vache qui rit' cheese advertisements. Paula's unqualified admiration for cartoon animation in general, and Walt Disney in particular, perhaps falls within an illustrative category; and, in this context, it is interesting to note that Disney was also a great admirer of Rackham, to the extent, it is said, of inviting him to work in Hollywood.

Paula's love of opera, also acquired during her years at St Julian, she owed entirely to her father. He had told her the stories on which they were based and played selected tunes on their gramophone; but he did not take her to a performance until she was thirteen. They went first to *Carmen* – an occasion made all the more special by having been kept secret until the last moment; and over successive years she saw most of the well-known operas. Operatic evenings were made additionally thrilling by the unpredictable qualities of some of the singers' voices, apart from those of the international

stars: 'We'd sit there cringing like mad in case they didn't hit a top note. There was a sense of real danger about it. Everything was on the edge, really risky, which is very important.'

Upon the death of her grandfather in 1943, the villa at Ericeira became the responsibility of Paula's father and the family continued the tradition, established in her grandfather's day, of spending the summer holidays there. Paula shared a bedroom with her younger cousin Manuela, Paula playing the grown-up sister by telling bedtime stories. Manuela remembers them being mostly about ghosts and skeletons, but they were often so frightening that Paula would be too scared to finish them. Characteristically, Paula's water-colours made at that time, some of which Manuela had the foresight to save, are the same horror tales, but told in pictures. In one Death with a scythe dripping blood approaches a sleeping girl; in another, crowds of people watch a distant, blazing city, perhaps a scene influenced by the burning of Atlanta in *Gone with the Wind.*

Paula's artistic talent was a source of pride to her relations and she was already fanatical in practising it. 'I never knew anyone like this you know', recalls her mother. 'She worked all the time. At sixteen or seventeen she was telling me not to disturb her. She locked her door! And if people came she'd say "Don't let them in. Say I'm not here". Can you imagine!' These teenage summers are poignantly caught in two snapshots. In one Paula performs a hand-stand while Manuela, clapping looks on, **33**. Shadows lend sadness to this moment of joy, in which curtains of rock further dramatize the moment. The rock on the left has a particular ambiguity. It could be a missing corner of the photograph itself. The second photograph, Paula's favourite, shows her sunbathing while her father sits near by in the shade, **32**. It is an image of two dreamers and, one imagines, two kinds of dream: the daughter has her eyes shut and a head full of fancies. The father has his eyes open and looks out to sea. His resigned, even exhausted, air speaks of adult concerns; or perhaps his mind is enjoying a restful blank between anxiety and regret.

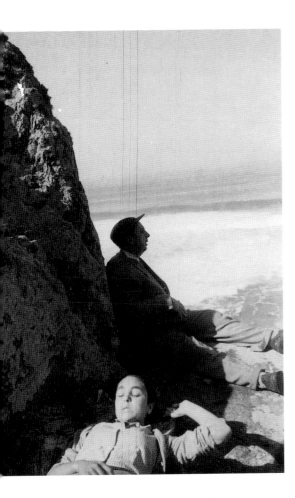

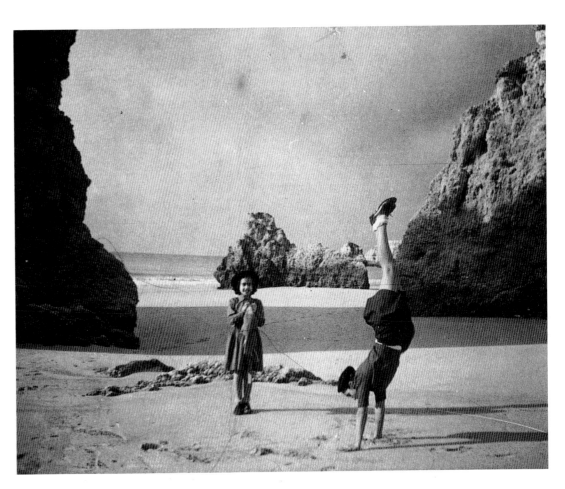

32 Paula and her father at Ericeira.

33 Paula and Manuela on the beach at Ericeira, 1949.

# SALAD DAYS

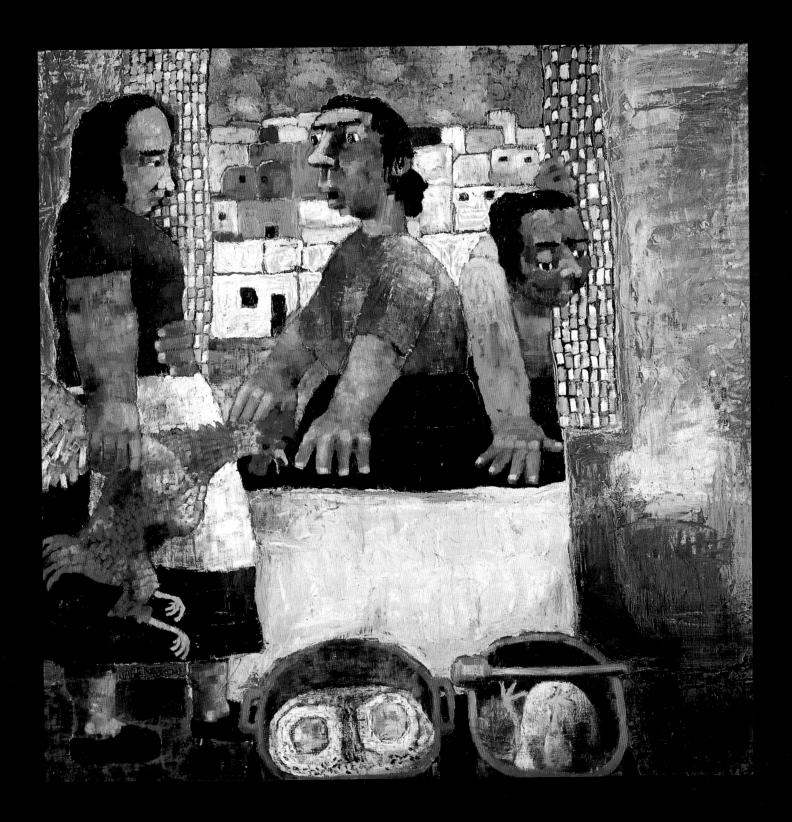

t was her father's idea that Paula should round off her education by attending a finishing school in England. 'When I was very young he said: "This is not a place for women, this country. You go away." And he sent me off when I was sixteen to England.'[9] Paula was sent to an establishment called The Grove at Sevenoaks in Kent, run by a Mrs Orr-Ewing. This person approved of her pupil's general enthusiasm and keenness for things other than art, which Paula nonetheless managed to practise compulsively, but observed that she was just a little bit 'the cat that walked by herself'. Her pupil's chief recollection, on the other hand, is of being nicknamed Sancho Panza because she was 'short, fat and greedy and could only ride a pony backwards'.[10]

Paula suffered what she considered the indignity of The Grove for two terms. Apart from eating a lot – she is today a very good cook – art was her chief compensation and, as at St Julian's, her talent was spotted by her art teacher, Mr Bradshaw. He suggested she should try for an English art school and, with her willing co-operation, arranged for her to be interviewed for a place in the coming year at the Chelsea School of Art in London. Without telling either her parents or her guardian in England (David Phillips, a friend of her father's) she went to the interview and was duly offered a place. Her guardian's reaction to this success was not encouraging: 'He just said, "You can't go. All that happens to girls who go to art school is that they get pregnant." Now that was funny wasn't it?' Funny, because Paula was to suffer exactly this fate at the Slade School of Art, also in London, for it was decided that if she really had to go to art school then it could only be to the Slade. Her portfolio of drawings was not considered good enough to qualify her for a place there, but after some effort her guardian managed to obtain for her the right to attend as a part-time student. Meanwhile Paula had dropped out of her final term at The Grove and returned for the summer to Portugal.

If anything, her parents seemed pleased by her initiative and could not have been happier than for her to be an artist – a rare response in any country at any time. In this case it is not surprising. Her mother, as we know, appreciated Paula's talent from a position of experience, while her father was always markedly liberal in his attitude to politics and the arts, to the degree, perhaps, that meant he appreciated his daughter's decision first

34  Previous page: *Under Milk Wood*, 1954. Oil on canvas, 110 x 110 cm. University College, London.

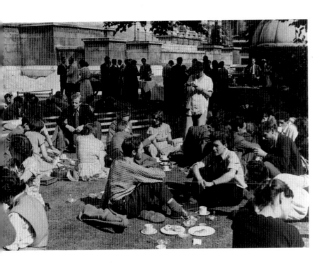

35  The 'strawberry tea' at the Slade, summer 1952.
Vic Willing is in the centre foreground, in profile.

and foremost for its display of independence. As Paula's friend the poet
Alberto de Lacerda has written: 'It would be fascinating to study in depth to
what extent her painting . . . is a female assertion opposing the chauvinism
of an ironic, dismissive, oppressive society.'[11] For in Salazar's Portugal
women were not even allowed a passport without proof of permission to
travel from their father or husband. The memory of such inequality riles
Paula even today. England represented a very real freedom.

Paula spent four years at the Slade, from October 1952 to June 1956. The
Slade was then at the height of its post-war popularity, a fashionable place
to be under the newly appointed Principal, William Coldstream, a man of
great charm, and with a wide range of contacts in and outside the art world.
Nearly all the male students had undergone the enforced two-year period of
military service on leaving school; they had seen something of the world and
were eager to resume civilian life. The intake included some notable indi-
vidualists. Among those who went on to establish themselves as artists were
Craigie Aitchison, Michael Andrews and Euan Uglow. Another was Paula's
future husband, Victor Willing, who was two years her senior in the school
and already married. He was twenty-four, English, and the most intellectu-
ally active of the students. He upset his tutors by playing the dandy and was
instrumental in inviting Francis Bacon to give a day's teaching, and David
Sylvester, Bacon's future chronicler and also something of a nonconformist,
to address the sketch-club. As a painter Vic (as he was always known) was
considered to be the coming star – a promise he did not truly fulfil until the
last ten years of his life.

Sylvester is still a friend of Paula's: his corpulent and bearded figure can
be seen among the spectators in the right-hand panel of *Crivelli's Garden* in
the National Gallery in London. In the 1950s he was notorious for sporting
a U.S. army combat-jacket on formal as well as informal occasions and as a
result of this he even came to the attention of Evelyn Waugh: 'Next day I
saw the most extraordinary man named SYLVESTER and cannot get him out
of my dreams night or day. He was an art-critic & looked like an American
soldier of the most alarming kind.'[12] Sylvester was the first critic to provide
an assessment of Paula's work: 'She is strange and individual,' he observed,
'an authentic and very courageous person who doesn't seem to mind to put
down what she feels. Sometimes her work is odd: I wouldn't expect it to be

done by a beautiful and cosy-looking and apparently well-adjusted girl.'[13] It is a perceptive comment, if dated in its patronizingly chauvinistic tone.

The Slade may have been the smartest of art schools but in its male domination – albeit typical of the time – it could echo Portugal. Paula particularly disapproved of the way women were not treated as equals, and the fact that rich girls were admitted at the expense of poor ones in the hope that they would support struggling young male artists by marrying them. Her memories of the teachers are mixed. Her tutor, William Townsend, was encouraging, and she enjoyed the visits of L.S. Lowry, who modestly admitted that the only reason there were never any shadows in his pictures was because he could never get them to look right. He applauded one of Paula's pictures on similar grounds: it succeeded in something that he could not himself have done. But she found Victor Pasmore, the most vociferous English advocate of abstract art, rude and dismissive.[14]

Paula lived first in a hostel in St John's Wood that her guardian had found for her. The contrast with Portugal could hardly have been greater. Bomb damage from the war remained largely unrepaired and the image of the area, now so prosperous, was one of seedy dereliction. These were the last years of steam-trains and coal-fires, whose smoke before the Clean Air Act combined to shroud the metropolis in sometimes impenetrable fogs or 'smogs', the well-named 'pea-soupers'. At dead of winter the smog often rendered the streets as grim as they had been in the days of Dickens. Paula recalls London having an acrid smell, and 'there was always this rustling in the dark as you walked home down the lonely short-cuts. I always imagined wild pigs were going to come rushing out, or murderers. It was really fraught.' A friend from Portugal, and a fellow-student at the Slade, was Teresa Black, with whom Paula shared digs. Teresa remembers it well:

Religion in Portugal was fifty years behind the times. We had to be chaperoned even to go to the cinema. In London we both gave up religion and Paula used to go to the cinema three times a day. I think she learned more from the cinema than she ever did at the Slade. She'd come in at 11 and be off by 12.30 or so in order to catch the movie matinees. She was a very quick worker. We were allowed to carry on more or less as we liked but we did do anatomy and life drawing. And with the models, we'd have the same one for three weeks running so we could finish a painting. I was very slow but Paula would complete hers in a couple of days. She never hesitated. And then she'd have the rest of the time to herself. I must confess I wasn't sure whether she was a genius or just childlike.

36 Vic Willing, 1960.

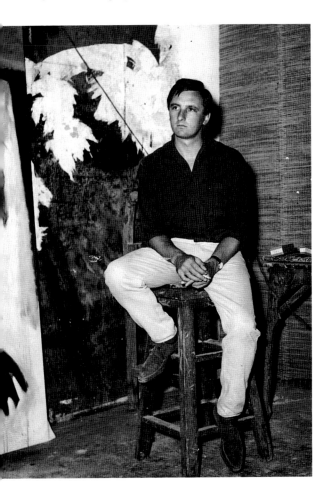

It appears that Paula was not an avid reader, but one book that, understandably, made a deep impression on her was Simone de Beauvoir's *The Second Sex,* planting, as it did, the first stirrings of independence in the minds of a whole generation of women. Its philosophy was not popularized until the 1960s; but for Paula, as for many others, it remains the key feminist text. With regard to books in general, and art books and magazines in particular, it should be remembered that in the 1950s they were neither so plentiful nor so affordable as they are today; and the same can be said of art exhibitions. Only two major London art exhibitions of the time made any impression on her, one devoted to Mexican art and the other to Goya.

As for pictorial fashion, Piero della Francesca was the most respected of the Old Masters at the Slade; but Paula's favourite picture in the National Gallery was Piero di Cosimo's mysterious *Battle of the Unicorns and the Centaurs*, a preference frowned on by her teachers and fellow students as being childish. She still admires it, and in the last forty years its reputation has seen a dramatic reversal. It is now one of the National Gallery's most popular masterpieces; the recently retired director there, Sir Michael Levey, thought it the pick of the entire Collection. The most celebrated artist among past Masters at this time was Cézanne, as it had been since the days of Roger Fry when Cézanne worship at the Slade was lampooned with jibes of 'Oh Cézannah! Oh Cézannah!' A puritanical taste for tenebrism made Giacometti the most regarded of living artists. Picasso was scarcely mentioned. He was considered a dark and anarchic force, who had progressively squandered a once great talent. Nevertheless, Victor Willing was one of many young artists to be bowled over by the Victoria and Albert Museum's exhibition in 1946 of Picasso and Matisse, which has often been cited as the most influential of all exhibitions on the English art world in the immediate post-war years. 'Seeing Picasso for the first time,' Vic recalled, 'was like being locked in a stall with a stallion.'

Contemporary taste among the students inclined to the vogue for Italian social realism, most popularly conveyed by the films of neo-realist cinema, and in painting by Renato Guttuso. But when Paula arrived she began by painting 'disgusting pictures of cities in flames with everybody screaming, running away – terribly over the top'. She thought they were very good,

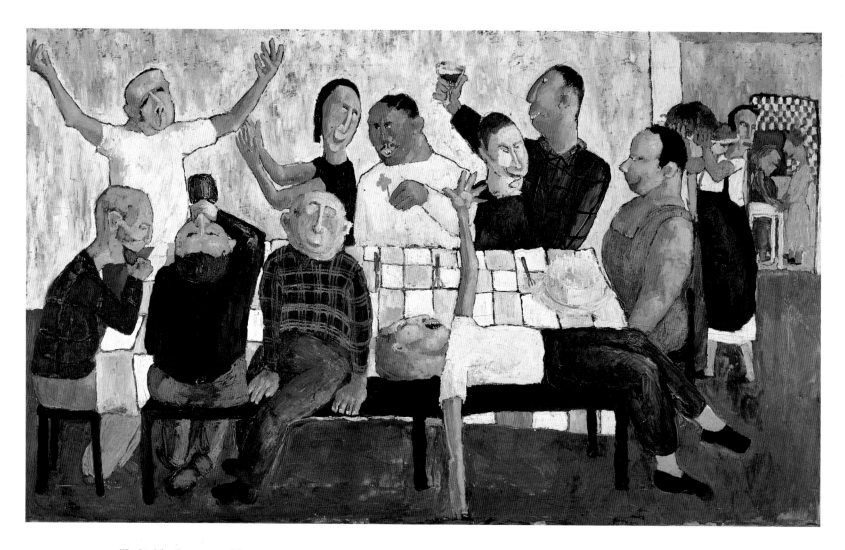

37  *The Birthday Party*, 1953. Oil on canvas, 124 x 205 cm.

although others disagreed. "'Oh you can't do something you don't know about", and of course they were right.'[15]

In 1953, for her first summer project, Paula painted *The Birthday Party*, **37**, which, in showing a scene from ordinary life, partakes of this more sober and realist spirit. It is a jovial subject and deliberately inclined to caricature. This did not go unappreciated. For many years *The Birthday Party*, audacious in size (124 x 205cm), filled a wall of the dining-room in the Estoril house; one maid employed by Paula's mother was never able to see it without having a fit of the giggles – a rare compliment for a picture. Paula's imaginative gifts as a storyteller are given a free rein in *The Birthday Party*; and if one was to sum up its message it would be that the women are shown in control, while the men are seen to be hopelessly out of control. No doubt there is a moral in this. *The Birthday Party* may be stylized to the point of caricature, but it is not *faux-naive*. This was, in Paula's words, 'as good as she could do' at the time, although she does admit making another more academic painting, now lost, of the same scene. It was probably not as impressive. *The Birthday Party* may be quite crude in its technique, but the characters' gestures and their implied relationships are precociously well observed.

In the spring vacation of 1954 Paula's father commissioned her to make two equally large paintings for the canteen at his factory. Remarkably, considering their size, they were completed in only two weeks during the vacation. These pictures are also 'social-realist' in subject, relating as they do to working life. One is of a local Portuguese fair, the popular evening entertainments where people promenade and dine at wayside booths. The second shows workers on a building-site. Men are sitting around, watched by various women. A pile of bricks in the middle-ground makes a formal connection with background buildings. These two pictures are complementary in several ways: play/work, night/day, dark/light; and for many years they hung side by side before falling victim to the iconoclastic fervour that briefly galvanized Portugal during the Revolution of 1974. They survive, but they are badly torn.

On the basis of these striking paintings it is no surprise to learn that Paula's talent began to be recognized by her teachers, and, along with three of her contemporaries, she was awarded first prize for the summer project

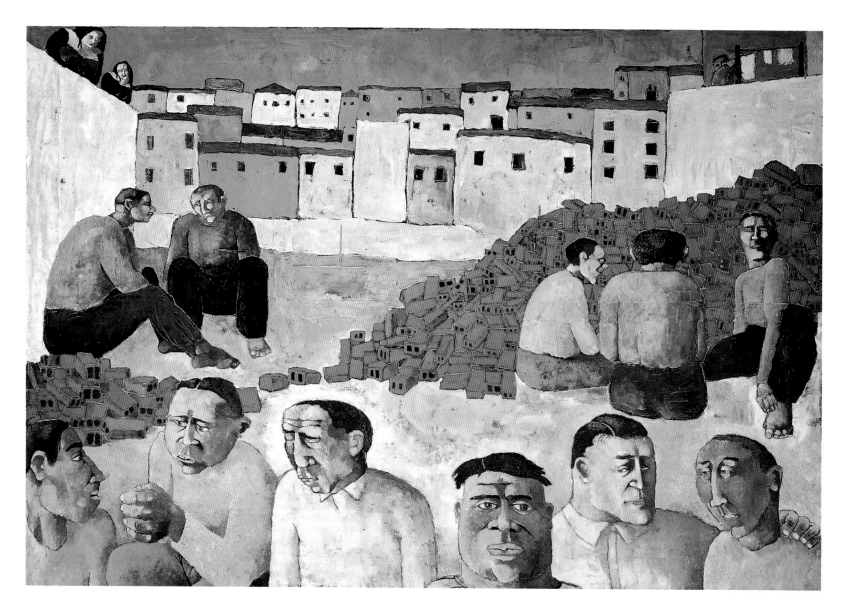

38  *Day*, 1954. Oil on canvas, 150 x 220 cm.

39   *Night*, 1954. Oil on canvas, 150 x 220 cm.

of 1954. The other prizewinners included David Storey, who was later to make his reputation as a novelist and playwright. The subject set them was Dylan Thomas's radio play *Under Milk Wood*, which Paula presented as a typically rumbustious Portuguese kitchen, with gossiping women and live and dead hens and chickens, **34**. This picture now hangs in the Principal's office at the Slade. Peter Snow, who maintains his contact with the School as a teacher, shares Paula's opinion that this and the other large and figure-dominated pictures that she produced at this period are more like her most recent work than anything she has done in-between, though thirty years of experience and hard work have contributed to a sea-change in accomplishment.

What happened to Paula's art as a result of her attendance at the Slade is difficult to determine, simply because so few of the pictures she made in the later 1950s have survived (most have been painted over). Teresa Black has some portraits by Paula that date from this period, and these are in the style of Chaïm Soutine, a passing influence. They are extremely accomplished portraits, but they can hardly be described as 'academic'. Indeed, Paula denies that the Slade *was* academic: 'I spent most of my time doing these pictures out of my head, which was encouraged. Not a restricting art school at all. Bloody good it was.' And yet, in the same interview she blamed the Slade for encouraging her to do, 'grown-up art. That's where art school was bad for me. I was painting out there on the easel in the coventional way and I lost touch with being a kid.'[16] Post-graduation blues is a common affliction among young artists, as Paula acknowledges, but in her case the temporary loss of direction that followed her departure may have had more to do with the influence of Vic Willing, with whom she had been in love almost from the moment she arrived. And he had a very different view of the School's influence:

> Imagination was anathema to Slade thinking, which was based on factual observation. As I said, I was a bit of a rebel at the Slade – I used to scandalize my sober teachers by telling them I admired Sargent, that sort of thing – but as soon as I left I became a slave to its prescriptive ways. It took me twenty years to recover, that's how I look at it. In the interim I painted stodgy pictures of nudes and figures.[17]

Paula seems to have suffered the same reaction; but for much of this time her emotional life was dominated by the complications of her love affair.

40 *Life Painting,* 1954. Oil on canvas, 68 x 55 cm.

The turmoil she suffered no doubt stood her in good stead later as an artist of the human comedy; but at the time, when divorce was a difficult and often sordid business, it was a trial by fire. One part of it she will always appreciate was her father's understanding and tolerance; Paula has a particularly tender memory of the time he drove her home to Portugal without raising the subject once, even indirectly.

# MARRIAGE

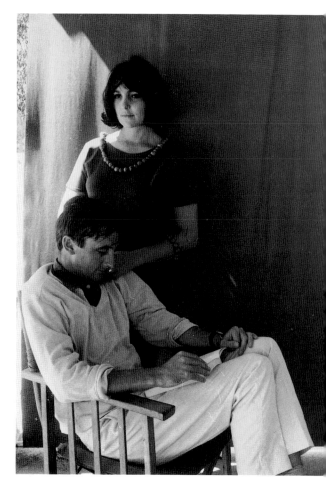

In January 1956 Paula gave birth to her first child, Caroline. The event took place in London and Luzia arrived from Portugal to help with the baby, enabling Paula to complete her final year at the Slade. The three of them then travelled home to Portugal, where Vic joined her in 1957. Paula's father treated him like the prodigal son, taking him to a local restaurant for a ritual celebration where Vic dined, unsuspectingly, on owl and donkey-meat. She and Vic returned to London in 1959 for the birth of Victoria, their second child, leaving Caroline behind in Portugal. It was while she was in London, and pregnant, that Paula happened to visit an exhibition by the French painter and father of 'Art Brut', Jean Dubuffet, a chance encounter that had immediate, and dramatic, consequences for her art:

> First I discovered Henry Miller. Oh, it was terrific. I couldn't get to the dirty bits quick enough. Then I discovered Dubuffet. And it released me. Whatever releases one about making art is beneficial. The exhibition was in London, and I was writing home these letters to Cassie (Caroline) with little childlike drawings at the foot of the page to illustrate what we were doing. And then I saw Dubuffet and I thought: 'This guy does what I do at the bottom of the letter big, right? And for real.' So I started doing my childlike scribbles big as well. It got me back in touch with being a kid again on the floor, in fact I began to work on a table, and play – and play.[18]

Vic encouraged her new-found zest by buying some old copies of Dubuffet's periodical *Cahiers d'Art Brut*. 'Art Brut', or 'Raw Art', was a term invented by Dubuffet to describe an artform that was unadulterated by market or academic considerations. Accordingly, it tended to be the obsessional concern of non-professionals – children, eccentrics or working people with no formal art education. As Dubuffet wrote: 'Art does not lie down on the bed that is made for it; it runs away as soon as one says its name; it loves to be incognito. Its best moments are when it forgets what it is called.'[19] It was with this in mind that, years later, Vic wryly concluded his preface to Paula's 1983 exhibition at the Edward Totah Gallery with the warning, 'She had better look out, people are beginning to think that this is Art.'

For Paula there was never any question of motherhood taking the creative place of art in her life: 'There's nothing creative about having babies. There's just this thing inside you and it comes out. That's all. It has nothing to do with imagination.' The example of Dubuffet gave her the confidence to abandon the 'serious grown-up' easel-based art that she had

41 Previous page: *Portrait of a Lady*, 1959. Mixed media on canvas, 73 x 100 cm.

42 Paula and Vic, 1962.

been attempting to produce since leaving the Slade. Vic encouraged her by prescribing a hard course of drawing. It did not matter what she drew, she just had to put pencil to paper and let her imagination roam – 'He always thought I was better at drawing than painting.' So she drew and drew, and eventually the pictures came again, raw in both colour and mood, as if she were literally 'drawing' her guts out. Victoria feels this may have had something to do with the fact that these pictures were done in the immediate aftermath of her birth. She describes them as 'uncomfortable' pictures – full of wounds, gore, teeth and spikes. But if their subject-matter reflects the pain and blood of childbirth, their undoubted gusto derives from Paula's pleasure at finding herself again through Dubuffet's unfettered example.

David Hockney was also influenced by the Dubuffet exhibition, and a contemporary painting of his, *Adhesiveness* (1960) has, despite being less organic and violent in its imagery, many of the same hallmarks as Paula's work of the same date – even down to the bared teeth and overt sexuality. The reason behind Hockney's response was, indeed, very similar:

> At the time I could draw figures quite well in an academic way. But that's not what I wanted in the paintings. And so I had to turn to something that was quite away from it, and I think that was the appeal of Dubuffet. Here was an opposite way, a crude way. I also liked his work's similarity to children's art, which is like Egyptian art in that it's all the same.[20]

Although Paula's chief aim in these pictures was to express the lack of self-consciousness, the innocent pleasure, of her own childhood years, which is invariably discernible in children's art, the results, for all their spontaneity, are far from unsophisticated. They show a particular taste for the humour and pendulant sexuality of Miró's figures and for the birds of Max Ernst, as well as for the fetishistic objects of tribal art that lie behind both. But each of these pictures by Paula also tells a story and each has the same degree of personal reference for her as her latest and most naturalistic works do: 'They're of people I was thinking about at the time – as if they were all together sitting round a dinner-table. But exactly who they were I can't remember anymore. I know that in [my] *Order Has Been Established* . . . **49**, the figure in the middle was a dumpy woman like a child, so I show her wearing a baby's frilly bonnet', she said in 1992. Painted in oil on canvas or on sketchpad paper, they are actually smaller than reproductions of them

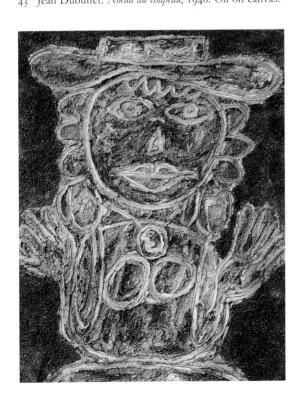

43 Jean Dubuffet: *Noeud au chapeau*, 1946. Oil on canvas.

44   *Gluttony*, 1959. Oil on canvas, 100 x 140 cm.

45   *Schmit's Restaurant*, 1959. Oil on canvas, 101 x 126 cm.

46  *The Eating*, 1959. Collage and oil on canvas, 95 x 113 cm.

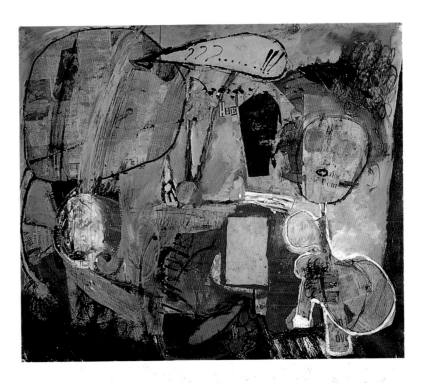

47  *Popular Proverb*, 1961. Collage and oil on canvas, 96.5 x 123.5 cm.

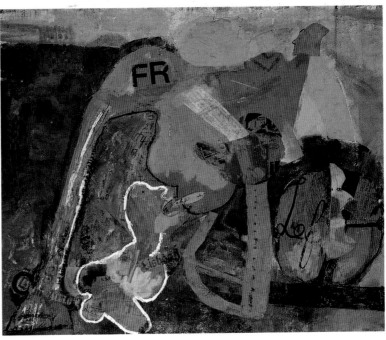

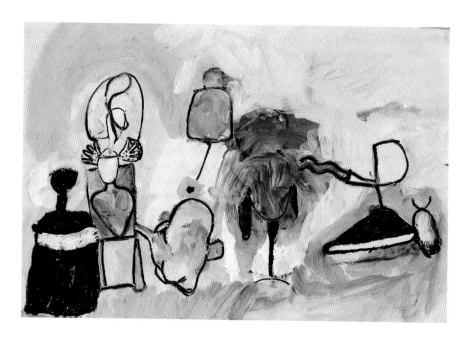

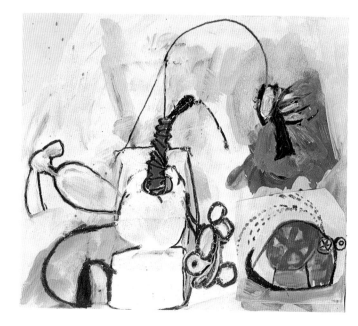

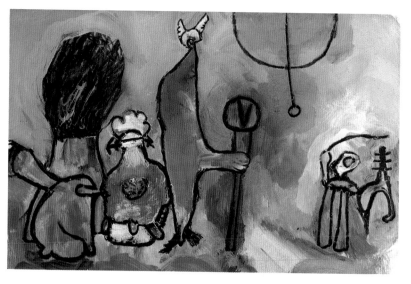

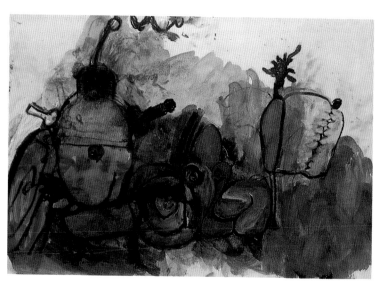

48 (top left) *Hurray for the Ding-Dong*, 1960. Oil on paper, 24 x 35 cm.

49 (above left) *Order Has Been Established...*, 1961. Oil on paper, 41.5 x 47.5 cm.

50 (top right) *Always at Your Excellency's Service*, 1961. Oil on paper, 22.5 x 25 cm.

51 (above right) *Trophy*, 1960. Oil on paper, 29 x 42 cm.

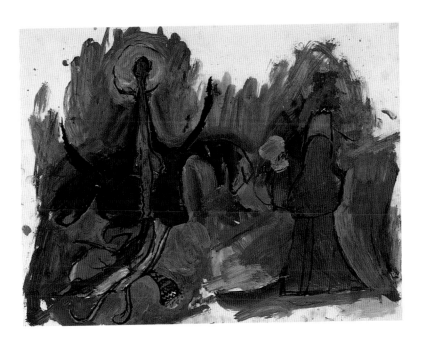

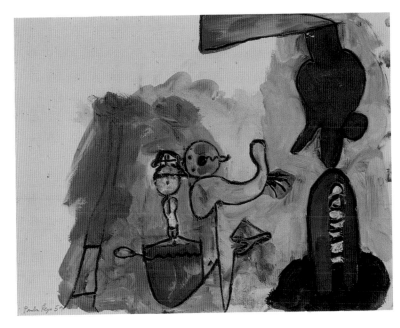

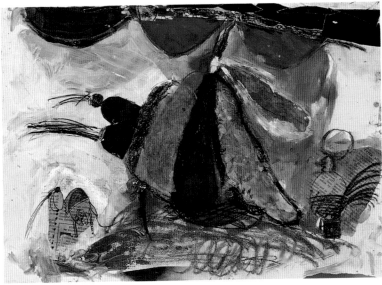

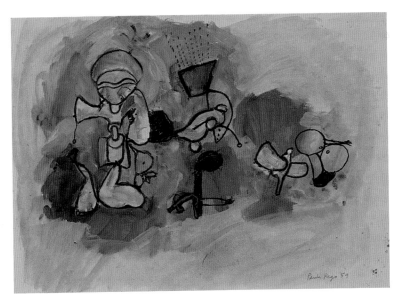

52  (top left) *Apparition*, 1959. Oil on paper, 20 x 30 cm.

53  (above left) *Queen*, 1961. Collage, crayon and oil on canvas, 20 x 30 cm.

54  (top right) *Untitled*, 1959. Oil on paper, 20 x 30 cm.

55  (above right) *Untitled*, 1959. Oil on paper, 20 x 30 cm.

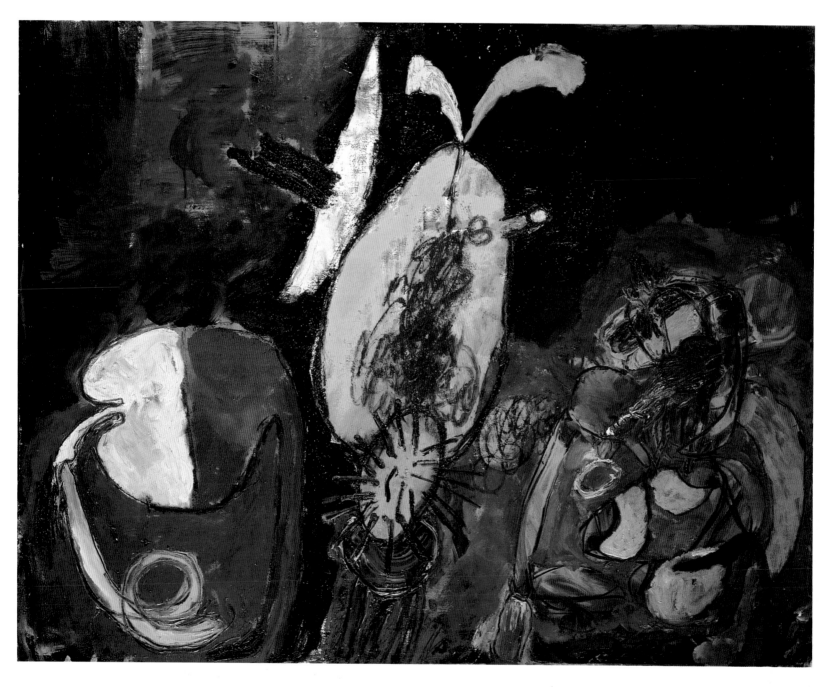

56  *Salazar vomiting the Homeland*, 1960. Oil on canvas, 94 x 120 cm.
Gulbenkian Foundation, Lisbon.

suggest, for example *Travelling Circus* (1960) or the *Untitled* series of 1959; but they remain among Paula's favourite works.

The violence in these works could also take the form of angry political protest, as in her *Salazar vomiting the Homeland,* **56** (1960) a picture that even the gallery owner Victor Musgrave – who was then England's leading advocate of Art Brut and Outsider Art – found too strong for his taste. 'It's got too many pricks', was his forthright explanation for refusing it; a reaction that suggests its political point is made more by the caption than by the image. Musgrave and Monika Kinley, who continues the Outsider archive today, remained enthusiasts of what they deemed the 'outsider' originality of both Paula's work and Vic's; and their support was constant and influential, not least for Paula in the 1980s.

From 1957 to 1962 – their third child, Nicholas, was born in 1961 – the family lived in Portugal. Although much of her time was taken up caring for the children, Paula still managed to work most days. Her father let them live in the villa at Ericeira, where they converted a barn into a studio – dividing it in two by a curtain. Caroline remembers them working there, usually in the afternoon, her mother more regularly than her father. Painting at that time was not an obsession with Vic. He could express himself in other ways, as a dandy or a businessman, and anyway he was more of an intellectual. But with Paula it was different. Painting for her was the essential outlet.

The children knew that when their parents were working they were not to be disturbed. In some ways this was an idyllic period, but Paula also remembers the isolation and their hunger for company. She and Vic sometimes felt so homesick for the remembered friendships and intellectual stimulus of London that they would go to the local hotel simply in the hope of hearing English voices; and occasionally they even asked perfect strangers back to the villa just for the pleasure of having conversations in English.

In these isolated circumstances, visits from their friends living in England – many of whom they knew from their time at the Slade – were particularly welcome, even the painter Philip Sutton, who harangued them on the iniquities of class and privilege as he sunbathed by the swimming-pool. Peter Snow, Michael Andrews and Patrick Caulfield were among those who visited, sometimes to stay for a holiday, sometimes only long enough to enjoy a long lazy lunch around the trestle table that stood in the shade of

57  Michael Andrews, Vic and Peter Snow at the Fair in Ericeira, 1964.

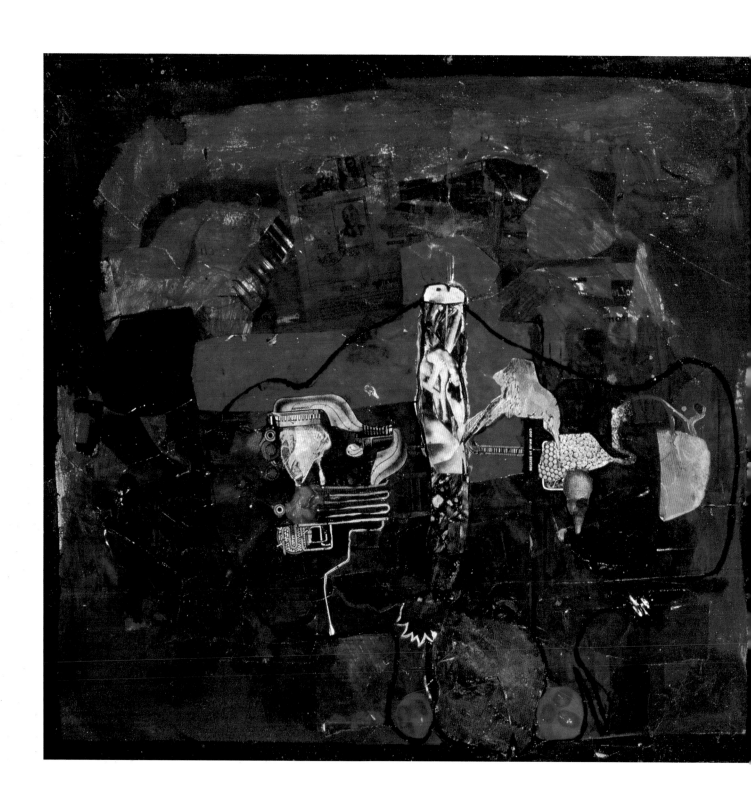

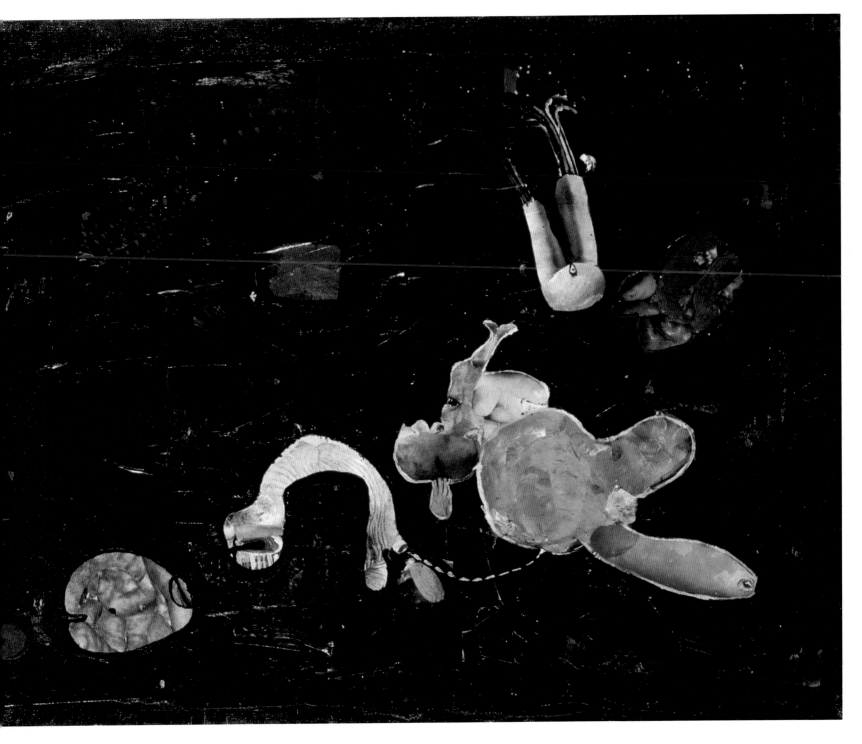

58  *Anatomy of Love*, 1960. Collage and oil on canvas, 60 x 140 cm.

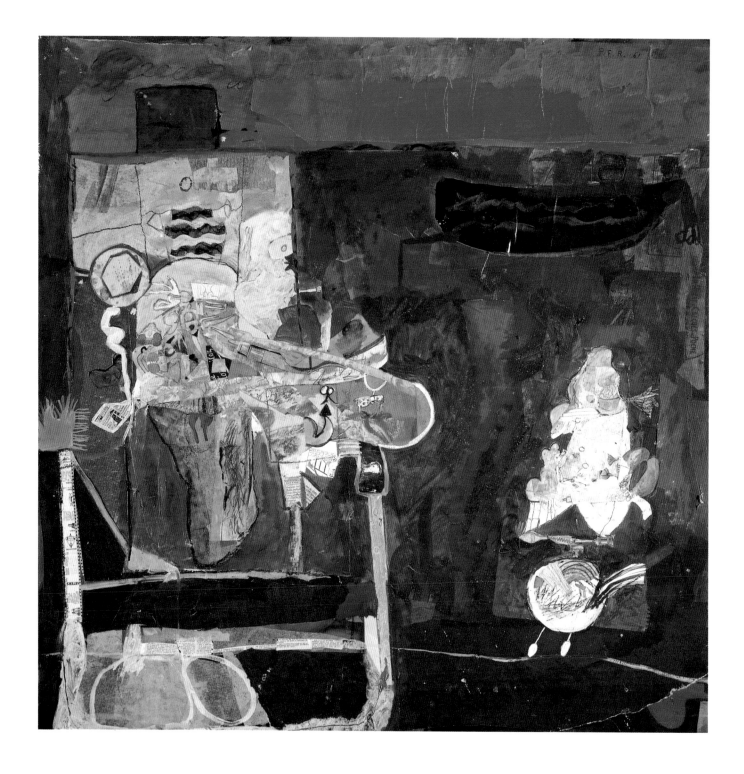

60   Paula and Vic with Nicholas, Caroline and Victoria at Estoril, 1962.

59   *Senhor Vicente and his Wife*, 1961.
Collage and oil on canvas, 90.5 x 90.5 cm.

the eucalyptus trees. But, despite the visitors, provincial life did not prove to be sufficiently stimulating: in 1962 Paula and Vic bought a terraced house in London – in Albert Street, Camden Town – and thereafter they spent their winters in London and the summers in Portugal.

Paula's immediate post-Dubuffet period was extremely productive. She had done several 'expressionist' portraits either of friends or models – the distinction does not seem to have bothered her – in which the accent was on the paint surface. But in these portraits she was describing the visible, whereas her drawings came directly from her own imagination, from 'feeling to hand', as she describes it. In her excitement at this rediscovery, which reconnected her with the intuitive spirit of her childhood delight in drawing stories for herself, she started to complete a painting each day, and to incorporate collage for the first time. To begin with, images were sometimes taken from magazines, but when she could not find exactly what was wanted Paula drew the image herself before cutting it out. She found the process of cutting pleasurable, just as she had when, all those years earlier, she snipped off the fingers of the doll.

For the first time Paula now felt confident enough to exhibit, and in 1961 she submitted three of her collage paintings for an open exhibition in Lisbon sponsored by the Gulbenkian Foundation. It was at this exhibition that she first saw the work of the painter Maria Inês Ribeiro da Fonseca, known as Menêz. Menêz was ten years Paula's senior, and already sufficiently well-established to have received a Fellowship the previous year from the Foundation. She subsequently became Paula's closest female friend. The exhibition in Lisbon also proved to be a professional watershed. All Paula's pictures were accepted and, as a consequence of their positive reception, in 1962 she was awarded a two-year Gulbenkian scholarship.

The following year Vic, who was then only thirty-five, suffered a heart attack at Ericeira while out walking with their dog. It was the dog that ran home to Paula and then led her to the spot where Vic was lying unconscious. (Vic later described how, lying with his face pressed to the earth, he imagined himself to be dead and buried.) While he convalesced, Paula channelled her own distress into *The Exile*, **62**. The whereabouts of this large painting is now unknown, but it remains one of her favourites, 'true to my feeling'. A photograph of it shows an elderly Republican, like her

grandfather, in a brown pin-stripe suit – a telling period touch – who has fled Salazar's fascist state for the safety of France. The old man's pensive, blue head appears to be in shadow, and bears an uncanny resemblance, in both mood and inclination, to Paula's favourite snapshot of her father on the beach. To the left of the old man is the wicked witch of the world of fairy-tales and a confusion of youthful erotic fantasies. The witch makes pancakes, which are being stolen by a crafty boy. It appears that every time a pancake disappears the poor cat takes the blame and gets a slap. To the old man's right is his sweetest memory, the spectacle of his lovely young bride on her wedding-day in May 1904, the date that is inscribed at her feet. The fragmented disposition of the figures makes it a difficult picture to read, though a wavy sea is clearly visible in the background. The nostalgic mood makes it a precursor of *The Dance,* **167***,* painted twenty-five years later.

61  Paula in 1965.

Paula had not neglected meanwhile to make professional strides in London. From 1962 she entered pictures for the annual exhibitions of the London Group, to which she was soon elected a member. At this time the Group, founded in 1914 as an exhibiting society for progressive artists, was enjoying a revival under the spirited presidency of Claude Rogers, a stalwart of the Slade teaching staff. The Group's exhibitions provided a useful showcase for younger artists, such as Hockney, Auerbach and Michael Andrews, with all of whom Paula remembers showing her work. In 1965 she consolidated her association with the Group by accepting a place on its governing committee. That same year she was also included in a mixed exhibition at the more assertively avant-garde Institute of Contemporary Art, then based at its original Dover Street premises. Roland Penrose, the friend and biographer of Picasso and the Institute's founder, was impressed by her, telling the painter and critic Keith Sutton that she seemed to be bursting with things she must say, 'and this necessity overrides the restraints of calculated harmonies and gives refreshing exuberance and originality to her work'.[21]

But Paula's real breakthrough came in Portugal in January 1966 with her first solo show, which was held at the Galeria de Arte Moderna in the Sociedade Nacional de Belas Artes, Lisbon. Within the world of Portuguese artists and critics she became famous overnight. It was especially gratifying for Paula that this important moment in her career was witnessed by

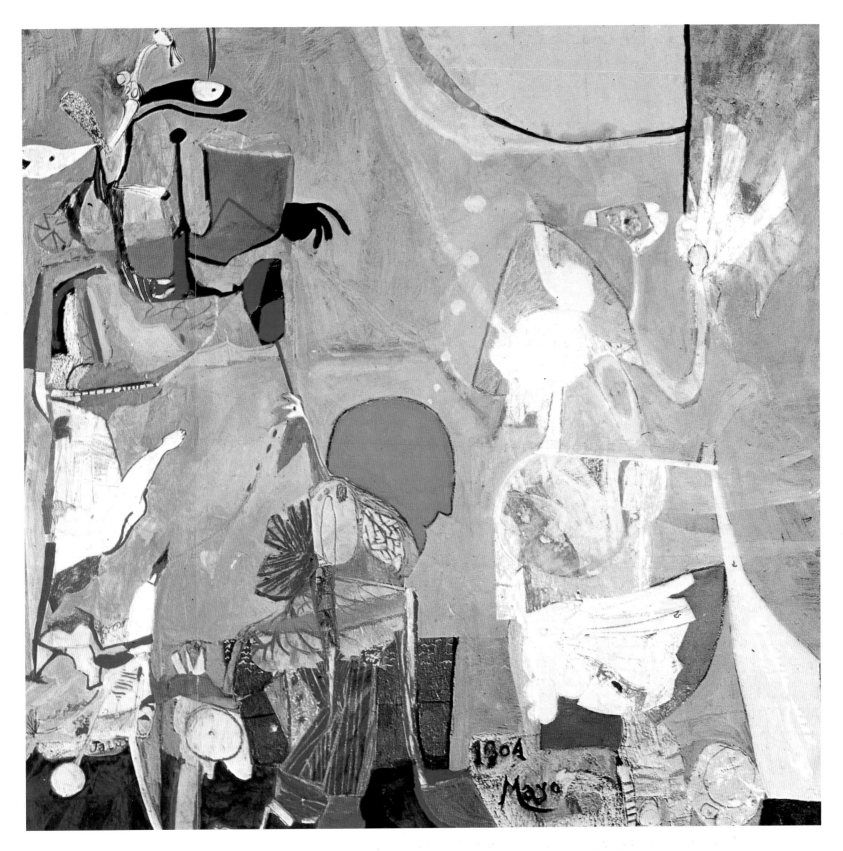

62  *The Exile*, 1963. Mixed media on canvas, 152 x 152 cm.

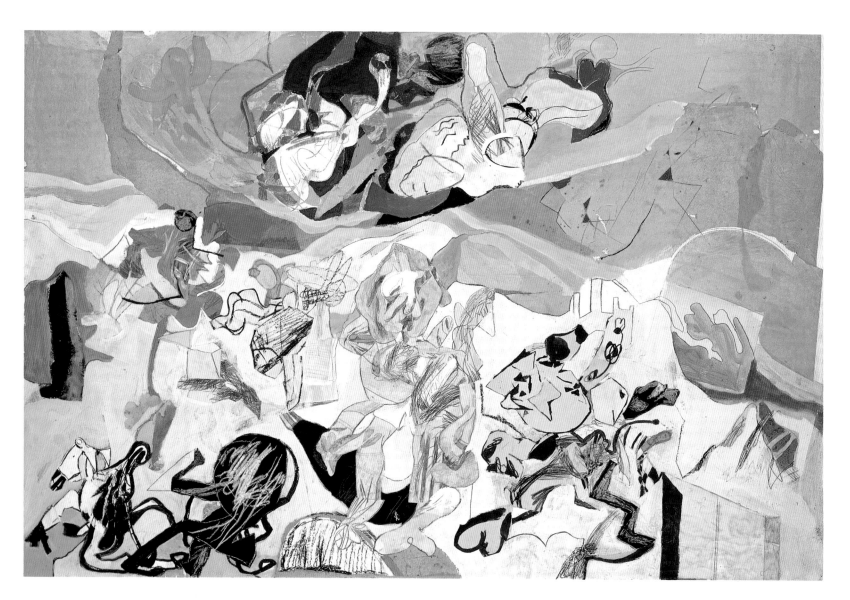

63 *Nursery Violence*, 1963-4. Mixed media on canvas, 101 x 152 cm.

64 *Snow*, 1964. Collage and oil on canvas, 68 x 92 cm.

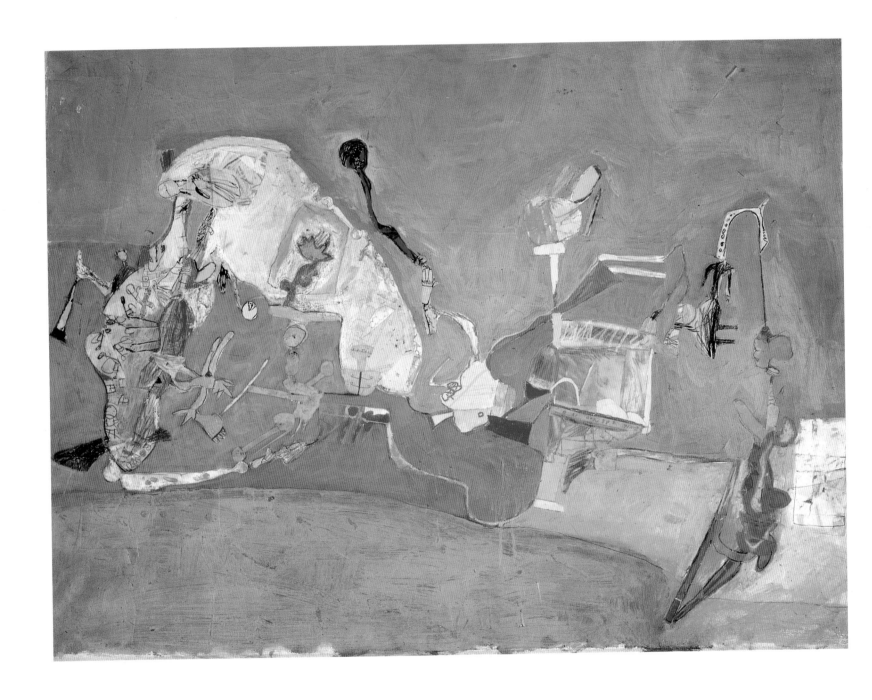

her father, who had been so supportive over the years, for he was to die only six months later. He was particularly pleased that her solo début took place in Portugal, and his approval of her work, much of which reflected his own liberal dislike of Salazar's regime, must have been intensely felt.

The catalyst for this exhibition was the Portuguese poet and essayist Alberto de Lacerda, a very close friend who also wrote the text for the catalogue. Lacerda was not only famous in his own country, but also enjoyed unique status in England having had his first book, *77 Poems,* translated by Arthur Waley when he was only twenty-six, and having subsequently made friends with some of the leading English writers of the day. As much at home in the artistic circles of London as those of Lisbon, he was particularly well placed to give help and encouragement. He gave Paula her first press interview, which appeared in the leading Portuguese daily newspaper *Diário de Notícias* on Christmas Day 1965. It concluded:

*AL:* In the family-tree of painting which do you consider your line of descent? Or don't you?

*PR:* None. The reason is perhaps that I get inspiration from things that have nothing to do with painting: caricature, items from newspapers, sights in the street, proverbs, nursery-rhymes, children's games and songs, nightmares, desires, terrors.

*AL:* Is this the way – using this arsenal both quotidian and fantastic – that you arrived at the images you now present to us?

*PR:* Yes.

*AL:* An idiotic question, but sometimes it is necessary to ask idiotic questions: Why do you paint?

*PR:* That question has been put to me before and my answer was 'To give terror a face'. But it's more than that. I paint because I can't help it.

When Paula re-read this interview a quarter of a century later her reaction was, 'Plus ça change . . . !'

The show stunned the Portuguese art world. In the words of the painter Eduardo Batarda it had 'an animal, vicious, formidable shock', its freedom of expression exposing just how compromised most Portuguese artists had become, the majority of whom, while pretending to confront the status quo, had, in fact, arrived at a tacit acceptance of it. 'Paula's exhibition in 1965 showed that real sincerity was possible beyond slogans or expressive clichés', remembers Batarda:

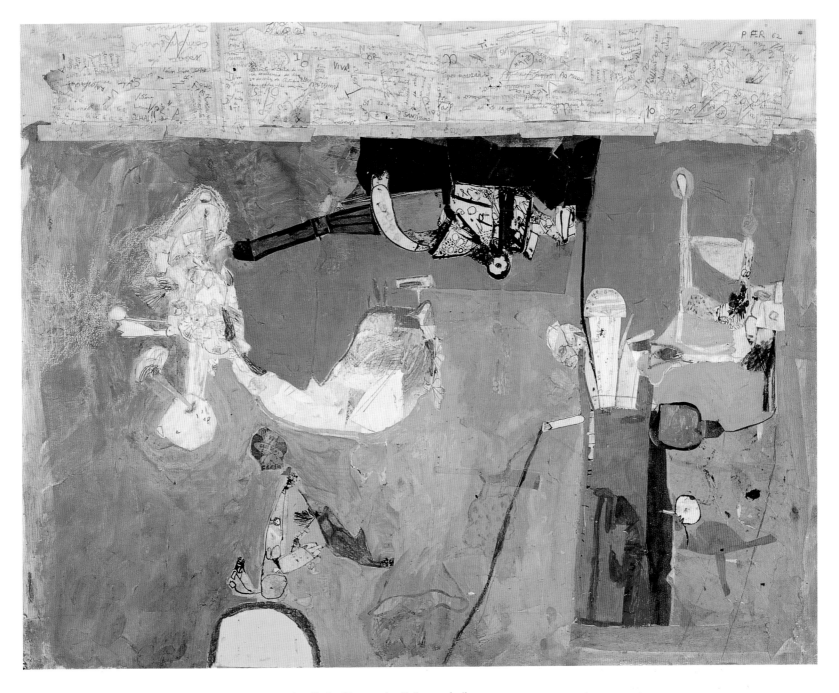

65 *Iberian Dawn*, 1962. Collage and oil on canvas, 72.5 x 92 cm.

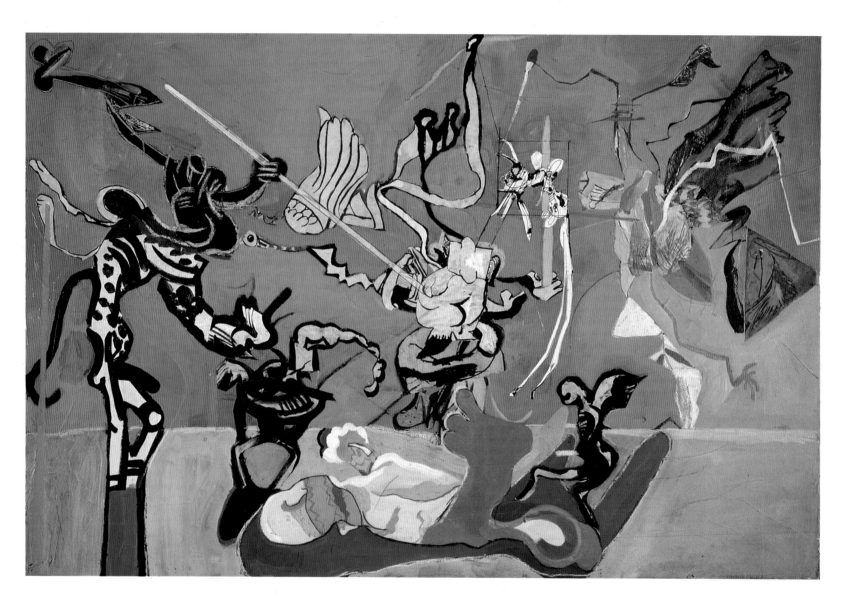

66 *Gorgon*, 1964. Collage and oil on canvas, 100 x 150 cm.

67 *Stray Dogs (The Dogs of Barcelona)*, 1965. Collage and oil on canvas, 160 x 185 cm.

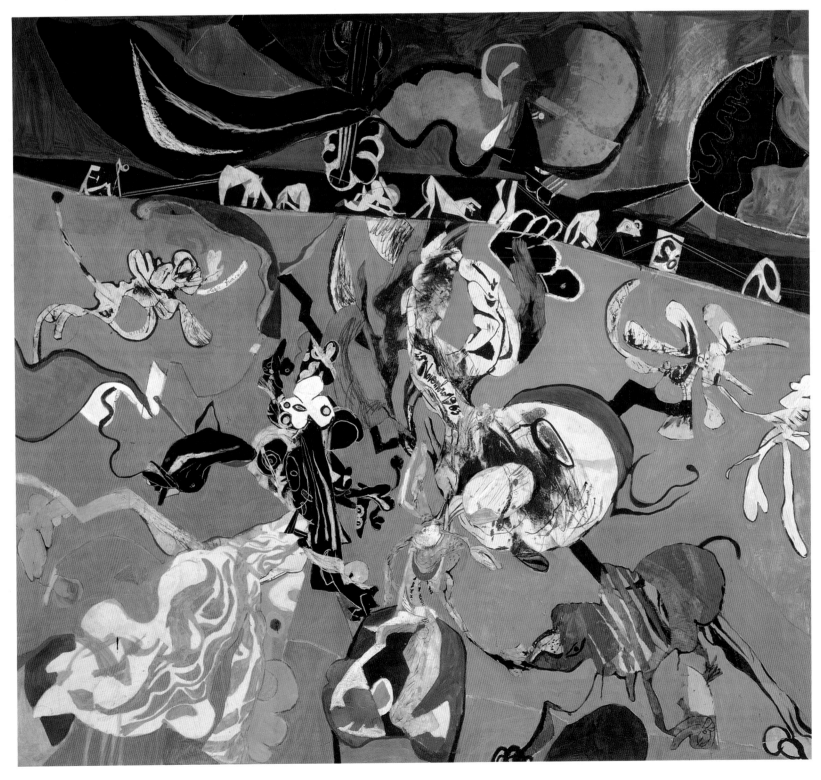

We could see literary, autobiographical and quotational superimpositions as part of a continuous improvisation. We could see that this improvisation was ruled by permanent, absolute, standards. We understood that these standards brought rigour and precision of method, while never allowing for self-censorship. This is hard to remember and still more difficult to express today; but how repugnant it was to us Portuguese artists at the time, how revolting to our repressed/repressive minds. Even the way she made her pictures, the technical approach, the very colours themselves (the colours of the next London season?) were shockingly new. There were so many reasons for our hatred – and hatred it was. Some of us called it admiration but that was certainly a lie.

The opening was not entirely free of unpleasantness. One angry old conservative turned on Paula, saying, 'You must be a slut to paint these pictures', to which she politely replied, 'No. Sluts paint churches'. As Lacerda explains:

Portugal absorbed the worst, most puritanical side of Catholicism; but Paula disturbed this entrenched moral view. Of all Portuguese visual artists she is the one that has most brought out, has been most honest in displaying, her innermost world for what it is, good or bad. She lays her subconscious bare – nothing is translated, nothing improved. It is just naked.

It was an affront to bourgeois good manners made all the more offensive by having been inflicted by one of their own kind, a 'nice' girl from a 'nice' family. However, three of the artists who expressed a genuine enthusiasm for her work were among the best known and most respected in Portugal, the veteran Almada Negreiros and the Surrealists Cruzeiro Seixas and Mário Cesariny.

The key work in the show was *The Dogs of Barcelona,* **67**. This painting had been triggered by a report in *The Times* that explained how the authorities in Barcelona had decided to solve the problem of the growing number of stray dogs in the city by feeding them poisoned meat. In *The Dogs of Barcelona* Paula equated the indiscriminate brutality of this decision with other harsh directives of the dictatorships in Spain and Portugal. As she was later to admit, 'I can only understand ideas in terms of human relationships – I don't understand political abstractions. People as characters are far more real to me.'[22] So the political situation led her to spin a story from her own experience, one that had relevance to her own life, and which addressed the arbitrary and often brutal pressures of adult control, of bourgeois protocol;

and the dog-like way in which we suppress and poison our individual natures in order to obey them.

Paula still responds to the 'vitality and toughness' of *The Dogs of Barcelona*, in which the unsuspecting animals appear in a strip near the top of the picture – a device previously used in the form of collaged sheets of writing in *Iberian Dawn*, **65** (1962), and which she employed most overtly in the *Opera* cycle of 1983. Below the line of lazing animals in *The Dogs of Barcelona* is an arena of convulsive action, a depiction of their torments: poisoned raw meat, more dogs and enormous flies furiously intermingle. The shrouded figure at the bottom of the composition derives from a painting of Lazarus licked by dogs, which she found reproduced in a book of Catalan primitive art that Vic had given her. When, in 1971, Vic described the genesis of *The Dogs of Barcelona* he added a highly personal note:

> It happened that when the picture had reached an impasse, the security of the family was threatened by a girl. The artist introduced this girl in the dark, heavy reclining form pressing into the top of the picture. An angry hour's work, this figure representing sloth, indifference and immediate self-interest made the theme of the painting clear in the mind of the artist and forced the picture to a conclusion.[23]

*The Dogs of Barcelona* can be placed in a wider art-historical context. The knottedness, the entrailed connections, are distantly related to the elusive sexuality of the imagery of Arshile Gorky; but this marks only a stage in the passage from the roughness of Dubuffet-inspired graffiti to the more smooth, comic-book accents of the late 1960s, announced by such increasingly large and readable works as *The Martyrs,* **73** (1967) or *The Punishment Room,* **28**, and *Hydra,* **77**, of 1969.

The last word on Paula's art of this time must rest with Alberto de Lacerda, whose observations, written with the benefit of hindsight, have a profound application to her work in general:

> The erotic element in Paula Rego's painting seems very direct on a first viewing. The more one enters her painting – and one must enter it, otherwise one cannot *see* it – the more oblique all her allusions become. The narrative element is there, no doubt. (She admits her pictures often tell a story.) But the sumptuous apparatus of rich colouring, the demanding structure, and a curious sense of line, even at her most painterly, uncover simultaneously an overall sense of abstraction. The ambiguity is at the root of the disturbance she causes in the viewer. Her paintings, even when the meanderings seem most private, reveal a profound revolt, moral, social, and political, as is the case with

68 Paula at work in her mother's house at Estoril, 1966.

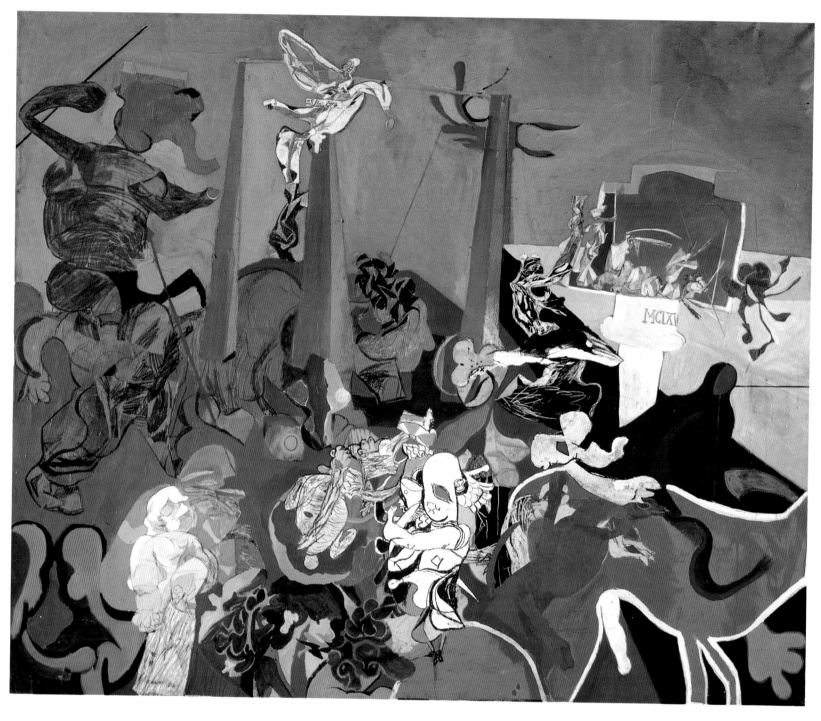

69 *Julieta*, 1965. Mixed media on canvas, 152 x 183 cm.

70 *Centaur*, 1964. Collage and oil on canvas, 140 x 139 cm.

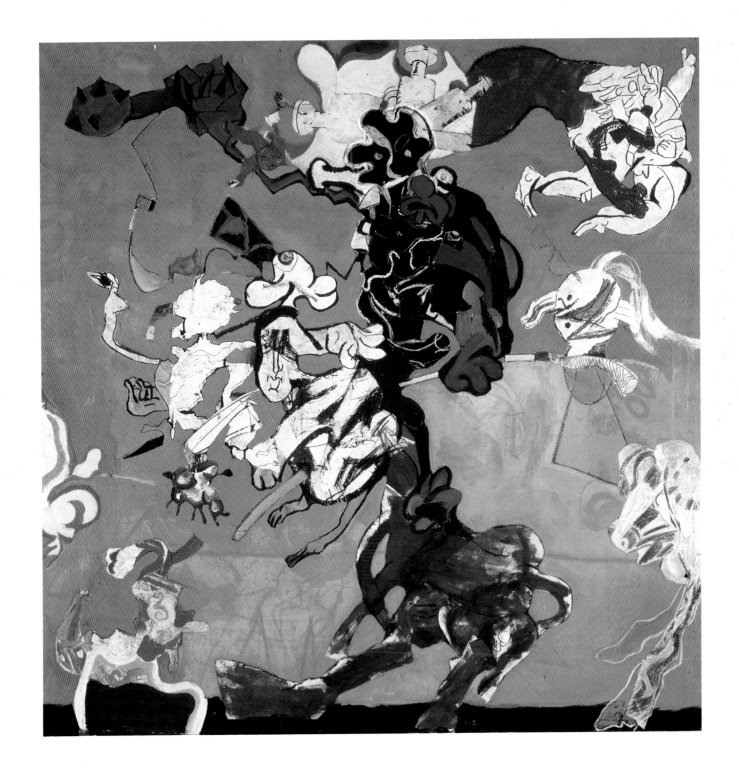

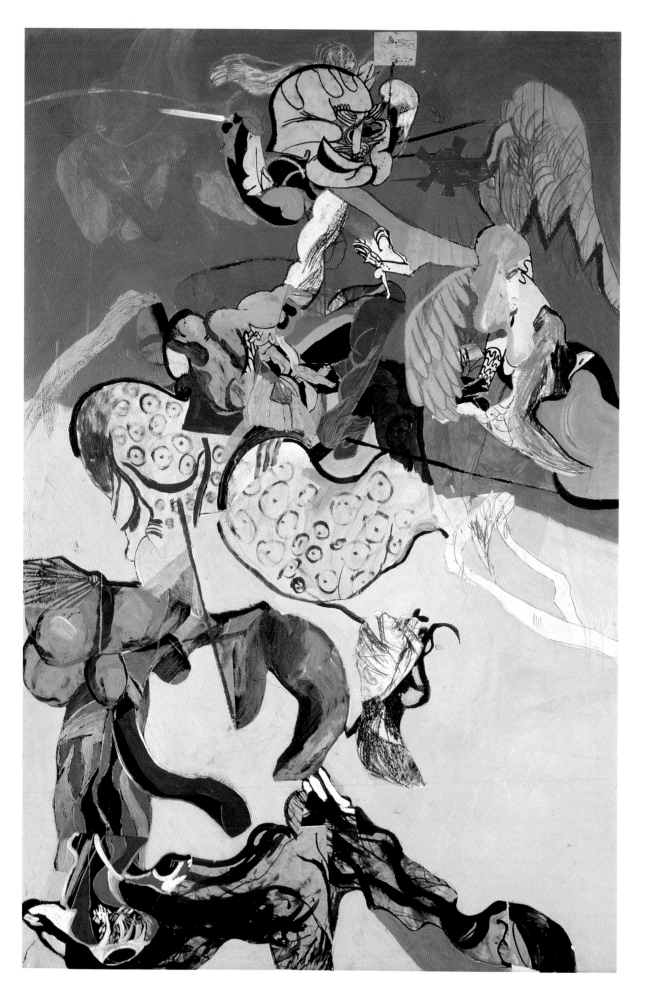

71 *Warrior*, 1965. Collage and oil on canvas, 162 x 101 cm.

72 (opposite) *The Firemen of Alijo*, 1966. Oil and collage on canvas, 152.5 x 183 cm. Kingston Polytechnic.

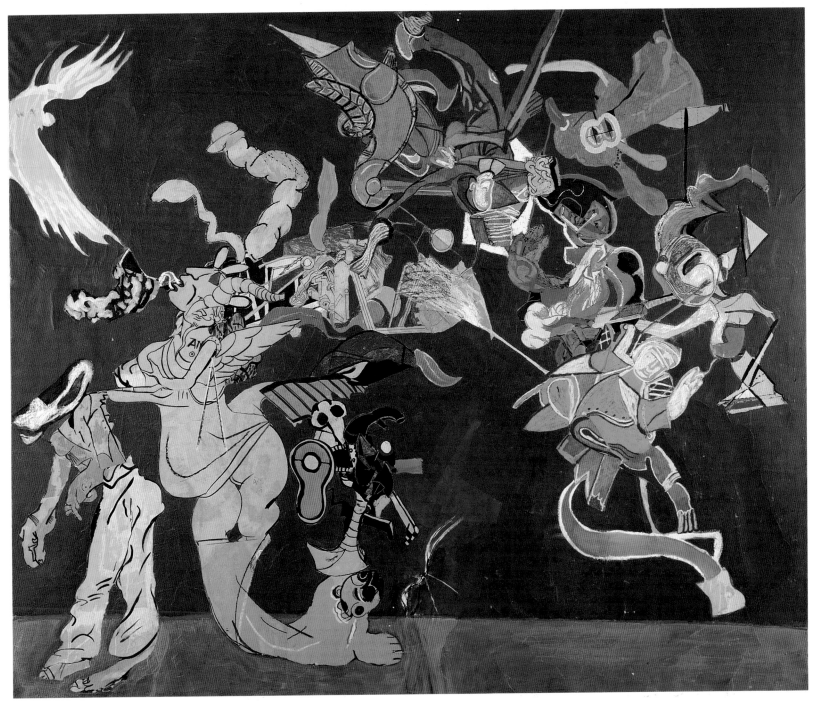

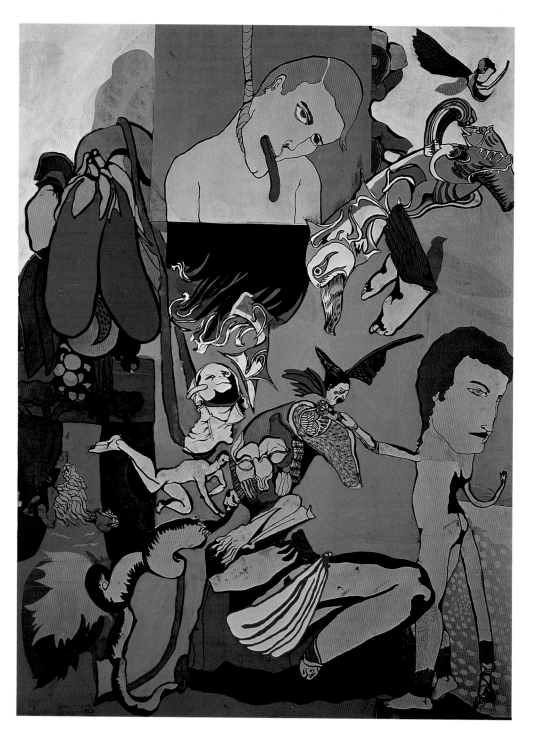

73  *The Martyrs*, 1967. Collage and acrylic on canvas, 130 x 95 cm.

74, 75, 76  (opposite) Paula and the children in the studio, London, 1966, taken for an article in *london life*. Photographer: Tony Sullivan

that masterpiece *Stray Dogs*. This picture (in which the word 'Franco' appears) was originally entitled *The Dogs of Barcelona*; the title was changed to avoid trouble with the Portuguese fascists. She manages to be convulsive and fluent, dream-like and ferocious. It's not at all a child-like world, but it knows all about the ligaments of innocence twisted by perversity and oppression. She said once that she painted to give fear a face. Her work shows both the terror and the courageous triumph.[24]

Paula painted *The Punishment Room* in Estoril, where the atmosphere revived memories and emotions from her childhood. Under the watchful eye of a grandfather figure, a little girl in a Carmen Miranda hat plays with a fairground toy shaped like a skull. The ice-cream cone is topped with a roaring lion. The boy lying in the field nearby little realizes that he is on a spring-board, and that if the snake-mother slumbering to his right were to fall off he would be catapulted out of the picture. The gay Tyrolean hat with dangling cherries is intended to provoke terror. Perhaps what especially differentiates this work from *The Dogs of Barcelona* and the other oil paintings that preceded it is Paula's enthusiasm for acrylic paint. Acrylic, being water-based and therefore quick-drying, proved to be particularly suited to her spontaneous method of working. It has the added advantage of not smelling of turpentine, a smell Paula was finding so repugnant that eventually she gave up painting in oils. The change to acrylics, then the most popular of technical innovations, seems to dictate the colour, though fashion also plays a part.

Each era has its fashionable colours, and London at the height of the 1960s saw a psychedelic outburst of colour in retail clothes after years of drab, post-war austerity. Sixties colours were purple, green, pink and yellow, often in gaudy combinations and patterns. The graphic infatuation with Art Nouveau – most famously popularized by Alan Aldridge's illustrations for the *The Beatles Song Book* – was another element of Pop culture to permeate her post-1967 work. 'Pop' she may not have been as an artist; but she was certainly affected by it. An element of urbanity enters her work, not least through its synthetic use of colour, which is quite different in character from the earthiness of her early collages. The change undoubtedly reflects her life in London. Britain was a completely urban society compared with predominantly rural Portugal; and Pop, an art movement which fully embraced technology, was a symptom of this urbanity. Photographs taken at that time

testify to Paula's enthusiastic acceptance of irreverent 1960s styles – boots, mini-skirts and Vidal Sassoon's 'hard edge' hair-cuts. Jet transport and post-war affluence introduced numerous tropical fruits and vegetables to Europe for the first time; one novelty for example, aubergine, is given its due by Paula in *The Martyrs*. Enthusiasm for Art Nouveau encouraged a taste for soft shapes, expressed by the voluptuous folds of the many-headed snake in *Hydra*, a vogue that briefly took the bizarre artistic form of 'soft sculpture'. Paula tried this too, realizing the distorted figures of her paintings in two doll-like forms made out of kapock-stuffed felt. She finished the decade on a high note by being chosen to represent Portugal as a painter at the São Paulo Bienal in 1969.

77  *Hydra*, 1969. Collage and acrylic on canvas, 120 x 120 cm.

78  (opposite) *Mussel Beach*, 1969.
Collage and acrylic on canvas, 150 x 150 cm.

# UPS AND DOWNS

aula did not select any of the work from the period 1966-80 for the English showing of her first retrospective, held at the Serpentine Gallery, London, in 1988. This reflects the unhappiness of those years, which began with her father's death in 1966 and ended with the sale in 1979 of the cherished villa at Ericeira. In between there was the Revolution in Portugal, the winding-up of the family business that followed and, worst of all, the diagnosis and rapid advance of Vic's multiple sclerosis. This was an affliction heroically borne, to the point of being the making of him as an artist. But his illness, nonetheless, became an increasing burden to his family.

One effect of her father's death was that Paula embarked on a series of poignant pen-and-ink drawings using her young friend Manuela as a model, **80**. Manuela's parents, Estefânia and Joaquim Morais (Estefânia was Maria Rego's sister) were neighbours in Estoril; and Paula began the drawings there, at a table in her mother's drawing-room. She drew irregularly over the next few, difficult, years. Dr John Mills, a school-friend of Vic's who retired as Head of the Scientific Department at the National Gallery in London in 1990, remembers Paula as a quiet woman, subordinate when in conversation with her husband. He recalls them both at work above a bothersome lot of stairs that led to the top floor of their house in Albert Street. *Walk with Grandfather,* **81** (1970) shows Manuela and some adults on a Sunday stroll through the park in Estoril. The location is largely identifiable by the clipped box-hedges of the formal garden that appears in the painting, an arrangement from which she derived the maximum graphic amusement. This play with line and detail is reminiscent of early works by Lucian Freud, who had taught at the Slade when Paula was there (David Hockney's drawings made in the 1960s also display this Freudian edge). But as with all Paula's work there is a deeper personal message beyond the formal or objective. Vic's account of it appeared in *Colóquio* in April 1971:

According to the social psychologists the ethic pattern which, in a paternalistic society, is imposed by the father is, also, indirectly imposed through the *mores* of the society, affecting the forms of behaviour, gesture, fashion and art. These forms reinforce direct authority and remind the process of self-domination to function when outside domination is removed. A chain reaction of aggression, revolt and redomination is the pattern of maturation and is reflected in the forms of behaviour, etc. The degree and nature of the individual's and the society's neurosis indicate with how much success this aggressive pattern is endured.

79 Previous page: *Contos Populares Portugueses: Three Little Devils Wrapped in White Thread*, 1975. Gouache on paper, 70 x 50 cm. Gulbenkian Foundation, Lisbon.

80 *Manuela at the Window*, 1967. Indian ink on paper, 20 x 30 cm.

81 *Walk with Grandfather*, 1970. Indian ink, 19 x 29 cm.

During 1970 the artist produced a number of drawings which were an unambiguous commentary on this pattern of self-dominance in a family context.

One might imagine the unspoken thoughts of the figures.

Order and civism, the hedges are well cared for. During a walk, a well behaved little girl does not run. In any case her hat would fall off. To insist is wilful. It is rude to grind our teeth.

For the catalogue to her second solo show which was held at the Galeria São Mamede in Lisbon in 1971, Paula included extracts from the erotic bondage novel *The Story of O*, the children's tale of *The Exemplary Little Girls* by the Comtesse de Ségur, Sigmund Freud's *Jokes and their Relation to the Unconscious* and works by several other writers, which she used to help explain the pictures. São Mamede was an important gallery, since it was managed by Cruzeiro Seixas, one of Portugal's leading Surrealists, who had helpfully voiced his approval of Paula's first, controversial, show in 1965. This new show crucially consolidated the success of her début. She managed five other solo exhibitions of new work in Lisbon and Oporto in the 1970s, as well as representing Portugal once again at the São Paulo Bienal in 1975, one year after the Revolution. Cultural politics in Portugal were as much in turmoil as the country's party politics were then, and Paula feels she was reselected on a safety-first basis, having fitted the bill before. She was not required to make any work for the Bienal and did not travel to Brazil to see it.

The English art world proved more obdurate. The early 1970s was a time when even a Keeper at the Tate Gallery could speak in all seriousness of painting being dead. The fashion for Conceptualism – in which the artefact was often no more than an explanatory text – reached its zenith (or nadir) at Documenta 5 in 1972; and younger artists on both sides of the Atlantic directed their attention to transitory, often deliberately hard to market and therefore anti-capitalist, presentations such as performance and environmental art; the fashion could hardly have been less sympathetic to Paula's humanism.

But in 1975 a grant from the Gulbenkian Foundation enabled Paula to take time off in order to research fairy tales. The Foundation has consistently been supportive of her as an artist, and never more so than on this occasion, when she was allowed, more or less, to dictate her own terms

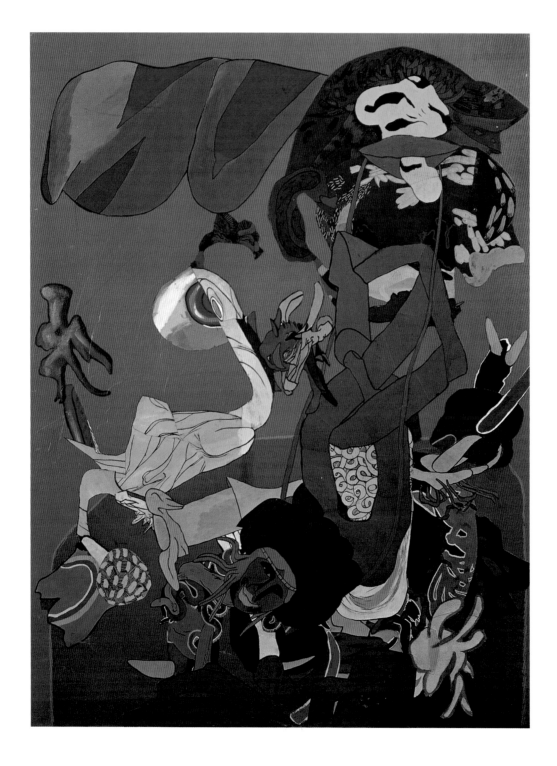

82  *Old Women*, 1970.
Collage and acrylic on canvas,
120 x 90 cm.

solely on the grounds that she needed financial help. She spent about six months on this project, spending most of her time in the British Museum and Library. The research led to Paula's decision to concentrate on illustrating some of the best-known Portuguese fairy tales. This she found a release after working in collage, a medium that, for her, had become ritualistic to the point of academicism. She enjoyed the break from routine that the illustrations afforded her, and the relief they offered by not first requiring her to make up a story of her own. In these ways they were very similar to her later break from painting in 1989, to make etchings of English nursery rhymes, although comparatively the Portuguese fairy-tale illustrations lack imaginative vigour, being heavily dependent in style on the Art Nouveau style of Edmund Dulac, Maxfield Parrish and Arthur Rackham. A desire for neatness stifles the often lively drawing making the finished result look, in Paula's own, later, opinion, as if they were 'ironed onto the page'.

Not surprisingly, the strain of Paula's domestic life took its toll during this period. Like her father, she suffers from periods of depression; like him too, as we learn from her mother, she is an obsessive worker. Since 1973 she has periodically undergone Jungian psychotherapy. This soon revitalized her interest in her own childhood and in folk tales, children's art and primal art – not least Art Brut. Her research into fairy tales and weekly sessions of analysis were mutually helpful in making her confront the legacy of her own childhood, which in turn benefited her art. Paula's picture-making derives more from this instinctual world of childhood than from the watchful one of adulthood; but her instinctual behaviour, the infant-like, sometimes infantile, mode she adopts as soon as she finds herself back on her hands and knees on the floor with a piece of paper and something to draw with, is unavoidably tempered by selfconsciousness – a self-consciousness she is at pains not to let gain the upper-hand. It is because it did gain the upper-hand for the illustrations to the *Contos Populares Portugueses* that they proved to be a disappointment. Nevertheless, their merits should not go unacknowledged, especially in the matter of details. Perhaps the most characteristically disturbing image is that of the elegantly gowned lady with a head-dress in *Branca Flor* which, on closer inspection, resolves itself into the shocking form of a sinister bird.

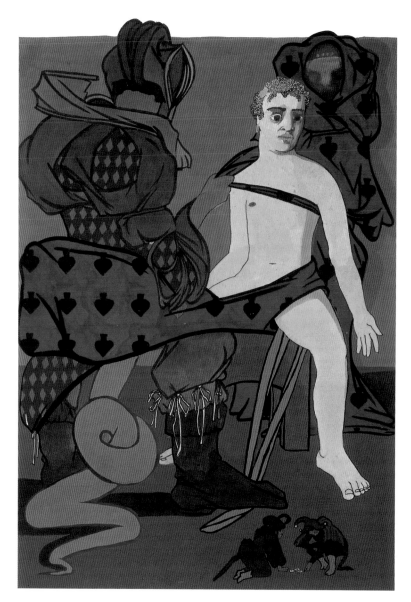

84 *Contos Populares Portugueses: Branca-Flor - Boy gambling with the Devil*, 1974.
Gouache on paper, 70 x 50 cm. Gulbenkian Foundation, Lisbon.

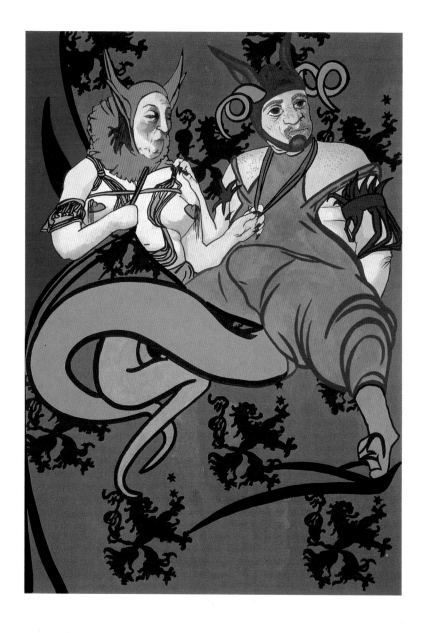

83 *Contos Populares Portugueses: Branca-Flor - the Devil and the Devil's Wife*, 1975.
Gouache on paper, 70 x 50 cm. Gulbenkian Foundation, Lisbon.

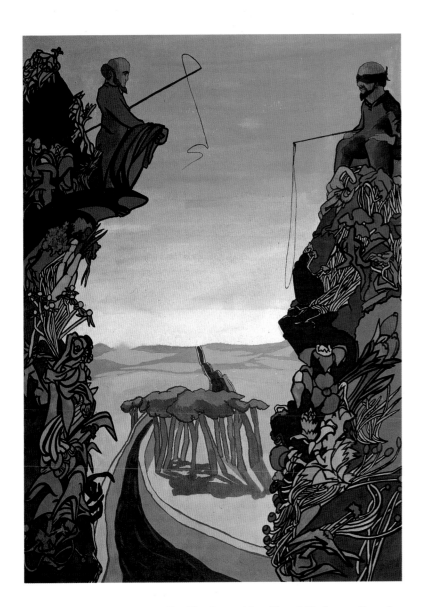

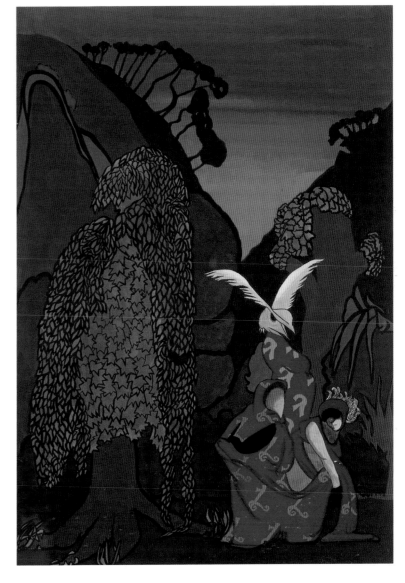

85   *Contos Populares Portugueses: Two Men Separated by a River of Blood*, 1975. Gouache on paper, 70 x 50.2 cm.

86   *Contos Populares Portugueses: Branca-Flor - Two Doves bathing*, 1975. Gouache on paper, 70 x 49.6 cm. Gulbenkian Foundation, Lisbon.

Rudolf Nassauer, the novelist and friend of several well-known English artists, first met Paula at this time. He has become a favourite model – a veritable 'muse' appearing in all manner of guises: as various animal caricatures, as Old King Cole in the etching of the nursery-rhyme (1989), as the sleeping Joseph in the painting *Joseph's Dream* (1990) and as a statue in *Crivelli's Garden* (1990-1), to name the most obvious. Nassauer introduced Paula to the palace and gardens of Hampton Court, near London, where she was captivated by the carved heraldic beasts, and he owns the picture that resulted from this visit, *Hampton Court*, **87** (1977). 'The cat's tail and the legs connect', Nassauer says of the main figure in this painting, 'but she'd have cut it off and put it somewhere else if she'd had half a chance. She has a funny side but a lot of taste.' He was equally instrumental in encouraging Paula to travel, for which previously she had found little need or time. Florence was a particular revelation, not least because of Botticelli's *Annunciation* in the Uffizi, which later was to inspire the large acrylic collage of 1981 of the same title. But in 1977 Paula was finding herself increasingly frustrated by the formal deficiencies in her technique. She wrote to her friend Hellmut Wohl, a Professor in the Art History Department at Boston University and an organizer of the exhibition 'Portuguese Art since 1910' at the Royal Academy of Arts, London, in September 1978.

The gaps between the forms worry me. I can *never* get these spaces right. That is why my pictures don't look like modern art. It's some sort of timidity on my part I'm sure. Another thing that escapes me is HOW to give substance to the forms. One day they look solid and 'real' and they seem to hinge on each other and splinter and creak, fall with a thud at the bottom of the canvas and drag across the surface, and the next day they are like dust, all lightweight and just stuck there.[25]

The exhibition was the first on this subject ever shown in London. Paula was honoured with eleven exhibits, the second largest selection. Hellmut Wohl wrote of her work in the catalogue essay:

In the work of no other Portuguese artist, and of few artists anywhere, does one encounter a similar conjunction of the consequences and implications of the weight of history – going back at least to the disappearance of D. Sebastião – and of the individual past. The sources of Rego's images are, among others, medieval illumination, the Spanish reviews *Blanco y Negro* and *Pluma y Lapis*, photographs in newspapers, illustrations of fairy-tales, the grotesque imagery of Portuguese popular fairs, the compositions of the late nineteenth-century Portuguese cartoonist Rafael Bordalo Pinheiro. Whatever

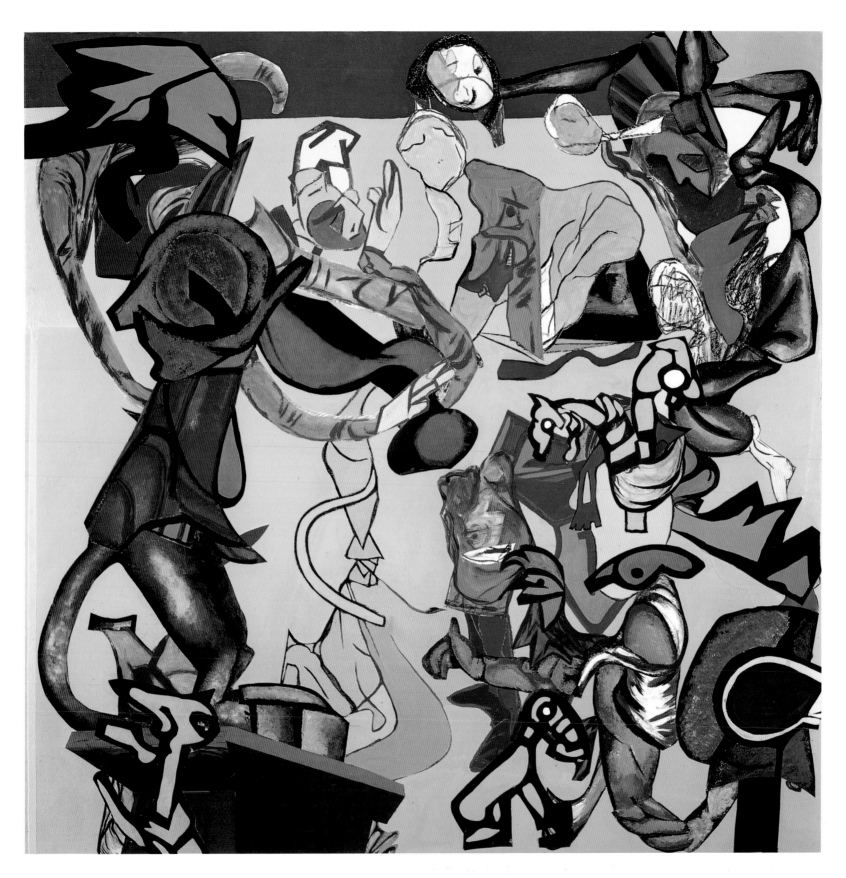

87 *Hampton Court*, 1977. Collage and acrylic on paper, 122 x 122 cm.

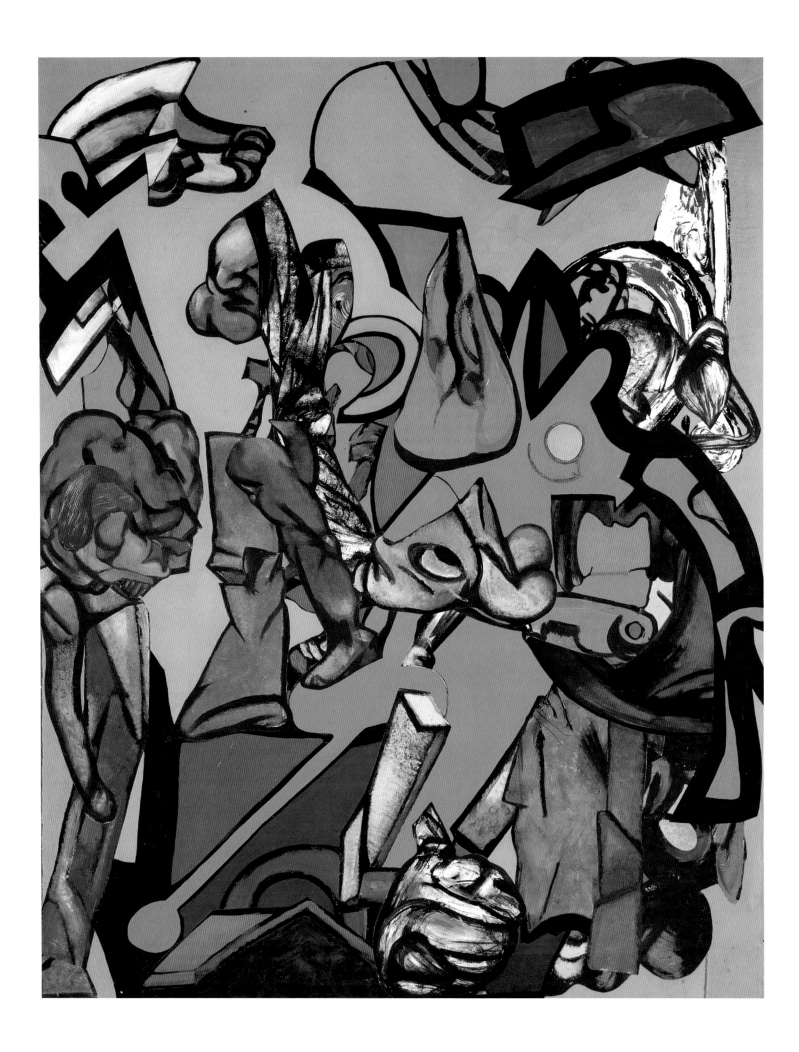

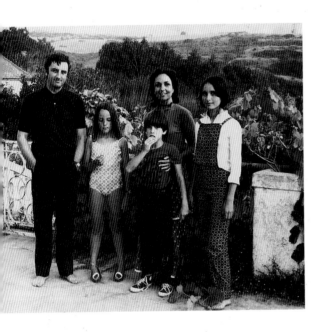

89  Paula and Vic with Victoria, Nicholas and Caroline at Ericeira, 1970.

88  *Domestic Scene with Green Dog*, 1977. Collage, gouache and acrylic on paper, 153 x 102 cm.

their origin, they provide the artist with vehicles for the expression of her feelings, and their structure is intentional, deliberate, objective and conscious. She has rightly insisted that however her work might be classified, it is not Surrealist.[26]

The collages of the late 1970s were to be Paula's last. At their best they represent some of the finest, and certainly the most ambitious, works ever produced in this medium which, arguably, began with floral paper cut-outs by the Irish botanical artist Mary Delany (1700-88), but did not develop into a genre until our own century. If we think of the modern masters of collage – Picasso, Braque, Schwitters – they have mostly used the method to intensify realism, constructing their pictures with the detritus of daily life. Rego's first collages were in this gritty tradition, but only in early works, such as *Popular Proverb,* **47** (1961) with its scraps of news-print, did she use material other than that written or made herself. The grit lay in the deliberate roughness of her method, particularly the way she pasted written sheets of paper along the top, like bills slapped onto a wall. This miserabilism and often graffiti-like detail, in which the figures suggest perspective by floating free from a crowded anchorage at the foot of the design, is slowly replaced by larger painted forms and a more solid overall construction.

In the final phase of these collages the forms fill the backdrop, so that increasingly backdrops function less as space and more as solid areas of colour in dynamic harmony with the previously isolated figurative elements. The sense of foreground and background, earth and sky, is never lost, but it is made less obvious. In *Hampton Court,* **87,** one of the most successful works done in this later style, the cat stands on the chimney-stack playing the violin, while the sky is filled with whirling figures that dance to his tune. It anticipates the wonderful etching *Hey Diddle Diddle,* **5,** she was to make ten years later in a naturalistic style. In *Hampton Court* this nascent naturalism is hinted at by the bold perspective of the chimney-stack: without it the image would be far more ambiguous.

In November 1980 Paula was much impressed by the retrospective exhibition of the Mexican artist José Orozco (1883-1949) that was held at the Museum of Modern Art in Oxford. She admired the way he went 'over the top' in his fiercely individual art; and in him she also found a narrative painter who understood the difference in art between narration and illustration. As Orozco said: 'To write a story and say that it is actually *told* by a

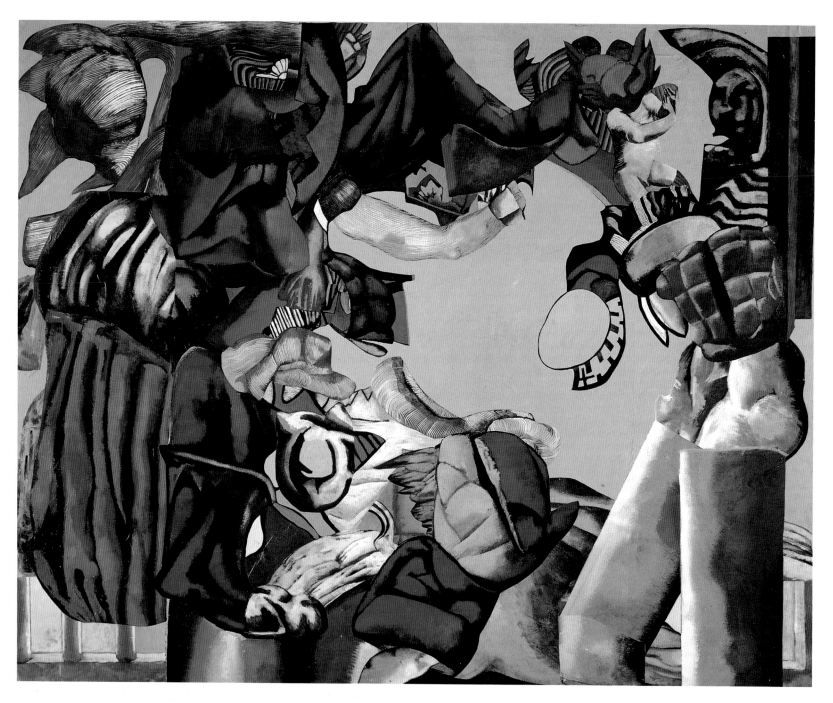

90   *The Annunciation*, 1981. Collage and acrylic on canvas, 200 x 250 cm.

painting is wrong and untrue. Now the *organic idea* of every painting, even the worst in the world, is extremely obvious to the average spectator with normal mind and normal sight.'[27] His bold example led Paula to embark on what turned out to be her last collages: *The Assassins*, *The Bride's Secret Diary*, **91**, and, for her the most successful of the three, *The Annunciation*, **90**.

For *The Annunciation* Paula went back to Botticelli. What had most impressed her about his *Annunciation* was the sense of awe, even terror, with which he had invested the moment when the young Virgin is informed by the archangel Gabriel that God has appointed her to bear His Son. The Virgin Mary has become so familiar to us as the symbol of maternal love that it is hard to think of her as a once real person, let alone as an innocent girl confronted by a mighty agent of God. Obviously, Mary would have been terrified, and it is this sense of terror that Paula set out to recapture. No sacrilege is intended here. Turning Gabriel into a huge, Bugs Bunny-like rabbit is merely a device, a nightmarish means of conveying the cowering child's shock and fear. The component parts of this picture are boldly realized in paint, with no fragments of incidental drawing. The atmosphere is successfully established, despite the fact that it is difficult to discern exactly what is going on. Her introduction of painterly passages and volumetric space have nothing to do with collage technique. It was time for a change, which she dates to a suggestion by the Portuguese artist João Penalva that she should cease cutting up her drawings. When she and Penalva met in 1978 he was a mature student at the Chelsea School of Art, but no ordinary one, having already had a successful career as a dancer. Penalva, who had left Portugal at the age of twenty, had only seen examples of Paula's work at the Royal Academy's 'Portuguese Art since 1910' exhibition. Vic was then teaching at Chelsea and it was he who suggested Penalva and Paula should meet. For their first meeting Paula was almost an hour late, but Penalva appreciated her flamboyant entrance dressed in second-hand pilot's overalls and high-heels. The only place they could find in which to talk and drink coffee was the foyer of a nearby cinema, where they got on so well that they remained oblivious to the puzzled and understandable stares of the management. Soon after, Paula invited Penalva to see her work. To his embarrassment he disliked the most recent collages:

To me Paula is best at drawing and she was cutting up her drawings, a terrible, muti-lating, violence. I didn't know then that this cruelty is part of her creative process. It seemed terrible that the flow of a line was lost. She ended up with line drawings where the 'inside' of the line was drawn with the brush and the 'outside' [was] 'drawn' by the scissors. They lost their identity as drawings and became only collage material, to be glued on the canvas or on each other and painted over. There was hardly anything left of them.

He also particularly drew her attention to the revival of interest in figurative painting then underway among students and younger artists. This, too, may have emboldened her to be more direct in her methods. Vic was now finding it increasingly difficult to get about, so for Paula to be goaded by the curiosity of a younger artist was a timely compensation and distraction. Penalva was soon visiting her studio every week, where they would discuss her latest work, a routine that continued up to 1985 or 1986.

Penalva denies that he was solely responsible for persuading Paula to return to direct painting, but he does remember protesting vehemently when she threatened to cut up a drawing of an heraldic beast he especially liked. Whatever the reason, or the date, he was clearly an important catalyst in her decision to abandon collage, and a valued critic of her work while she was coming to grips with naturalism. In a way, their seniorial roles were reversed at these times, although a respectful distance was, and still is, main-tained. To this day he refers to her respectfully as *vous*, whereas she uses the more familiar *tu*. If she sought a final opinion in matters of judgement it was always from Vic.[28]

91   *The Bride's Secret Diary*, 1981.
Paper collage and acrylic on canvas, 150 x 150 cm.
Rugby Art Museum.

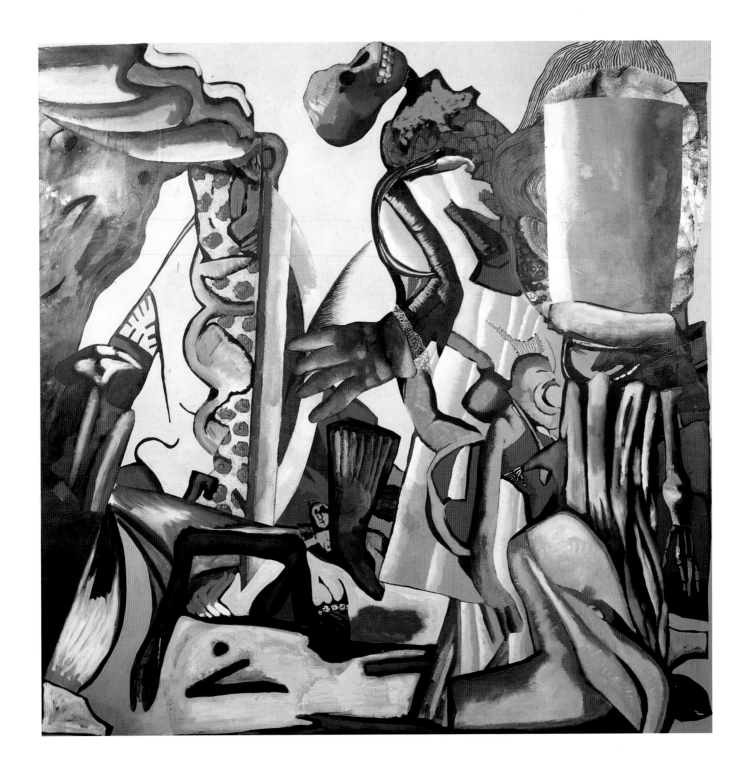

# BACK TO BASICS

Paula had always drawn the image first on paper before cutting it up to make her collages; she had also left many drawings uncut and, as in the case of her Portuguese fairy-tale pictures in the mid 1970s, had intermittently done whole series of uncollaged works on paper which were never intended for secondary use in her canvases. But with the *Red Monkey* series of acrylic paintings on paper, **95-99**, she rediscovered the thrill of direct working, to the extent of abandoning collage altogether:

> In collage you're doing it in stages so you're not actually doing it right there. You first of all draw it on the paper, then you cut it up, then you paste it down, then you change it, then you shove it about, then you may paint bits of it over – so actually you're not making the picture there and then you're making it through a process, so it's not so spontaneous.

Not only that, she found she drew with a zest and truth to her own experience that she had not felt since her post-Dubuffet outburst twenty years before:

> When a child does a drawing and calls it 'Mummy', for the child that IS Mummy. To us it looks like a stick, a round ball, but to the child that really is Mummy. It is the same with me. When in 1959 I painted those drawings after seeing Dubuffet to me they were real too; and when I painted what I call the *Red Monkey* pictures in 1981 I felt exactly the same. Those were the two times when the paintings have for me become most real, closest to my personal experience.

The result could hardly have been more dramatic, even shocking, both in form and content, although perhaps the pictures were less of a surprise to those who were close to Paula, as her daughter Caroline makes clear: 'I think Mum always works in cycles. She starts loose and then gets tighter and tighter and then loosens everything up and the cycle begins again. She's very brave like that; and at the same time she seems to anticipate the fashion. She's always one step ahead.' Certainly the exhibition at the Arts Council-supported AIR Gallery in London in the early summer of 1981, where the directly painted works appeared alongside her last, and largest, collages, most dramatically announced Paula's renewed commitment to painting in general and to naturalistic art in particular. While she had held true to representation throughout the period, in collage she had developed a tendency to obscure the image.

92   Previous page: *Red Monkey drawing,* 1981. Acrylic on paper, 76.5 x 56 cm.

93   *Half Ant, Half Lion,* 1981. Acrylic on paper, 76.5 x 56 cm.

94 *Red Creature*, 1981. Acrylic on paper, 76 x 56 cm.

Vic, on the other hand, had found a new freedom of expression, perhaps partly induced by the drugs he took to alleviate the increasingly disabling effects of his illness. Sitting in his studio, whole pictures would come to him in the form of visions. He would jot these down in drawings before the memory of them faded, and later work them up as paintings. Vic's exhibition at AIR in 1978 was forthrightly depictive and well received. It marked a change of fortune in his career as an artist, driving him to ever greater exploits through the 1980s when, in a bitter paradox, his reputation prospered as rapidly as his health declined. Husband and wife seemed inspired by each other's efforts and successes; though typically, with her love of fairy tales, Paula says the real stroke of luck for them was the time when, in 1975, she won third prize in the Portuguese national lottery.

Paula's new paintings, done in her customary acrylic on paper, tell the story of her own daily life, with most of the characters caricatured in the form of animals. As always, the situations imply the presence, dominance and attraction of men. Female characters are caught in the middle, and invariably they are up to no good. No wonder so many women see themselves and their predicaments in Paula's art – predicaments spelt out so brazenly that, as a friend recalls, 'It was like seeing someone being allowed to talk at table for the first time.' The AIR exhibition attracted some favourable reviews, but only two drawings and one substantial collage were sold. *The Bride's Secret Diary*, **91**, was bought by Monika Kinley on behalf of Rugby Art Museum. More important, however, the exhibition led to Paula securing the support of a commercial British gallery for the first time, Edward Totah in Covent Garden.

The idea for the *Red Monkey* series was first prompted by Vic, when he told Paula about a toy theatre he had possessed as a child in which there were only three characters – a monkey, a bear and a one-eared dog. The idea of the theatre, together with her amusement at the antics of a married couple in a popular strip-cartoon of the time, set in motion a series on the theme of family wrangles and lovers' triangles. The first painting, *Butterfly Escapes Lion and Dog*, **100**, while not yet employing the characters of the toy theatre, did establish the tone. In this picture a bashful female insect is faced with choosing between a lion and a dog. The lion is something of a joke, a pantomime-lion rather than the king of beasts. He represents sex and

95  *Birth of Red Monkey*, 1981. Acrylic on paper, 68.5 x 101 cm.

96  *Red Monkey Beats his Wife*, 1981. Acrylic on paper, 65 x 105 cm.

97  *Wife Cuts Off Red Monkey's Tail*, 1981. Acrylic on paper, 68 x 101 cm.

98  *Bear, Bear's Wife and Son Play with Red Monkey*, 1981. Acrylic on paper, 69 x 105 cm.

99  *Monkeys drawing Each Other*, 1981. Acrylic on paper, 68.5 x 101 cm.

100  *Butterfly Escapes Lion and Dog*, 1981. Acrylic on paper, 68.5 x 101 cm.

security – but temporary security only, as he supports something that looks like a cross between an erect phallus and a primitive umbrella. The dog is angry. He points accusingly at a little shelter in whose shade squats a tiny ape. This is a more permanent form of shelter than is offered by the lion's umbrella. It is a home. The dog represents dependability; the lion entertainment. The female insect finds herself unable to choose between these two intransigent male animals and decides to escape her predicament by turning into a butterfly and 'zooming off'.

The cast for the subsequent *Red Monkey* series is, basically, drawn from that of the toy theatre, with the addition of a female character in human form. The titles of the pictures in the series are similarly explicit: *Red Monkey Beats his Wife*; *Wife Cuts Off Red Monkey's Tail*; and *Bear, Bear's Wife and Son Play with Red Monkey*. In this sequence the monkey moves from a position of dominance, to defeat, to humiliation, while his wife turns from a victim into a tyrant. *Wife Cuts Off Red Monkey's Tail*, **97**, is the turning point – a gruesome image, in which the monkey vomits and the frightened bear dodges off. These pictures may be in the guise of jokes, but their humour could hardly be blacker. As Paula has said, it is difficult to paint pictures that will reveal every secret to those who feel most threatened by them. The large collage *The Bride's Secret Diary* has the same date as the *Red Monkey* series. It is as ambiguous as the series is forthright, as if the secrets of one are exposed in the other. In the immediate aftermath of the cathartic AIR show, Paula continued to paint smaller pictures mirroring isolated incidents in the vein of the *Red Monkey* series, but using a broader palette. *Rabbit* pictures and others feature a little girl who has a tendency to show off. Compared with the *Red Monkey* pictures they are more reflective, inspired by memories of her past rather than engaged in the conflicts of the present. A typical example is *Pregnant Rabbit telling her Parents*, **101**, where a doleful cat-mother clings to a protective and resolute dog-father. The cat-mother's attitude is particularly complex. She may cling to her husband for support or protection but there is also smugness in the cruel and defiant way she exploits her daughter's humiliation. Cats, after all, are the only animals that play with their victims. It is as if the cat-mother is using the situation more to consolidate her power than to extend her sympathy. It reminds us that lovers are not the only ones who can threaten a marriage: children can too.

101  *Pregnant Rabbit telling her Parents*, 1982. Acrylic on paper, 103 x 141 cm.

That Paula's subjects invariably have their origin in personal experiences cannot be denied, but it would be an over-simplification to suggest that they are always true to the facts any more than novels are. Nevertheless, invariably she has specific people in mind, although not always with predictable results. When Paula told her mother that she was the cabbage in *Rabbit and weeping Cabbage*, **106**, Maria was delighted: 'Oh, how lovely – you've made me look so young!' she exclaimed.

For her first exhibition at the Edward Totah Gallery in 1983 Paula showed the *Rabbit* and *Little Girl* pictures and three recent works, which were among the most crowded and densely painted she had ever produced. In cinematic terms these paintings – *Samurai*, **112** (1982) is one example – might be categorized as 'over-plotted', meaning that the incidents have got the better of the story. For a successful story the situations must be seen to have arisen naturally from the actions of the characters; the characters should not be forced to fit some predetermined narrative line. The former approach is Paula's instinctual method. 'All my work is to do with metamorphosis. It comes about in the actual physical making of the picture, the trial and error of working.' One thing spontaneously leads to another; she does not work to a plan and, at her most 'plotty', this can be a disadvantage. But it is also the key to her originality.

'Really the design is very simple', argues Penalva of the pre-1987 paintings:

Formally she either hangs or fills, and her backgrounds are either blank, diagonal or divided horizontally. That's all there is to it. It's really the personages who count for her. She is always more interested in telling the story than in painting a picture, because to her there is no picture if there is no story to tell. There's always some sort of sacrifice going on and if she has to choose between the characters and the formal devices of the painting, I think she will always sacrifice the painting. What is so good about her work is that the images are so memorable. I can remember vividly the many versions of paintings in progress as well as the finished ones. The intensity is always there, even if each picture is a bumpy ride and from one visit to the next one never knew who would have been thrown out of the bus!

As an example Penalva cites *Monkey hypnotizing a Chicken,* **113** (1982). What he particularly likes about this painting is the way the orange diagonal in the background does not hold true, but suddenly upsets logic by filling the gap between the monkey's legs: 'When you point out "mistakes" to Paula, she

102   *Lovers*, 1982. Acrylic on paper, 122 x 152 cm.

103   *Little Girl Showing Off*, 1982. Acrylic on paper, 103 x 141 cm.

104   *The Owl's Dinner*, 1982. Acrylic on paper,
103 x 141 cm.

105   *Pioneers*, 1982. Acrylic on paper, 122 x 152 cm.

106   *Rabbit and weeping Cabbage*, 1982.
Acrylic on paper, 103 x 141 cm.

107 *Going Out*, 1982. Acrylic on paper,
102 x 136 cm.

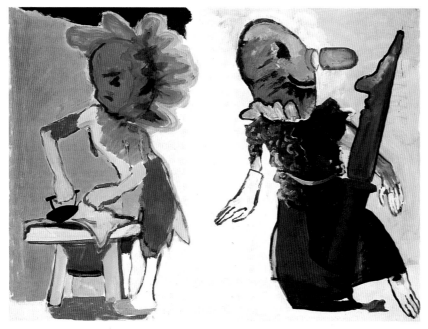

108 *Cabbage and Potato*, 1982. Acrylic on paper,
103 x 141 cm.

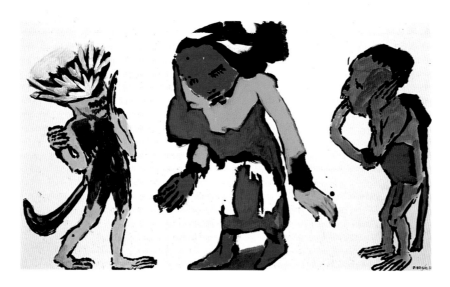

109 *Girl with Two Monkeys*, 1981. Acrylic on paper,
78.5 x 134 cm.

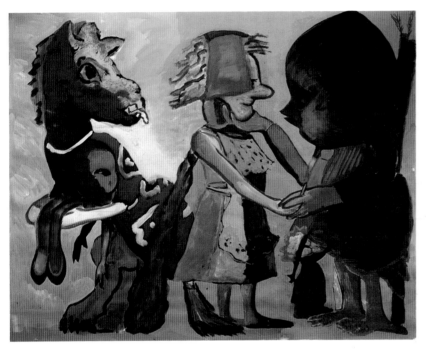

110  *The Chicken persuading the Woman*, 1982.
Acrylic on paper, 122 x 152 cm. British Council.

111  *Sick Bird*, 1982. Acrylic on paper, 122 x 152 cm.

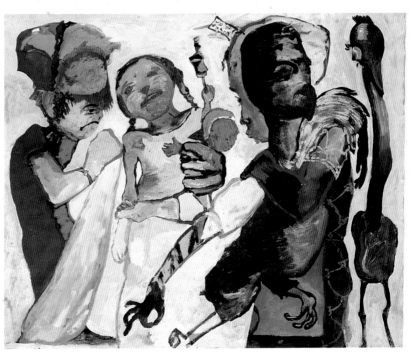

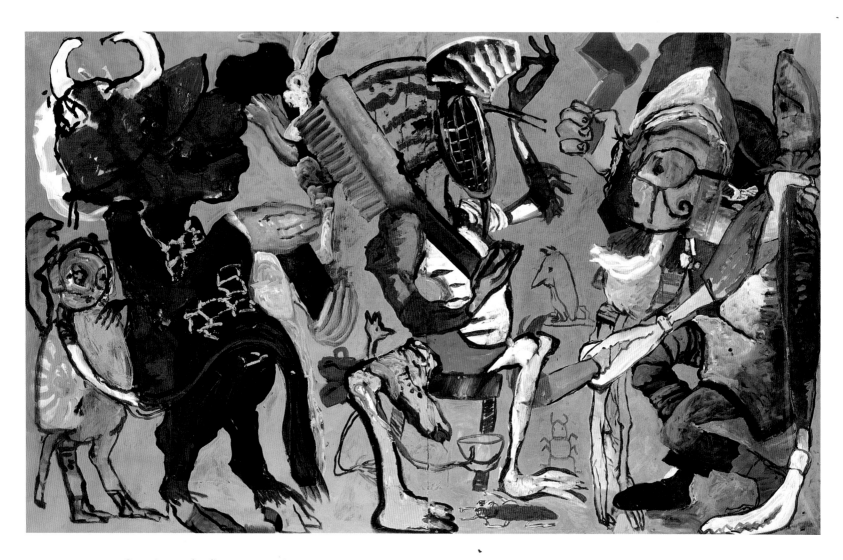

112  *Samurai*, 1982. Acrylic on paper, 156 x 215 cm.

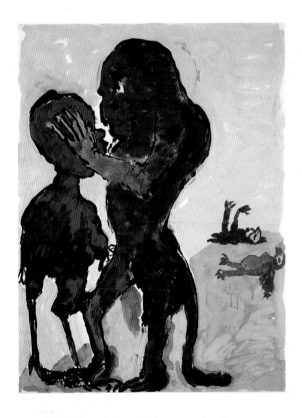

113 *Monkey hypnotizing a Chicken*, 1982. Acrylic on paper, 78 x 58 cm.

just says "it doesn't matter", and of course she's right'. Certainly, in the case of *Monkey hypnotizing a Chicken* the spatial ambiguity arising from the need to fill the gap adds to the unsettling nature of the image, funny though the hypnotized chickens are, 'zonked out' in the middle-distance. And formally it works, bolstering the already formidable presence of the hypnotist.

*Samurai*, **112**, for all its violent action, is leaden by comparison. One of the problems here is that the three principal characters are of the same size, demonstrating how dependent the success of Paula'a pictures often is on enlivening jumps in scale from one character to the next. In *Samurai* the gaps are filled with relatively tiny characters that only clog the design. Part of the problem stems from the fact that Paula fills a pint-sized picture with a quart of content. *Samurai* is not so much a story as a conglomeration of incidents. By deciding to increase the size of the paper she used, Paula gave herself more space in which to manoeuvre.

The direct outcome of this decision was the *Opera* series. This arose when the gallery owner Moira Kelly invited her to take part in an exhibition of English art, 'Eight for the Eighties', organized to coincide in New York with the American bicentennial celebrations. As Paula only had two months' notice in which to do the work she decided on the operas because they provided her with a ready abundance of stories. The twelve she chose were the ones she remembered hearing as a girl with her father – *La Bohème*, **118**, *Aida*, **115**, *Rigoletto*, **116**, *Faust*, **117**, *Carmen*, *La Traviata*, *The Girl of the Golden West*, **114** and other popular favourites. In other words, they have a more personal significance than might be thought, especially since the standard plot in these stories concerns a girl in conflict with her parents over the man of her choice. Most of the *Operas* measure 240 x 203 cm, the same size, in fact, as the largest collages.

The *Operas* also mark a shift from painting back to drawing, the instinctive kind of drawing to which Paula always resorts when she feels herself to be drifting away from the truth. They are among the most entertaining and graphically inventive of all her works, lightly directed by the operatic narrative and intermingling animal caricature with human figures. The predominant colours – beige, brown, umber, black – are those of ancient Egyptian frescoes (a particular interest of Vic's) and Attic pottery, with its figures in ceaseless action. But the leaps in scale, from dominating figures to the most

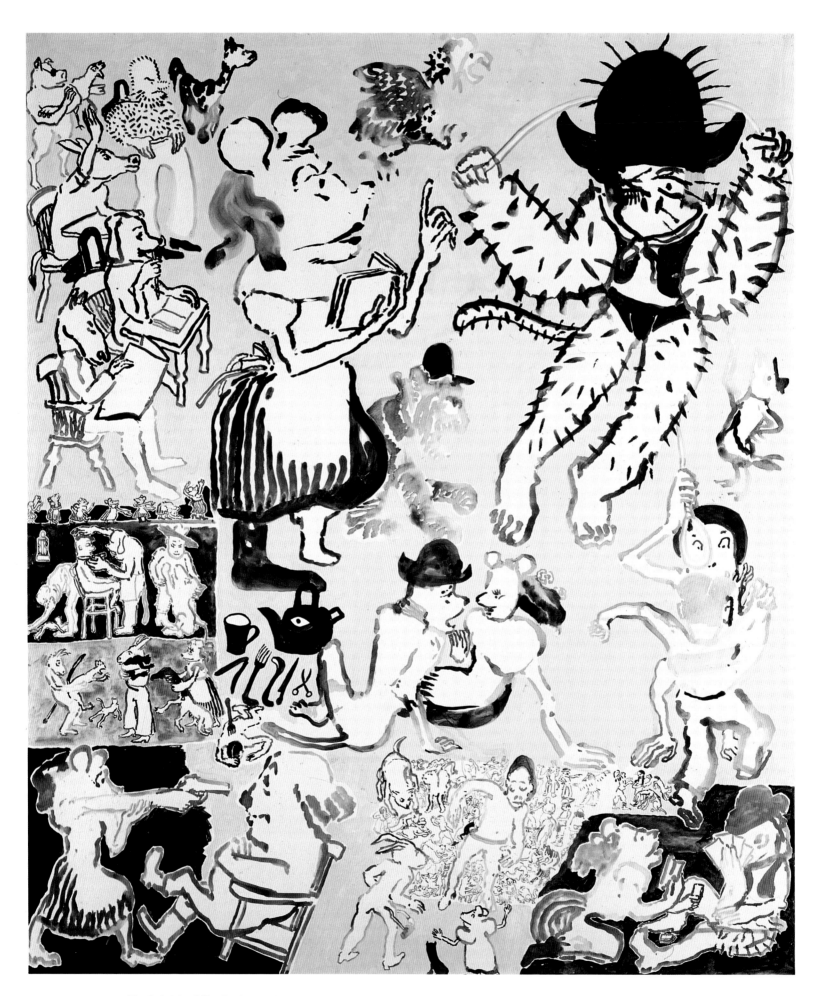

114  *The Girl of the Golden West*, 1983. Acrylic on paper, 240 x 203 cm.

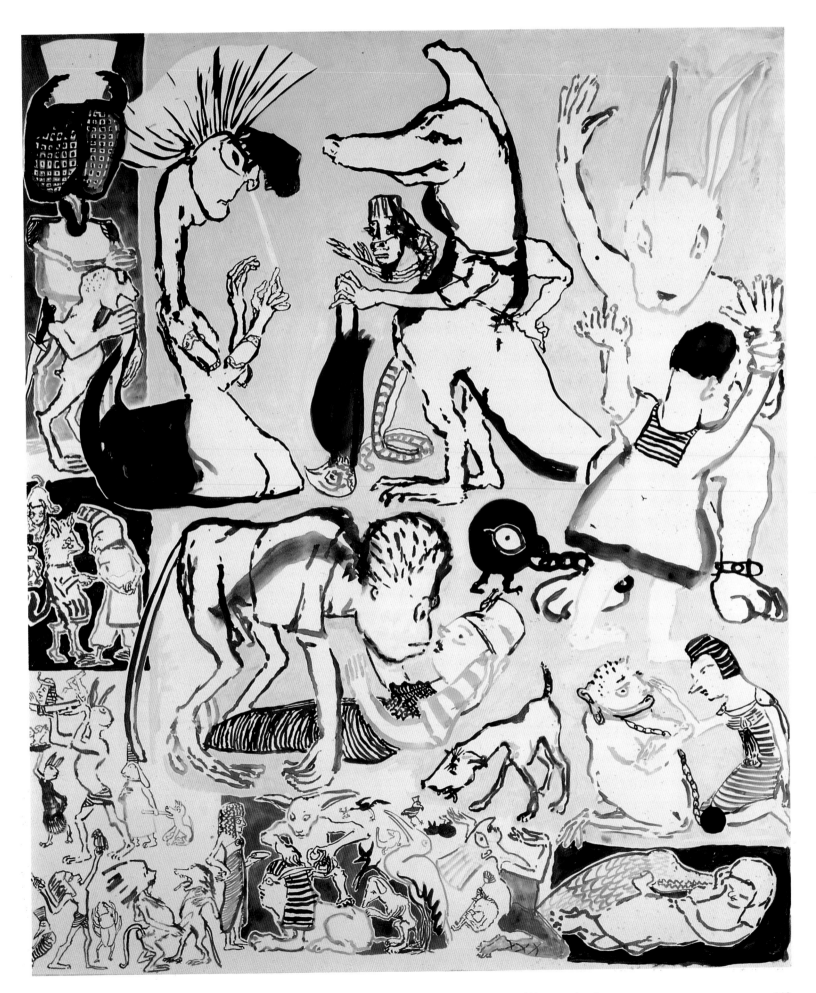

115 *Aida*, 1983. Acrylic on paper, 240 x 203 cm.

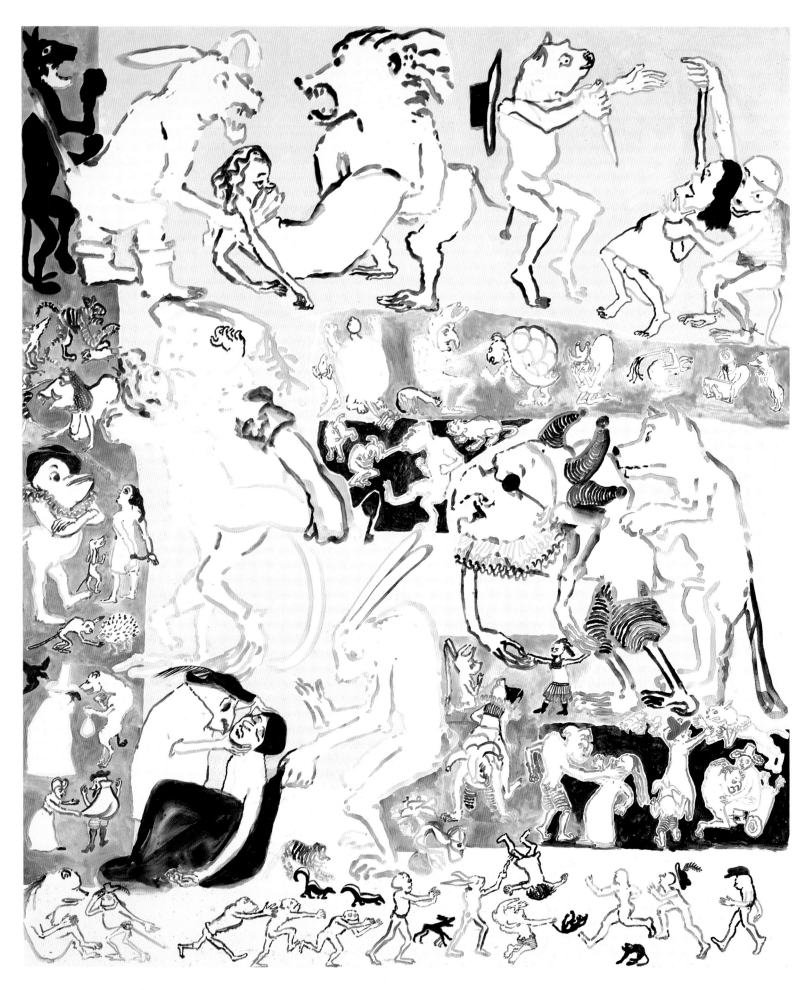

116 *Rigoletto*, 1983. Acrylic on paper, 240 x 203 cm.

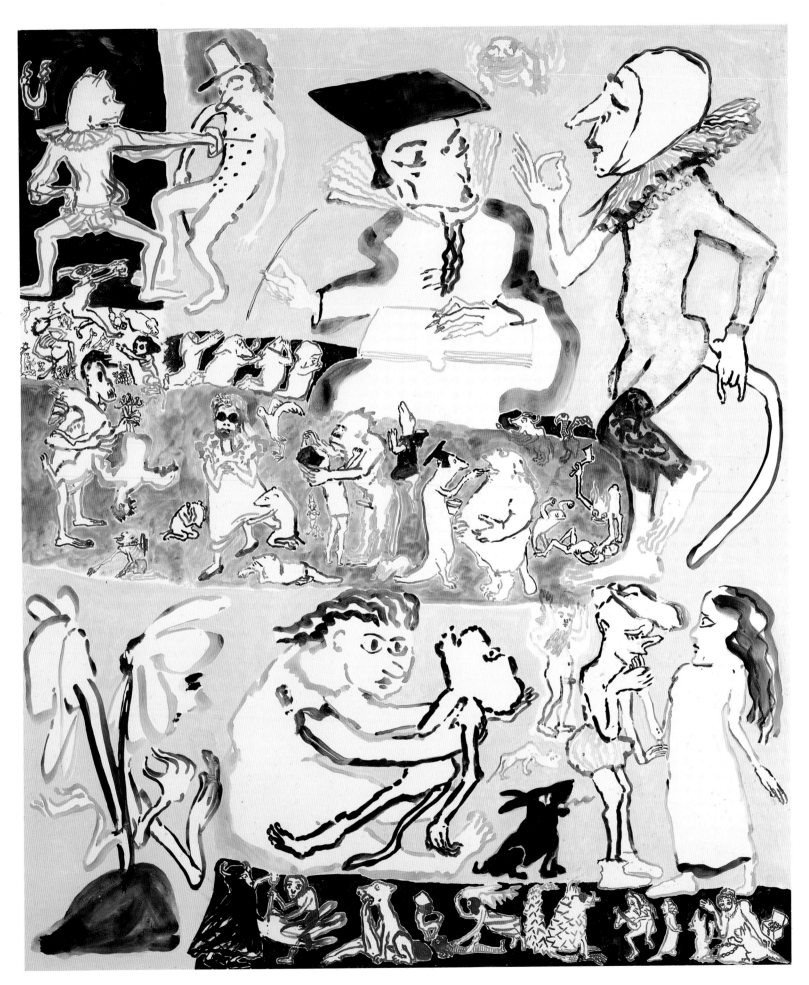

117 *Faust*, 1983. Acrylic on canvas, 240 x 203 cm.

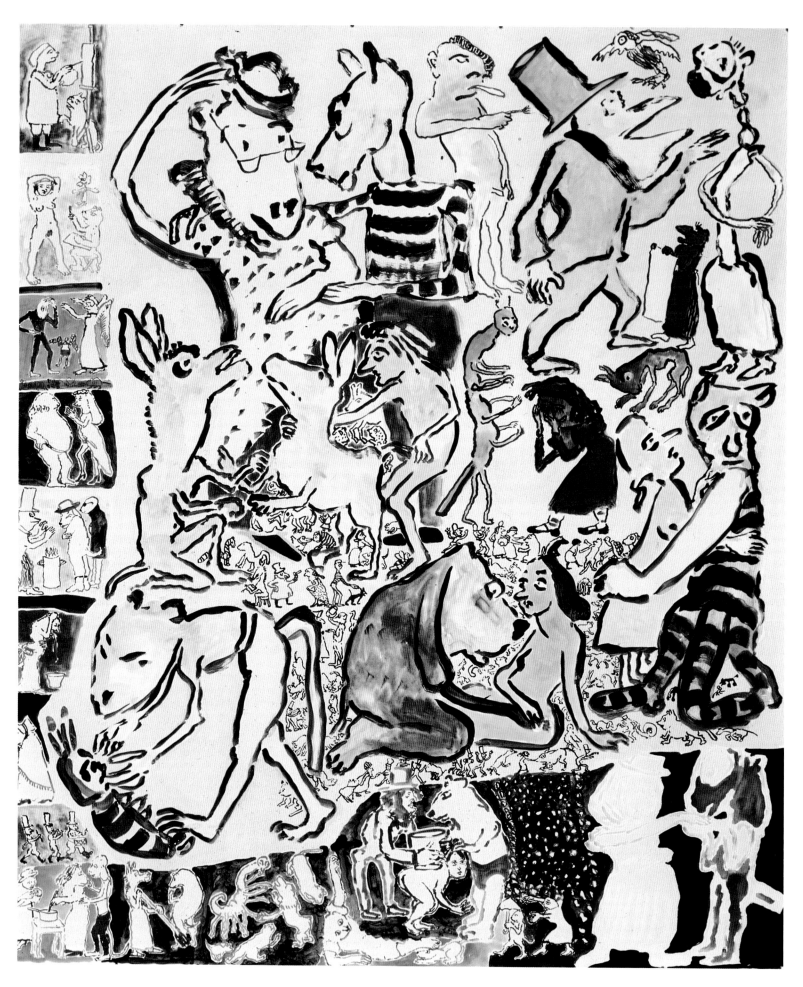

118  *La Bohème*, 1983. Acrylic on paper, 240 x 203 cm.

minuscule and elaborate detail, are more typical of primal or children's art, and even of comic strips. As Paula explained in an interview she gave around that time, the *Operas* 'are more like doodling, and though they are drawn quite precisely, they are done so automatically that everything comes out just like a seismograph. There is no censoring of any kind.'[29] She made them by starting at the top and working across, then down, going back through the composition filling the gaps with the 'friezes' first seen in her work of the early 1960s. Penalva was struck by her discipline in making them; the method did not allow her to make mistakes. He considers them the most carefully planned of her pictures before *The Maids*.

Since the *Opera* series was to be exhibited in New York, where later she would be showing in the group exhibition 'Marathon '83', Paula decided to visit. She had never been to the USA, and her trip was made memorable by a tremendous car crash that occurred while she was strolling down a street in SoHo. The car narrowly missed her before smashing into a store-front, scattering the contents in every direction but apparently without hurting anyone. She was thrilled. It was just what she had expected New York to be like from the movies. This event was pictorialized in a large painting *Toute en flammes*, **129** (1984), which in December 1991 in Lisbon was sold for a considerable sum.

The true, grand finale of the *Opera* series is not an opera at all. *The Proles' Wall*, **119**, was commissioned for 'Nineteen Eighty-Four', the exhibition commemorating George Orwell's famous novel that was held in 1984 at the Camden Arts Centre, London. Having experienced dictatorship in Portugal, which included blacked-out newspaper photographs and articles so heavily censored that there was often nothing worth reading except the sports pages, Paula considered Orwell's account of state tyranny unconvincing. She also disliked his style of writing, finding it morose and self-pitying and, worst of all, stiflingly unimaginative.

When Paula began thinking about visual images for Orwell's story, it occurred to her that the proles – the dispossessed class in the novel – would have been unable to write (having been forbidden education), and therefore would only have had the means to express themselves in the more primal form of drawing. She imagined this as graffiti on a wall, and proceeded to draw an equivalent on board, *The Proles' Wall* – the dimensions of which are

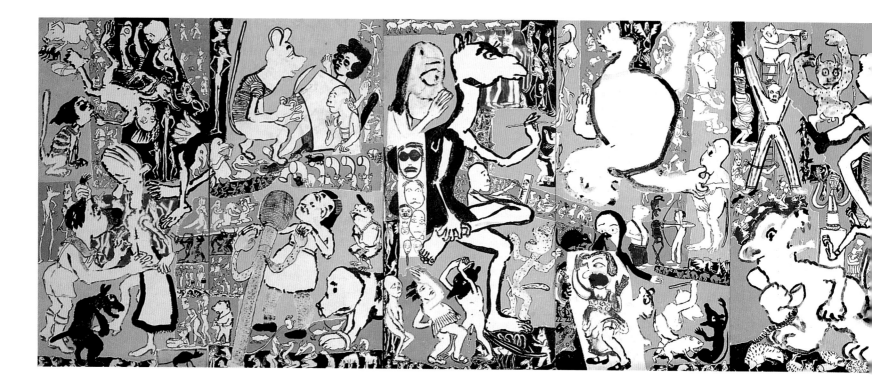

119 *The Proles' Wall*, 1984. Acrylic on paper,
244 x 1220 cm. Gulbenkian Foundation, Lisbon.

literally the width and length of a wall. Characteristically, she was more concerned with understanding Orwell's book in terms of its characters than with the political positions they symbolized. Accordingly, she turned many of them into animal caricatures, but not without some reference to her personal life. Paula's Winston Smith, the victimized central character of *Nineteen Eighty-Four* is a teddy-bear; whereas his torturer, O'Brien, is a *real* bear, because bears popularly embody both playful charm and fierce aggression. Typically, it was this duality that Paula found the most convincing and compelling aspect of the book – 'the double-sided notion of pain and love' – a theme, as she says, that is common to all her work and to all human experience.

Paula made some of the children into vicious little bears, their nastiness explained, though not excused, by the example of their father, Parson, who sews up the breast of his mother while a dog sexually assaults her foot. Elsewhere, children are spies. Paula depicts them as old beyond their years, with knowing looks familiar to her from the little hustlers and procurers she

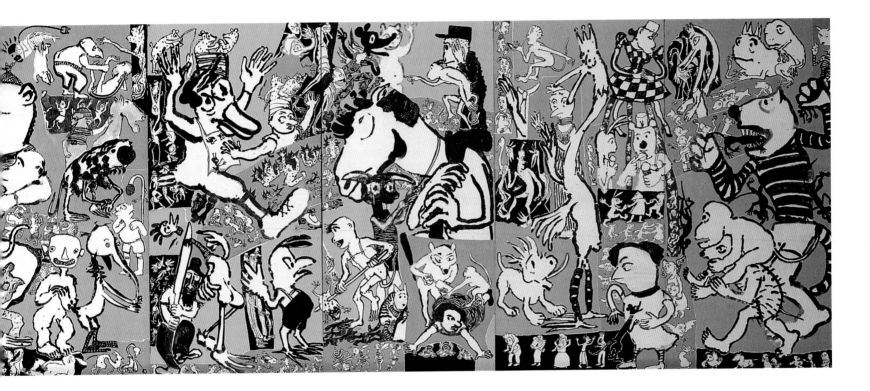

saw at the fairs in Cascais and Estoril. It is a vital message of Orwell's *Nineteen Eighty-Four* that the children are corrupted by the system. Paula found Julia, Winston's girlfriend, unconvincing as a character, and so she is presented as a cross between a doll and a girl. She is deprived of pubic hair in order to emphasize this lack of reality. As for Winston, he appears in the form of a camel as well as that of a bear. When he writes his secret diary (a favourite Paula subject) the walls spawn creeping animals. Winston is a guilt-ridden person, largely because of his mother, whom he feels he did not love.

In the novel rats symbolize fear and this is the only point where Paula's use of animals in the picture corresponds with those in the book; elsewhere she goes her own way, making up the shortfall with characters of her own. The goose-headed people derive from a dream she once had, and the drawing of *The Proles' Wall* began with one of them. As for flamingoes, she had wanted to include some in a picture ever since seeing them in a wildlife documentary on television: 'This is how I always work – drawing on my own life and dreams and feelings'; so the painting became her diary,

120   Detail from *The Proles' Wall.*

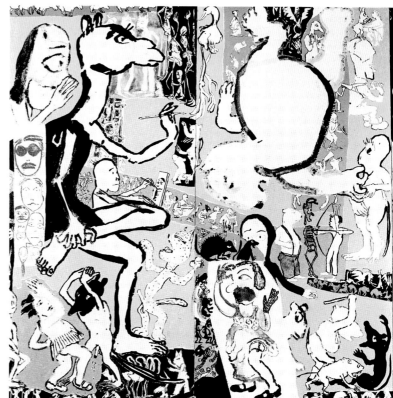

121   Detail from *The Proles' Wall.*

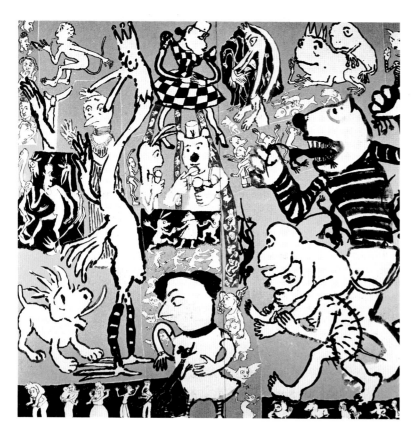

paralleling Winston's in the novel, except that he used his to re-establish the past, whereas in Paula's diary present and past are interwoven.

'Interweaving' also describes her method: the giant scale of the drawing imposed a plan as it progressed; like 'knitting', as she describes it, she had to keep an idea of the pattern in her head. Pattern is one aspect, but like the *Operas*, to be properly appreciated *The Proles' Wall* is best seen in close-up, its vitality lying in the details – unflagging across twenty feet, **120, 121**. Now in the permanent collection of the Gulbenkian Foundation in Lisbon, it is the largest of her works prior to *Crivelli's Garden*, another painting that was conceived as a 'wall'.

After her exertions on the *Operas* Paula returned to a sketchbook scale. She had been fascinated by a book she read on medieval manners, *The Knight, The Priest and The Lady*, and embarked on a series of pictures about courtly love. As she progressed, the female figures began to remind her of the young women in the 'Vivian Girls', the pictures by Henry Darger that she had seen in the 'Outsider Art' exhibition at the Whitechapel Art Gallery in 1979. The drawings were shown in an open studio exhibition at Berry Street. Victor Musgrave and Monika Kinley, who had selected the 'Outsider Art' exhibition, came to the opening and were struck by Paula's enthusiasm for Darger's work. They subsequently sent her an article on him. After reading it Paula abandoned courtly love as a theme and decided to paint various scenes from the lives of the 'Vivian Girls'.

The 'Vivian Girls' were the heroines of the novel *The Story of the Vivian Girls in What is Called the Realms of the Unreal or the Glandelinian War Storm or the Gaudico-Abbiennian Wars as Caused by the Child Slave Rebellion*, which Darger had both written and illustrated. Darger was a particularly interesting example of the phenomenon of 'Outsider Art', or 'Art Brut'. He had spent most of his adult life between 1916 and his death in 1972 working by day as a toilet-cleaner and bandage-roller in a Chicago hospital, while spending his spare time secretly devoting himself to the great passion of his life, this one long novel. Following his death it was discovered that he had left an amazing saga in thirteen volumes, that concerned the exploits of a gang of girls who lived on a distant planet controlled by wicked soldiers. The story tells of the endless ways in which the girls get the better of the soldiers.

123 *Turandot*, 1984. Acrylic on paper, 75 x 55 cm.

122 (left) *Grape Harvest*, 1984. Acrylic on paper, 76 x 56 cm.

124 *Two Girls with a Goat*, 1984. Acrylic on paper, 61 x 76 cm.

125 *Two Girls with a Goat*, 1984. Acrylic on paper, 61 x 77.2 cm.

The 'Girls' and their pranks immediately appealed to Paula's subversive imagination, and she set to work at once, painting directly onto canvas for the first time since the 1960s. Her usual method is to paste paper over the canvas, since she prefers working on a smooth surface, or, as of 1992, on paper vacuumed onto plastic sheeting; but on this occasion she was inspired to work directly by the sight of some sail-fabric in a nautical shop in Portsmouth. Penalva, who, on the whole, is critical of Paula's lack of interest in materials, remembers the first painting of the series being made on two strips of this plastic sail-cloth, crudely stitched together. Entitled *The Vivian Girls in Tunisia*, **126**, it was exhibited at her solo exhibition at The Art Palace, New York, in 1985, where she was pleased with the way it looked; and also in her 1987 touring exhibition organized by the Aberystwyth Arts Centre, 'Selected Work, 1981-1986'.

*The Vivian Girls* reintroduced a broad spectrum of colour – a reaction to the limitations of the *Operas* – and subversion runs riot. The display of anarchy and mayhem has a voracious quality. In *The Vivian Girls breaking the China*, **127**, it is her mother's best set of china that is being smashed – the festive use of colour is in the full-blooded tradition of Iberian and, at its most violent, Latin American folk art. This was brought home to Paula later, when she saw the exhibition 'Art in Latin America' at the Hayward Gallery, London, in 1989.

'*The Vivian Girls* are the heroines and the slaves of my stories', she told Barbara Laszczak:

They have been enslaved by the adult world but they always fight back. They are themselves capable of evil deeds, as evil as those of their captors. Nevertheless their evil deeds are always of a private and malicious nature, done usually out of spite and never out of higher moral ideals, as they know that these are the pretext used by their jailer-teachers to perpetrate the worst tortures.[30]

As usual, Paula incorporated ideas in these works that had emerged during discussions with Vic and others. This is a standard procedure, as Caroline explains: 'She's always complained: "Oh, I don't know what to do next", and she was always saying this to Dad. But I think it was a form of flirtation, as she purposely took second place to him. But she would also ask us, "Why don't we go to the beach", one might say, "that might give you an idea." "The beach!" she'd exclaim, "Cassie, that's brilliant!" And the problem

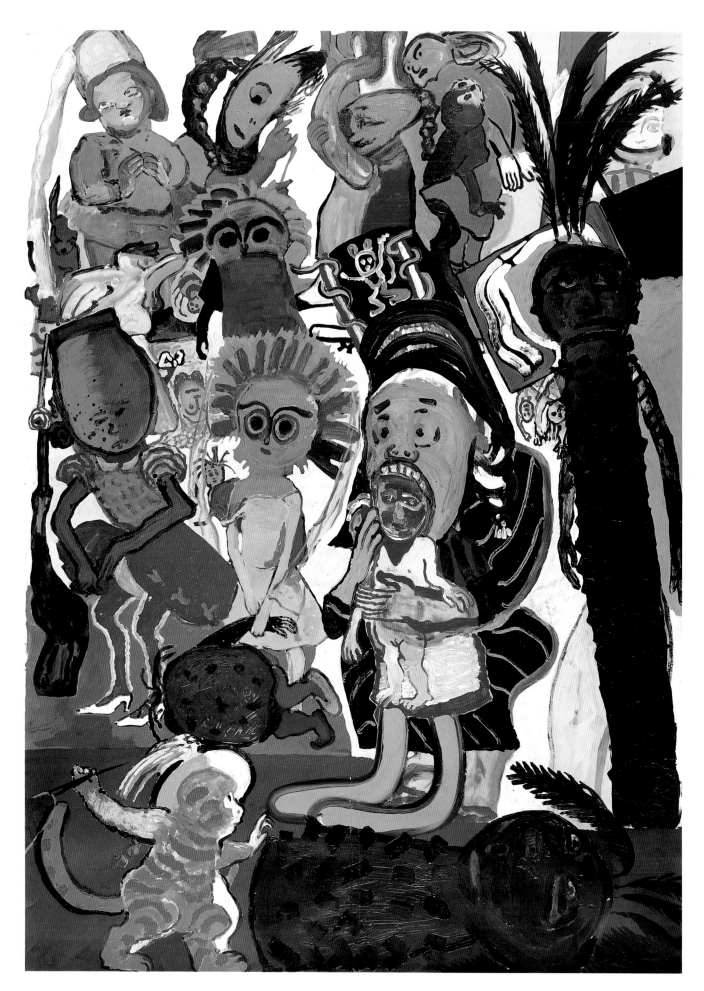

126 *The Vivian Girls in Tunisia*, 1984. Acrylic on canvas, 200 x 100

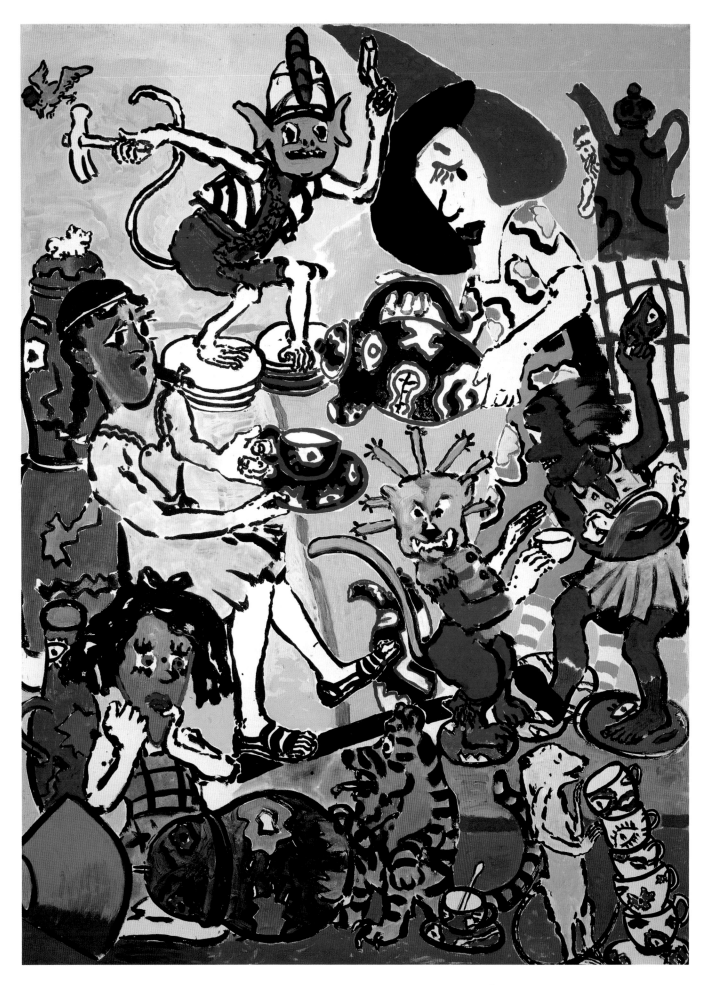

127 *The Vivian Girls breaking the China*, 1984. Acrylic on canvas, 240 x 180 cm.

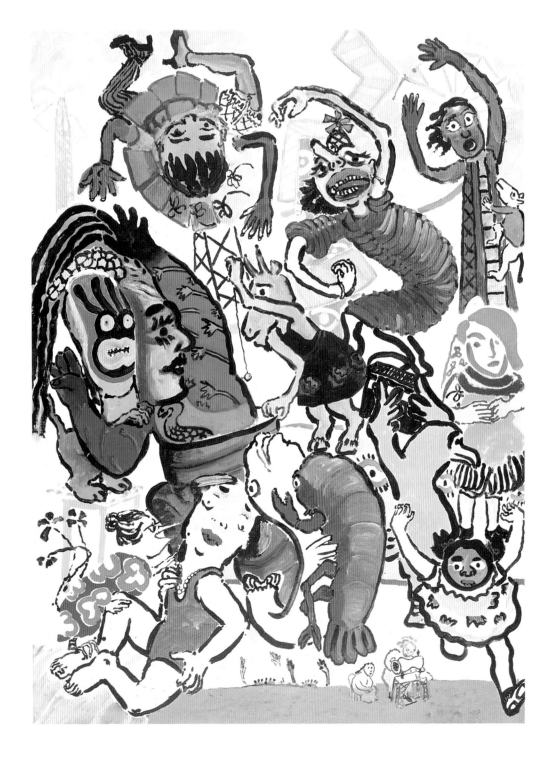

128  *The Vivian Girls with Windmills*, 1984.
Acrylic on canvas, 242 x 179 cm.

129  (opposite) *Toute en flammes*, 1984.
Acrylic on canvas, 207 x 161 cm.

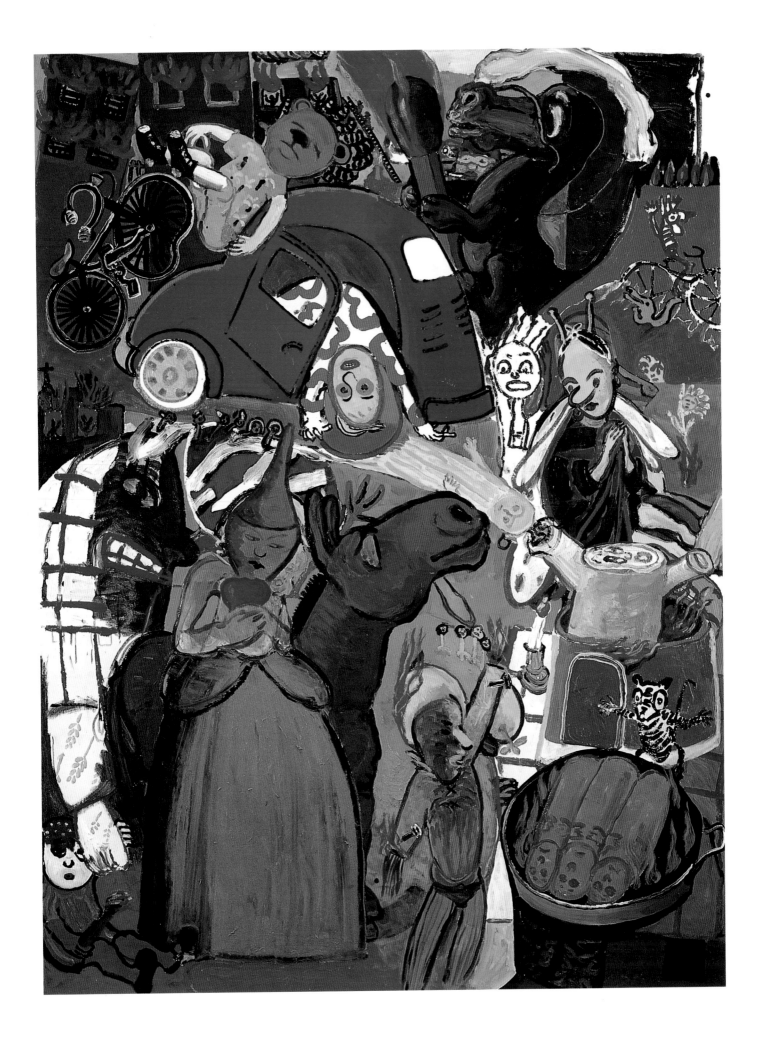

would be solved.' This continues to be Paula's practice. Even when she is dissatisfied with a painting in progress she will seek advice from friends or visitors, and act on it, if she thinks it's right. When she was painting *The Vivian Girls with Windmills,* **128**, Vic said: 'Do a girl running out of a picture'. It was something he had always urged her to try, but perhaps the thought of it particularly exhilarated him now that he was himself unable to walk.

The *Vivian Girls* series, for all its colour, is essentially about drawing. By contrast, the pictures that followed it are arguably the most spontaneous and painterly of any of her works to date – the brilliant sequence that begins with *The Pig's Secret* (1984), and culminates in *Paradise*, **131**, *On the Beach,* **132**, and, best of all, *The Bride*, **134**, all dating from 1985. The accent in these pictures is on speed, as the fluidity of the paint shows. Some of them were completed in a single day. On a 220 x 200 cm scale, which more or less matches the *Operas* series, and using a watercolour technique that similarly affords no mistakes, these pictures can reasonably be described as 'action paintings'. The ideas tumble over one another: they are as colourful as one of Carmen Miranda's cornucopian head-dresses and as full of gusto as Henry Miller's writing at its most Rabelaisian. Done on all fours in Paula's characteristically childlike fashion, they reveal their method by an unintentional foreshortening, with legs and bodies invariably disproportionately small when compared with the heads. Paula dressed some of the girls in the kinds of swimsuit once given her by her grandfather, and the mood is indeed that of the fun of summer holidays, though plenty of shocks and horrors can be seen in these tangled images, just as the friendliest of Paula's seas is full of blades, spikes, claws and stings. Exotic flowers, crustaceans, prettily dressed girls and other assorted things one finds on a beach are recurring themes in these carnivals; and indeed Paula forthrightly describes *On the Beach* as being about sex and gluttony. Vic was not so sure about them, thinking them too close to the florid decorations associated with gypsy caravans and folksy watering-cans, an association with popular art that, needless to say, she took as a compliment.

In 1985 Paula was honoured by being selected once again for the São Paulo Bienal, but this time to represent Britain. Others included the performance artist Stuart Brisley, the sculptor John Davies, and her friend Patrick Caulfield, whose work she has always greatly admired. For this show she

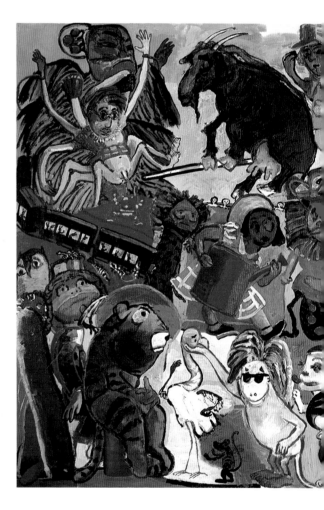

130  *The Vivian Girls on the Farm*, 1984. Acrylic on canvas, 240 x 180 cm.

131  *Paradise*, 1985. Acrylic on canvas, 220 x 200 cm.

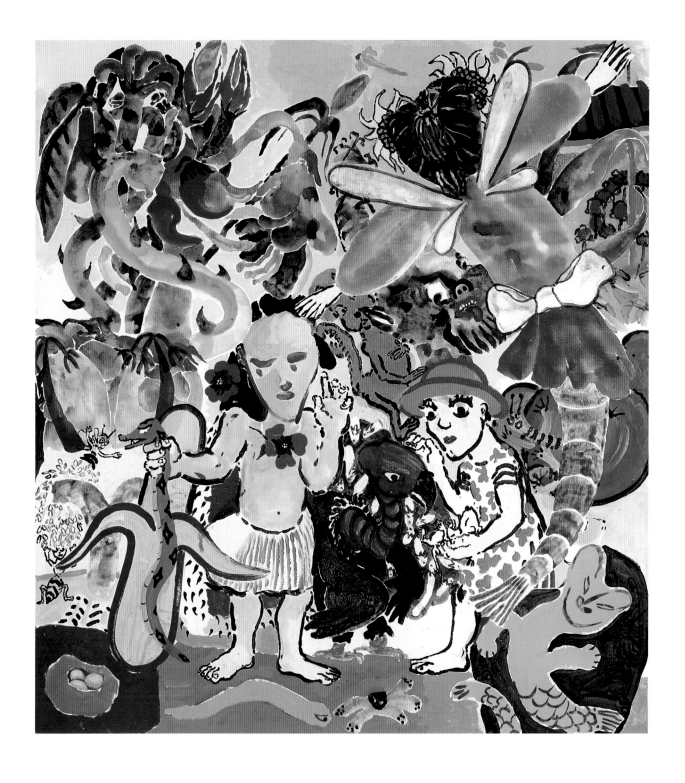

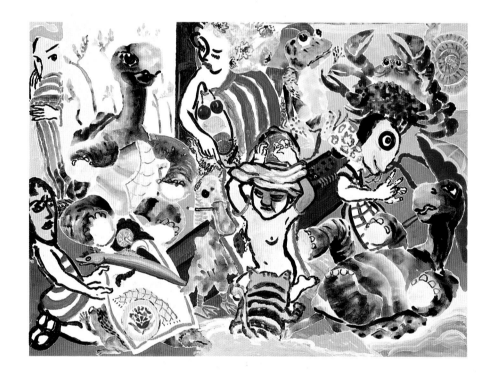

132  *On the Beach*, 1985. Acrylic on paper, 200 x 220 cm.

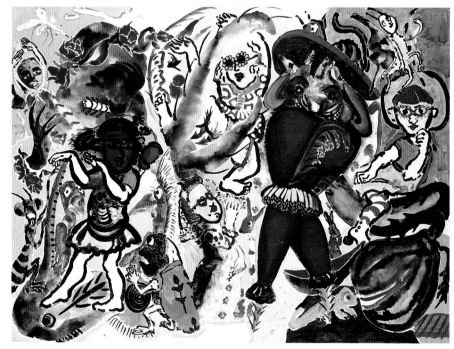

133  *Girls with Sunglasses and Vegetables*, 1985. Acrylic on canvas, 180 x 242 cm.

134 *The Bride*, 1985. Acrylic on canvas, 220 x 200 cm.

exhibited a selection of pictures that she had made after the *Vivian Girls*, and even contributed a rare essay to the catalogue on the meaning and method of her work:

My favourite themes are power games and hierarchies. I always want to turn things on their heads, to upset the established order, to change heroines and idiots. If the story is 'given' I take liberties with it to make it conform to my own experiences, and to be outrageous. At the same time as loving the stories I want to undermine them, like wanting to harm the person you love. Above all, though, I want to work with stories which emerge as I go along. It is something I have done in the past, and now I wish to do exactly that.

That summer Paula had her first solo show in the USA, at The Art Palace, New York and was included in an exhibition of women artists at La Mama. She also showed in Liverpool, *The Pig's Secret* being exhibited at the fourteenth John Moores Exhibition. In a brief catalogue entry Paula says that she found it 'very, very difficult to know what to say about this particular picture, as I was a bit ashamed at finding out what the pig's secret was. I would rather leave people to make up their own stories about it'. If any other artist risked writing something so whimsical, one would probably dismiss it as affectation; but in Paula's case one can be certain that she is referring to some incident in her own life – and, since pigs are her favourite animals, the revelation must have been somewhat shocking to her.

Her choice of pigs is no idle preference. In her mother's house in Portugal there is an aviary in the patio extension to the dining-room. Tropical birds were kept there from time to time, though invariably they ended up killing each other. Cruzeiro Seixas remembers when the aviary was empty and the discussion turned to what would be the most suitable pets for it. Various pretty things were suggested – birds, butterflies – until it came to Paula's turn. 'Little pigs', she said, without a trace of sarcasm.

These bright acrylic paintings, packed with incident and riotous with colour, still veil meaning in caricature; but now 'the masks', as she describes them, begin to fall away: the animals are substitutes for naturalistic representations of people. There is an undeniable sense of confidence in this more open declaration, but we should not take appearances too much at face value. Paula claims that not speaking her mind has always been more of a problem in her life than in her art. But even when her works are

135  *Qui Est Là?* 1985. Acrylic on paper, 68 x 45 cm.

136   *Le Festin*, 1985. Acrylic on paper, 69 x 45.5 cm.

137   *Le Marchand de Sable*, 1985. Acrylic on paper,
68.5 x 45 cm.

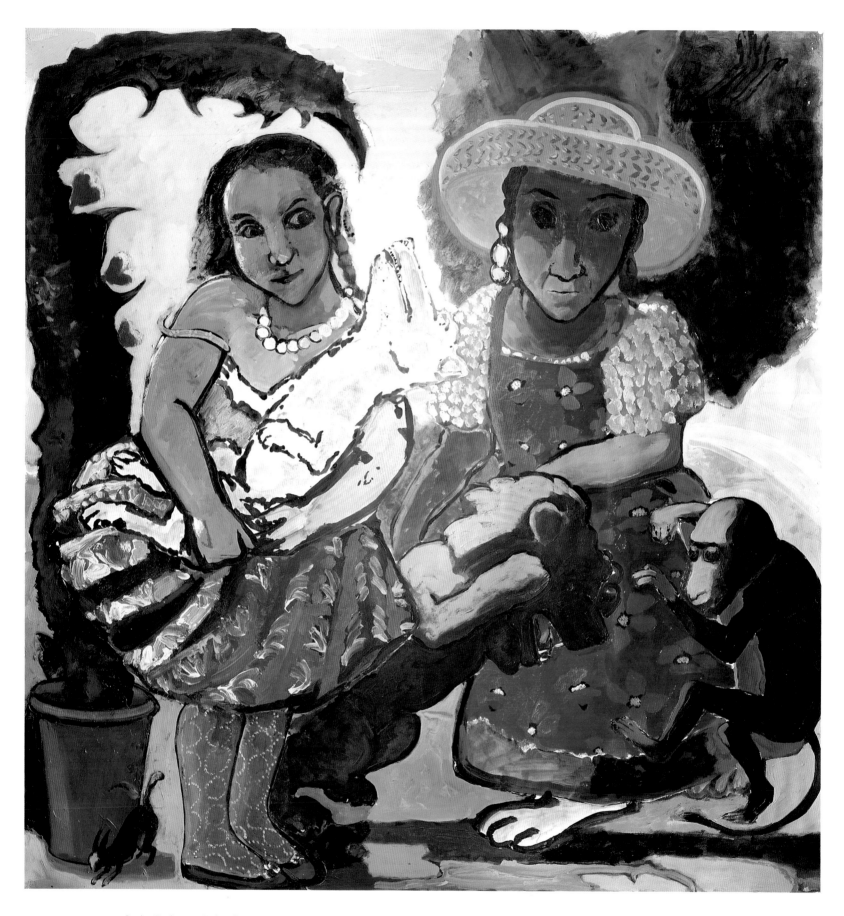

138  *In the Garden*, 1986. Acrylic on paper on canvas, 150 x 150 cm.

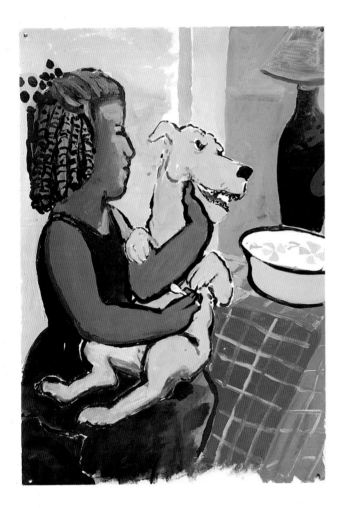

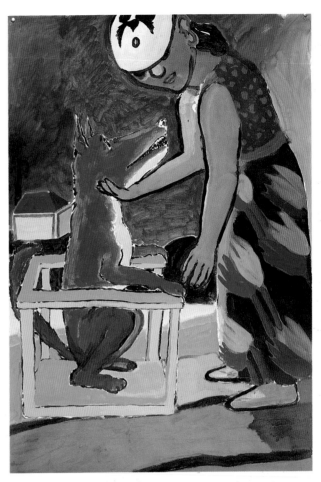

139 (above) *Untitled 'Girl and Dog' series*, 1986.
Acrylic on paper, 112 x 76 cm.

140 (above right) *Untitled 'Girl and Dog' series*, 1986.
Acrylic on paper, 112 x 76 cm.

141 (right) *Untitled 'Girl and Dog' series*, 1986.
Acrylic on paper, 112 x 76 cm.

142 (above left) *Untitled 'Girl and Dog' series*, 1986.
Acrylic on paper, 112 x 76 cm.

143 (left) *Untitled 'Girl and Dog' series*, 1986. Acrylic on paper,
112 x 76 cm.

144 (above) *Girl shaving a Dog*, 1986. Acrylic on paper,
111 x 75 cm.

145  *Girl lifting Up Her Skirt to a Dog,*
1986. Acrylic on paper, 80 x 60 cm.

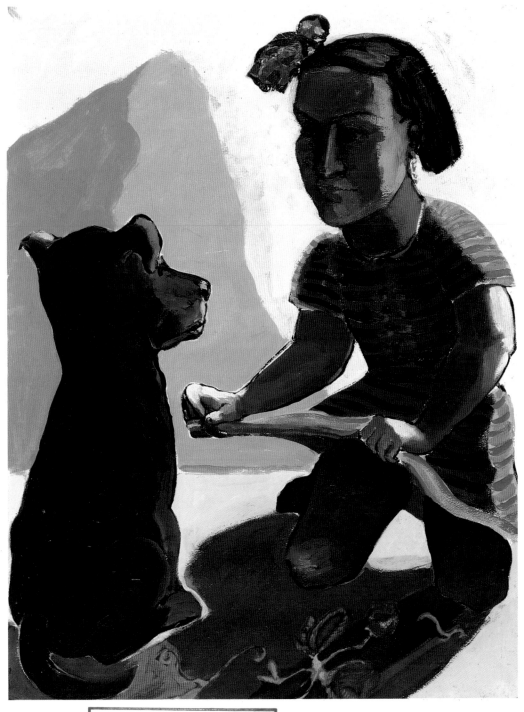

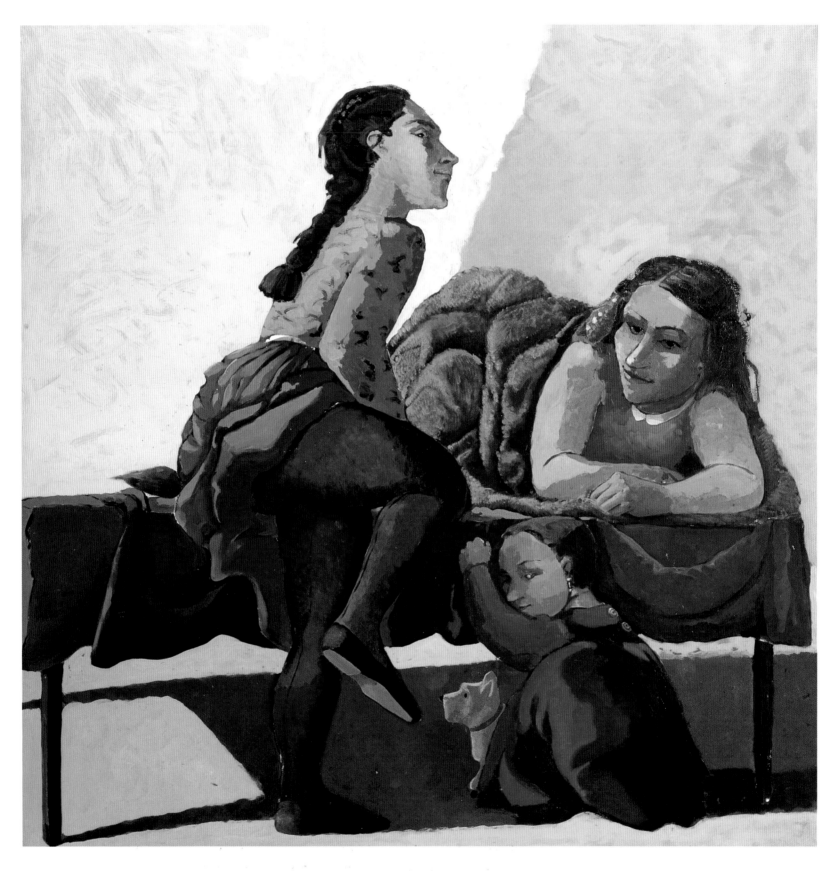

146  *Looking Back*, 1987. Acrylic on paper on canvas, 150 x 150 cm. Saatchi Collection, London.

147  *Girl exposing her Throat to a Dog*, 1986. Ink and wash,
29.8 x 33 cm.

representational they still take the form of metaphors and parables; they remain as much an inner as an external vision. And this continues today.

Two works in acrylic on paper from 1984 of girls playing with a helpless goat, **124**, **125**, prefigure the *Girl and Dog* series of 1986, a series that Vic had suggested. In these paintings a sick dog is nursed by one, sometimes two, girls. The cast changes, but the theme is constant. The dog is petted, dressed, spoon fed, helped to drink and, in one particularly trusting case, offers its throat to be shaved. Apart from the lumpish size of the animal this last action gives the clue, if any were needed, that this is no baby but an invalid, a man in the guise of a dog.

The designs are bold and often brilliantly coloured; the sense of firm tenderness on the part of the woman, of alternate compliance and stubbornness on the part of the dog, are recorded with a keenly observant eye. But successful though these pictures are, they act only as a prelude to the larger works in which Paula finally throws discretion, and therefore animals, to the wind.

Invalids and babies – both of which are states of helplessness – test the love of those responsible for them to the limit; but particularly invalids. In *Girl lifting Up Her Skirt to a Dog*, **145** (1986), Paula shows the frustration and anger that often smoulders within relationships based on dependency of one sort or another. The dog looks blank, the girl is angry; she is, at one and the same time, willing the dog to react and jeering at him for his inability to do so. Paradox is one of Paula's favourite devices; and here the most wounding of paradoxes is presented: we most harm those we love. An attendant air of menace is also often openly declared, as in *The Little Murderess*, **154** (1987), where the protagonist is intent on strangling an unseen victim. Incidental objects and details metaphorically enrich the meaning of the work. The sprig of mistletoe knotting the girl's hair is a symbol of fertility – a symbol we recognize, perhaps only obliquely, when we kiss under the evergreen mistletoe at Christmas, the most barren point of the year. The ox-cart speaks of yokes and burdens. The little murderess may enjoy new life through delivering death.

More disturbing in its ambiguity is *Looking Back*, **146** (1987), in which the theme of the invalid is superseded by a study of female relations, here two adults and a little girl. One of the women lounges on a rather uncomfort-

able bed with a look of contentment on her face, as if lost in pleasant reverie. She is covered by a fur blanket. 'The women have killed the dog', explains Paula. But this vestige of a dead animal might be more sinister – a symbol of one of their male victims, a lover, perhaps, who has paid the price, either with his life or by losing all self-respect. The other woman dances on one leg, her dress riding up to expose her stocking'd thigh, while she appears to be clutching her groin. She has a sly look. The little girl who plays at her feet is 'looking back' at us with a knowing smile on her face – subversion personified. And yet we also know, because we can remember our own childhoods, how little we change: this little girl has her own life, one that consists of plotting, eavesdropping, seeking revenge at the feet of grown-ups, like an animal in the depths of a forest. Paula too has 'looked back' by means of Jungian therapy, in which the analysand is encouraged to relive his or her childhood memories:

> When you talk about childhood you come to realize that you're the same as you were; through therapy you get reconnected with childhood – not least through re-reading fairy tales. When I read Bruno Bettelheim's *The Uses of Enchantment* it confirmed what I knew, which is nice. Once you enter into the world you find other people are interested in the same thing.

But what of the adults in *Looking Back*? Is theirs a sexual relationship, or are they merely gossips? Is the dancer desperate to share her secret, perhaps, before the excitement of it all drives her to the nearest lavatory? This reading of the picture was suggested by a woman, while a man thought that the dancing woman was masturbating. But that is the way of Paula's pictures: they are not illustrations, they are events.

Formally, these paintings marked a radical change, the most radical one of her career, ushering in what must now be seen as her mature style:

> It all changed when shadows started to appear. When you have light and shade you have volume and you can't have things floating up in the air, otherwise it looks ridiculous. Once you have grounded your figures, because they have volume they can take a lot more space around them, so you don't have to pack everything in. Then you begin to put in more props to tell the story. Folds and skirts are important – huge skirts, which have sexual connotations, cover the body and hold many secrets.

In *Two Girls and a Dog*, **151** (1987), the fragility of the sick dog is equated with a pitcher threatened by a hammer. These still-life props, which rein-

148   *Two Girls and a Dog*, 1987. Ink and wash, 29.8 x 41.9 cm.

149   *Snare*, 1987. Acrylic on paper on canvas, 150 x 150 cm. British Council.

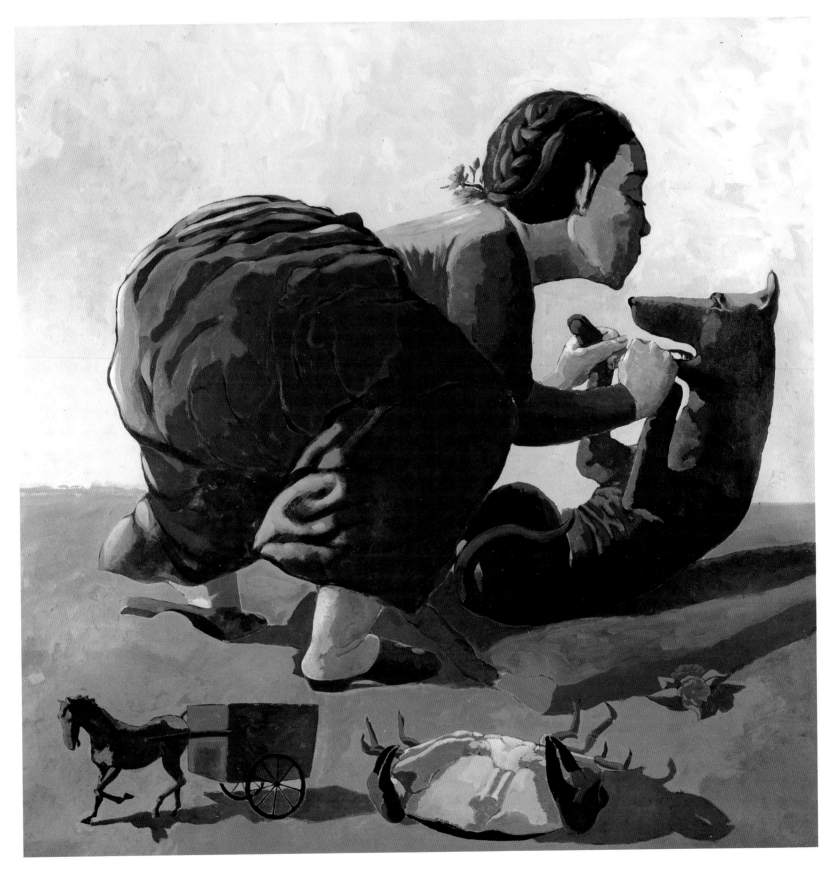

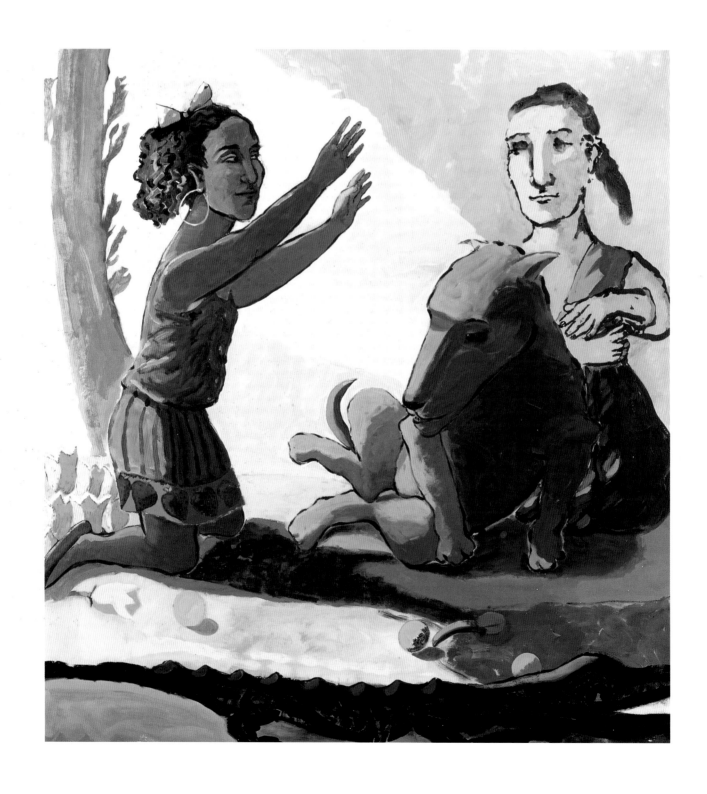

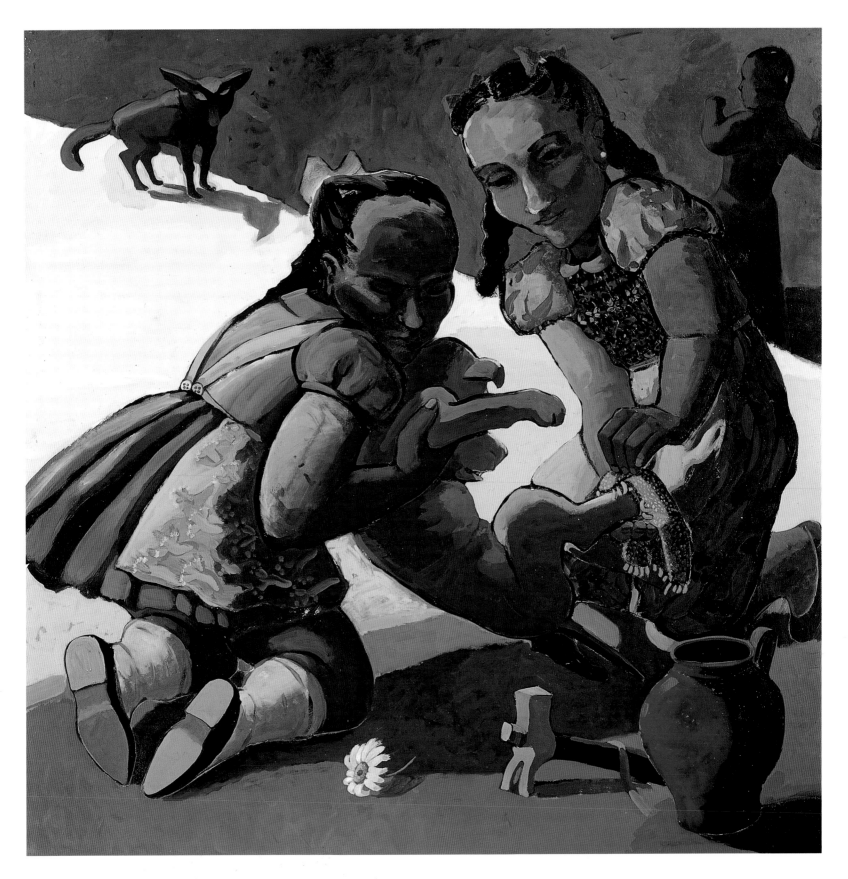

151 *Two Girls and a Dog*, 1987. Acrylic on paper on canvas, 150 x 150 cm.

150 (opposite) *Abracadabra*, 1986. Acrylic on paper on canvas, 157 x 150 cm.

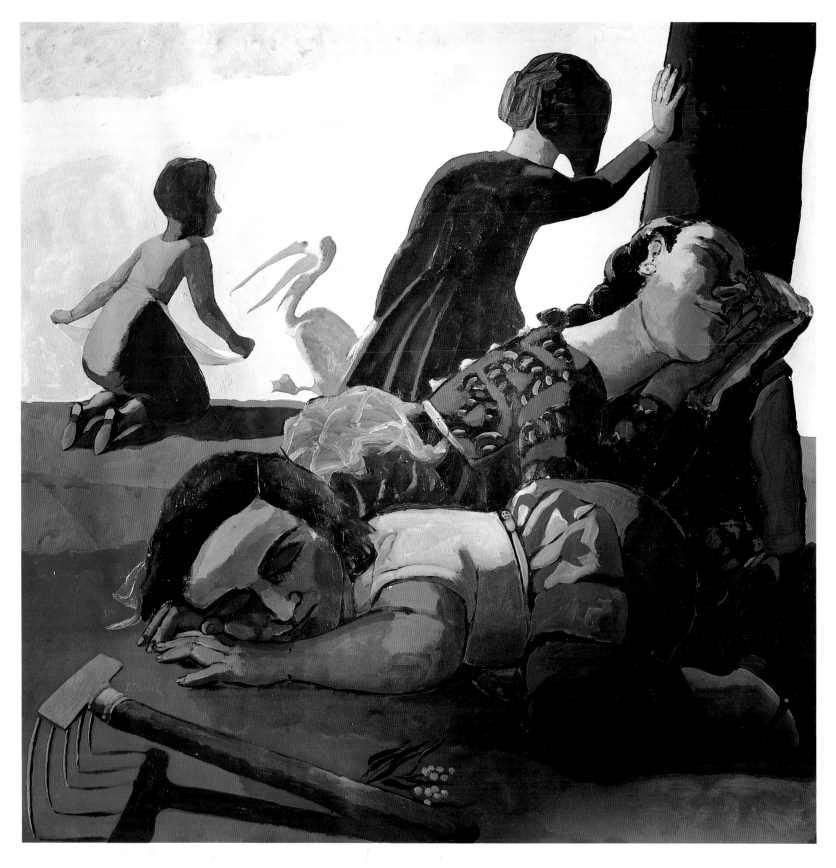

152 *Sleeping*, 1986. Acrylic on paper on canvas, 150 x 150 cm. Arts Council of Great Britain.

153 *Prey*, 1986. Acrylic on paper on canvas, 150 x 150 cm.

force the situation in the form of a metaphor, originate in the simple objects that, for example, Miss Turnbull, her art teacher, used to set up for the art class at St Julian's. In *Snare*, **149** (1987), originally titled *Beached*, the helplessness of the sick dog and the stranded girl is likened to that of an upturned crab. The girl's dress is excessively rumpled – 'like a walnut', in Paula's phrase – a provocative symbol, not least because of its association with the impotent dog's own wrinkled testicles. Although firmly grounded, the girl inhabits a dreamlike space of eerie shadows within a desolate landscape bounded by the kind of infinite horizons often found in Surrealist art. This dreamlike horizon can also be seen in examples of Vic's work. For Vic, reverie played an important part in the evolution of his art, with pictures appearing to him 'through' the wall in his studio like visions. The integrity of this experience was confirmed for him when he read Gaston Bachelard's *The Poetics of Space* and *The Poetics of Reverie*. In the *Dog* series Paula seems to have found something in common with Vic, not least in their dreamlike moods and often airless atmospheres of impending doom. Bachelard's comments on childhood have a special relevance: 'How is it possible not to feel that there is communication between our solitude as a dreamer and the solitudes of childhood?' he writes. 'And it is no accident that, in our tranquil reverie, we often follow the slope which returns us to our childhood solitudes.'[31]

154 *The Little Murderess*, 1987. Acrylic on paper on canvas, 150 x 150 cm.

# DROPPING THE MASK

The 'Girl and Dog' exhibition of 1987 at the Edward Totah Gallery in the heart of London's West End marked a turning-point. It was Paula's first commercial success in England, and as a consequence she was approached by Marlborough Fine Art, with whom she signed a contract towards the end of that year. Marlborough, with its global network of galleries, placed Paula's works on the international market for the first time, and their prices increased accordingly. Paintings one could have bought at the final Totah show for £5,000 were fetching ten times that amount by 1992. 'I'm sorry she went, but really she had no alternative', was Edward Totah's philosophical reaction. And he was right. Paula had reached a new phase in her art as well as in her career. 'We didn't see each other as much after the *Girl and Dog* series', says Penalva. 'It wasn't that we ceased being friends. We still talk for hours on the 'phone and she still asks me to go to the studio and see her work in progress. But around the time of the *Girl and Dog* pictures I thought I wasn't needed in the same way as before. She had a new confidence and I was afraid of disturbing something very new and maybe fragile.'

That Paula was embarking on a new chapter in her art as well as in her life was soon declared by *The Maids*, **158**, the first large-scale and purely figurative work she had painted since the 1950s; but thirty years on from then, these new works have an added sophistication and ambition. As Penalva said, 'She takes a long time to make up her mind, but when she does there's no turning back.' For Paula, the change was the inevitable consequence of introducing shadows into her work; but there was a new set of problems too:

The drawings are from mind to hand and the pictures just make them more concrete, that's all. Of course more complex things come into it. In pictures you can see things better. You have to find the right gesture, the right stance, expressions on faces have to be right. I used to do things that were flying all over the page, because I wanted it to look like a page from a book; the whole story spread out like a book so that you can read it from left to right, top to bottom. But to make the figures three-dimensional I had to ground them and that meant light and shade. I said to Vic: 'I don't know how to paint the floor.' And he said: 'It's very easy. You do the object and when you make the shadow that makes the floor.' Seeing the Arts Council's 'Northern Light' exhibition of Scandinavian art changed my paintings a lot. It came at the right time. I mean, if I'd seen that show, like, four or five years before, I wouldn't have looked at it twice.[32]

155  Previous page: Study for *Departure*, 1988. Ink and wash on paper, 42 x 29.7 cm.

Shaded volumes first began to appear in Paula's recent collages, notably in *The Annunciation* (1978) and *The Maids* (1986), and the paintings that followed have a common origin in the folds of *The Annunciation* Madonna's robe. They wear the sort of skirts that 'have sexual connotations, cover the body and hold many secrets'.[33] This secrecy is deepened by the paradox that, as her friend the critic and painter Ruth Rosengarten puts it, 'the more precisely she captures a gesture, the greater its ambiguity'.[34]

Just what the story might be in *The Maids* is, as usual, left to our imagination. The title derives from the play by Jean Genet in which the maids murder their mistress; and the air-less, window-less, stage-like setting, full of drapes and props, might lead the viewer to see it as an actual scene from a play. But for Paula it is real enough: these are not characters *in a play* but characters *playing*, though at what is another question. The only thing we can be absolutely sure of is that the maids are up to no good. One seems to be feeling the back of her mistress's neck with the practised hand of an executioner. Do those folds in her apron and dress hide a knife? And the branches of the tree – whether real or part of a mural – stretch out from behind the screen like crafty fingers itching in devilish sympathy. Meanwhile, the Alice-girl is being restrained by the other maid, who seems, perversely, to be at once saving her from witnessing the horror about to be perpetrated while holding her privy to the deed.

The props serve as the metaphoric counterpoint to the main action. The boar is the male presence, but in its stuffed state it is as impotent as the absent husband; and when the husband is away, the maids come out to play. As for the cut arum lily lying on the table – it may be a foreshadowing emblem of the beheading of the unsuspecting mistress, or the end of the little girl's innocence, or both.

The setting, as one might expect, is a remembered one – the bedroom of Paula's mother, albeit subject to a degree of poetic licence. It is a bedroom in the house where Dona Violeta once made Paula's life a misery; where the jingling sounds of the BBC World Service charmed away the murderers in the shadows of her bedroom in the darkest days of the War. But *The Maids* enfolds a still deeper meaning. The model for the mistress – as for so many of Paula's later paintings – is Lila Nunes, who nursed Vic in his last years. It was Lila who squeezed the paints, adjusted the brushes and literally

156 Study for *The Maids*, 1987. Ink and wash on paper, 42 x 29.7 cm.

157 Study for *The Maids*, 1987. Ink and wash on paper, 29.7 x 42 cm.

158 (opposite) *The Maids*, 1987.
Acrylic on paper on canvas, 213.4 x 243.9 cm.
Saatchi Collection, London.

supported him while he completed his final series of pictures against all the odds.

*The Maids* is the first and prototypal picture of Paula's most recent cycle of work, which in his last essay Vic described as 'awkward naturalism'.[35] The awkwardness remains but, paradoxically, as Vic identified, this very failure 'leads to an uneasy success when after all, this is not prosaic but Gothic in feeling'. It is an awkwardness made explicit by Paula's hard-earned, and sometimes illogical, use of perspective; and also from the trouble she often has in filling blank spaces.

Both weaknesses are exposed by *The Soldier's Daughter*, **159**, where the girl's firm grip on the limp body of the goose contradicts the slackness of the overall design. Part of the problem in this painting is that too much of it is blank, and therefore depends for its interest on the paintwork; a hard task with water based acrylics, which never have the tonal richness, the lustre of oils. All the more so when Paula insists on using a painterly technique which seems to have been spurred by her admiration for the later paintings of Lucian Freud. Penalva, in a salty phrase, says it is like 'trying to make a soufflé without using eggs'. And he elaborates:

> Her career is truly unique; only a few years ago Victor Musgrave and Monika Kinley thought of her as an outsider artist. Then she's taken up by the Marlborough. Then she works at the National Gallery and becomes part of the establishment! And everybody is right. She is an outsider and she is a great painter. In fact I think only now is she a primitive painter, because she's doing pretend oil paintings using acrylic, and that is in itself an attitude she completely ignores. This naivety casts yet another light on her work, as if there weren't so many already. I admire the way she just goes on minding her own business, doing what she does well and struggling to master what she wants to know. Like a student, really. She doesn't get old.

*The Maids* was immediately recognized as one of Paula's most important pictures but, more than any other, it also had the effect of associating her art in the public mind with that of Balthus. This critical misinterpretation is easy to understand, if irritatingly overstated, – not least because she has never taken much interest in Balthus's work. But the trappings of privilege, the echoes of the Tenniel child (Tenniel's illustrations for 'Alice' having been a common source for both artists), the atmosphere of drama, and even, to some extent, the chalky colour, make the association

159 *The Soldier's Daughter*, 1987. Acrylic on paper on canvas, 213.4 x 152.4 cm.

160 *The Cadet and his Sister*, 1988. Acrylic on paper on canvas, 213.4 x 213.4 cm.

unavoidable. Nevertheless, what proximity there may be is more a matter of style than substance.

With Balthus the artist is the voyeur of burgeoning sexuality, the imminent corruption of teenage girls, whereas in Paula's work there is no sense of male voyeurism. On the contrary, since her work is so autobiographical, the artist herself is a player in the drama. In addition, Balthus's principal subject remains relatively unchanged, while each set of circumstances in Paula's paintings is new, and innately more novel and complex for having been painted by a woman. Invariably, the props are more obvious than the themes they symbolize; and always there is the uneasy feeling that the viewer may, metaphorically, be struck from behind. As Paula has said of the mistress in *The Maids*: 'Who knows, perhaps she's a man in drag?'

Vic was to die in 1988, and as John Mills has observed of the pictures that followed *The Maids*, 'there are a lot of farewells.'[36] *The Soldier's Daughter*, **159**, *The Cadet and his Sister*, **160**, *Departure*, **162**, each in its way speaks of impending loss, and of the knowledge of loss. The difference between them and *The Exile* is of experience. In a sense age is exile, a lengthening history of loss. But exile seems also to be a particularly Portuguese form of sadness, perhaps the soulful legacy of the nation's seafaring history and imperial past. There is the fierce sadness of the *fado* tradition in folk music; and the literary notion of *saudade* – an untranslatable word, but summed up by Alberto de Lacerda as the feeling that 'even if we don't want to go back to the past, it's there and it can hurt like hell'. Paula remembers *The Exile* fondly because it had *saudade*, 'truth to my feeling'.

Faithful to this spirit, all these pictures have Portuguese settings, most dramatically in *Departure*, in which Paula portrays the great cliff at Ericeira; but elsewhere the white-washed houses, with their balconies and open windows (in old houses in Portugal windows have shutters), lining the narrow streets, evoke the village itself – now, sadly, in the process of being rebuilt for the tourist industry. The villa that Paula and Vic had been forced to sell in 1979 serves today as a building-yard for surrounding developments – a place of chained-up guard-dogs and stacks of bricks, tiles and neatly cut and numbered piles of marble. The delicate house remains, its pointed roof a gentle reminder of Macao and the oriental limits of Portugal's empire; but the eucalyptus avenue Paula and Vic had planted is gone, and even the grass

161  Study for *Departure*, 1988. Ink and wash on paper,
42 x 29.7 cm.

162  (opposite) *Departure*, 1988.
Acrylic on paper on canvas, 213.4 x 152.4 cm.

has been ground to dust by the heavy trucks. Only Luzia, faithful to the end, remains, surrounded by hens and various mementoes, in a little cottage screened by bamboo.

There are numerous other personal references in these pictures. The model for both the cadet and the young man in *Departure* was Ron Mueck, Caroline's husband; the sky in *The Cadet* is intended to match the blue of the skies in Paula's childhood book of catechism. And there is the quality of the light itself, which is so poetically mirrored by the gilded blue and white of Portuguese tiles:

> Portuguese light is like looking into a pool. It contains you. It's green, yellow, warm. At sunrise and sunset in the summer we have something called 'the golden hour'. In England the light is more hazy and it's colder. You are on your own. It's more brittle. In Portugal you see a long way, far away – forever really. The horizon of the sea is clear, far, far away – it goes on. But the horizon of the sea in England is hazy.

This difference in light has its counterpart in the greater mysteriousness and gentleness of English folk tales and fairy stories; which in her opinion are less harsh and cruel than Portuguese ones – though one would hardly think it from some of her interpretations of the English nursery rhymes.

Nothing is ever as straightforward as it seems in Paula's art. There is always a twist, as many female admirers of her work have noted; and it is difficult to pin her down on the way one should interpret her pictures. The story she tells one day can be entirely different from the story she tells the next. Her pictures are true to this complexity. Clarity has increased their ambiguity, as has been said. We are as many people as we meet; we are the sum of our own contradictions. Consider the two interpretations of *The Cadet and his Sister*, offered by Paula at different dates. The first is from the formal interview she gave for the catalogue to her 1988 exhibition:

> I wanted the young man to be slightly younger than his sister, possibly thirteen and she'd be like fifteen, and she's more knowing than he is and he's depending on her quite a lot. I can't really explain it any more because the whole thing came to me in one go. I very much wanted that avenue going up and disappearing into the distance, a bit like a theatrical backdrop. And the sky is meant to be like a sky from my catechism book. And then the props were very important. Her bag had to be brown like that, and lined in red. I mean it had to be dangerous, as if it could snap shut. Both it and the gloves are like – I suppose it's pretty obvious – but like sex symbols. But opposites. And

the cockerel is small and puffed up, and a pretend one, a porcelain one; so it shows he's impotent, the poor cadet. And it's a lesson you see – a lesson for us and also a lesson between the two of them. It's about accepting fate; accepting the way things are; in a nice sort of way. It's not an unhappy picture at all.

The second is from a conversation in 1990:

> It's about incest. They have just made love. She dresses him. He is going away to do his military service. The cock is his masculinity. The handbag is her femininity. It's a container but it snaps shut. It could castrate him. The gloves have various connotations – a surgeon, a gardener, a butcher. The walls are abrupt and the avenue seems false, like a backdrop. Or if it is real it is a dead-end – incest leads nowhere. His future is destroyed. She will control him forever.

Yet, early in 1992, Paula could not remember ever having described the picture in this latter way: 'It's about domination, that's all', she said firmly. But she has let it stand, on the grounds that it is just another story.

The sexuality discernible in so much of Paula's work is most fiercely set forth in *The Policeman's Daughter,* **164**. This speaks of authority – the jackboot strikes forward as if caught up in a march; the raking street-light is as pitiless as a searchlight. The confined girl's predicament is symbolized by the cat: the outside world of the night calls, but the cat cannot respond; it, too, is trapped. The girl polishes the phallic boot. Her arm is rammed into it almost up to her shoulder. The window is open, but it offers no means of escape. The view from it is as empty, and as hopeless, as the interior. The girl sits in her father's heavily studded chair, at once the beneficiary and the victim of his authority. Her anger and frustration show in the tight grip of her fist and in the way her mouth is pursed shut. It is significant that it was only when Victoria, Paula's actress daughter, sat for the painting that it began to work. As for policemen, they remain a pervasive presence in Portuguese society. Emilia, the woman who looks after Paula's mother, is married to a policeman. Cecilia, who stands in for Emilia when the latter is away on holiday, is also married to a policeman. She is a country girl, who likes to work barefoot in the old country way. She is also St Cecilia in *Crivelli's Garden*, where she appears with a broom, the embodiment of Portuguese sturdiness.

When she first began painting *The Family,* **166**, Vic was still alive, and at that time Paula had a different title in mind for it. This was *The Raising of*

*Lazarus*, as if by force of will she might succeed in painting a miracle into being. The painting is the *Girl and Dog* transformed into naturalistic detail. As we can see from the man's eye, fear brings out the animal in us all. Yet he is in safe hands. Paula's cousin Manuela, the surrogate 'sister' with whom she used to share a bedroom at Ericeira, posed for the woman at the man's side, Lila for the one in front.

If a picture was not working Vic used to say it needed 'Rousseau's dog', a reference to a favourite painting by the Douanier Rousseau in which a little dog is the vital detail that balances the overall design. The foreground in *The Family* needed filling in with something, but Paula was not sure with what, or whether it should be symbolic. Vic suggested she put in the kind of object 'you could reach out and pick up'. Hence the jug. The shrine against the far wall is typical of the kind one finds in Portugese homes, not least in her mother's bedroom. The lower panel of the shrine illustrates the fable of the heron that removed the bone from the throat of its enemy the fox.

As usual, when Paula had finished and was lost for an idea she asked Vic what she should paint next. 'Paint people dancing', he said. *The Dance*, **167**, was the picture she had embarked on when he died. The dresses hold their secrets, the young man might just as well be her son Nicholas ('the image of his Dad') as his father; the moon sails beyond the old military fort and reveals the joy of a summer night. It is wholeheartedly nostalgic, with no sense of menace or subversion – a final farewell, all passion spent. 'Since Dad died', Nicholas says, 'there is not the same conflict between the characters in the paintings.' *The Dance*, was the first purchase made by Nicholas Serota after he became Director of the Tate Gallery, and Paula's first major painting to enter its collection, where it joined two paintings by Vic.

After painting so strenuously and on such a large scale it was a relief for Paula to turn to other media again; and there is a characteristic sense of pent-up energy released in the suite of thirty etchings illustrating some of the most popular English nursery-rhymes that formed her first solo exhibition with Marlborough Fine Art in the winter of 1989. Paula had shown some etchings – much indebted to Goya – at the Edward Totah Gallery in 1987; but the series *Nursery Rhymes* was her first sustained involvement with the medium. Because of her relative inexperience in etching, she chose to

163 Study for *The Policeman's Daughter*, 1987. Ink and wash on paper, 42 x 29.7 cm.

164 (opposite) *The Policeman's Daughter*, 1987. Acrylic on paper on canvas, 213.4 x 152.4 cm. Saatchi Collection, London.

165   Study for *The Family*, 1988. Ink and wash on paper, 29.7 x 42 cm.

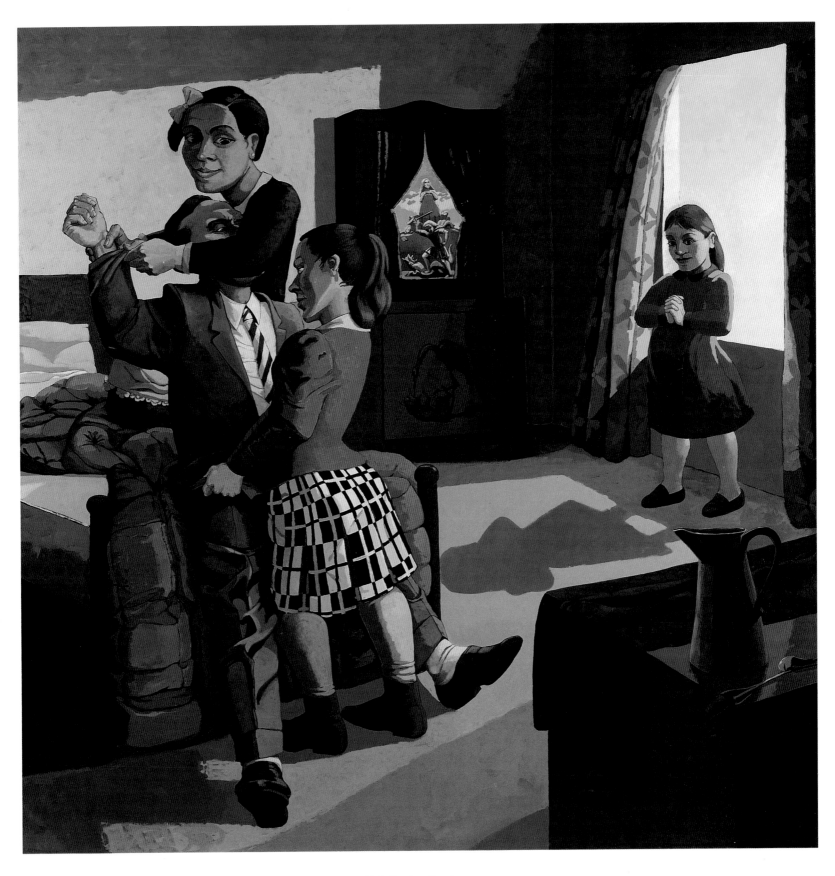

166  *The Family*, 1988. Acrylic on paper on canvas, 213.4 x 213.4 cm. Saatchi Collection, London.

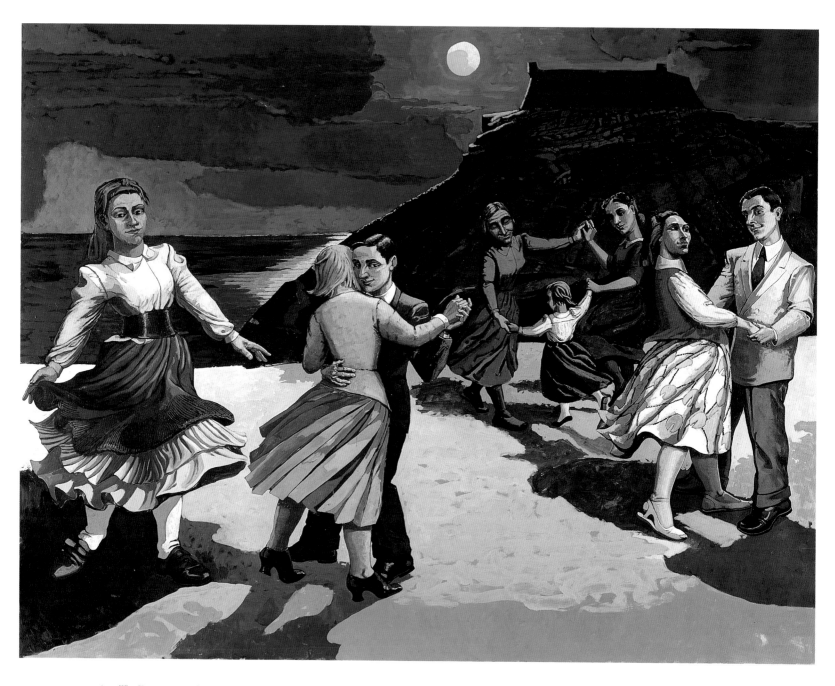

167   *The Dance*, 1988. Acrylic on paper on canvas, 213.4 x 274.3 cm. Tate Gallery, London.

168  Study for *The Dance*, 1988.  Ink and wash on paper, 29.7 x 42 cm.

work with her friend Paul Coldwell, a sculptor as well as a printmaker. Paula's interest in folklore made her well-suited to the theme, but nonetheless it was hard to see how even she could find something new in such frequently illustrated and over-familiar ditties as 'Three Blind Mice' and 'Baa Baa Black Sheep'. But she did, and so subversively that the rhymes will never seem quite the same again.

Those mice, for instance, in *Three Blind Mice,* **169**, are shown blindly groping while the farmer's wife shepherds them with cold calculation, as if contemplating what torture to inflict on them next. As for the large ram in *Baa Baa Black Sheep*, **2**, he is the randiest imaginable, a great big bully of a beast with whom the 'dame' is clearly quite infatuated. The little boy 'who lives down the lane' can be seen in the distance, his head on one side. He seems puzzled, the way children are when they catch grown-ups behaving out of character; and the dame, his mother, waves at him with false reassurance, the way grown-ups can when caught in a compromising situation. She has betrayed her feelings. At this moment, nothing in the world is more important to the dame than the big black ram, and she fingers his rich and reassuring fleece in wonder. One's heart aches for the little boy, just as it does for the helpless mice at the mercy of the vicious farmer's wife.

Paula first conceived of the *Nursery Rhymes* series in the form of a book to give her granddaughter Carmen for a birthday present. She only illustrated the rhymes Carmen knew, using ink and light colour washes. It was from this chance present that the idea for the etchings arose, providing her with a fresh opportunity to take another road back to childhood, for she was familiar with English nursery rhymes from her own schooldays. According to Paula, 'having grandchildren is interesting, because they remind me much more of my childhood than my children did. Your own children are always too close, too much of a concern.' Most of the ideas for the series came unconsciously except for the first etching, *Little Miss Muffet*, **4**, which is unique in its consciously Freudian bias: 'I haven't read Freud but this is what he says apparently – that spiders are mother figures, not letting you get away. So I made it with lots of grabbing arms and hairy, sticky bits – horrible.' Miss Muffet looks suitably traumatized by the monster spider, but it seems not to have bothered Carmen in the least.

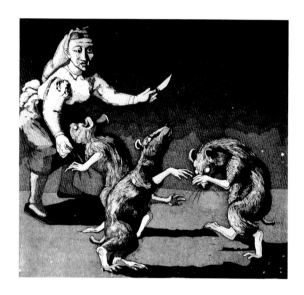

169  *Three Blind Mice (2)*, 1989. Etching, 52 x 38 cm.

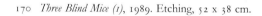

170  *Three Blind Mice (1)*, 1989. Etching, 52 x 38 cm.

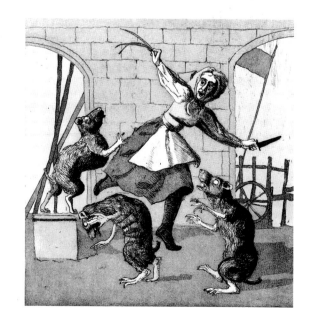

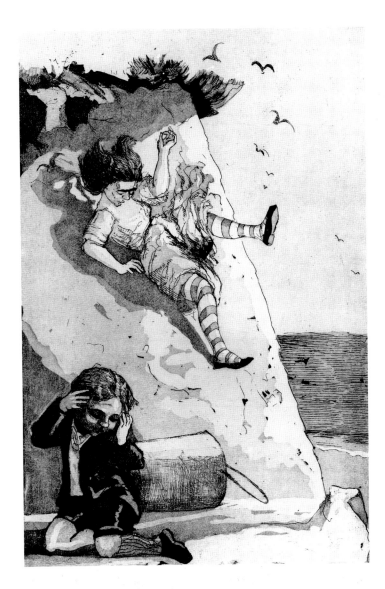

171   *Jack and Jill Went up the Hill*, 1989. etching, 52 x 38 cm.

172   *There was an Old Woman who Lived in a Shoe*, 1989. Etching, 52 x 38 cm.

173 Study for *The Rehearsal*, 1989.
Ink and wash on paper, 29.7 x 42 cm.

One of the most disturbing, and therefore most successful, images is *Polly Put the Kettle On*, **14**. Surprisingly, considering its powerful mood of foreboding, it was conceived quite spontaneously. 'I remember not knowing what to do next and I was sitting there at this table where there was one of Carmen's dolls; so I just started by drawing the doll and that turned into the big girl. The other girl's face is a sort of self-portrait, which I did from the mirror to see how the shadows fell.' The print is just off square, which adds to the scene's uneasy atmosphere – a trick she learned from Vic – while the uniforms and the dominant female bring to mind the painting of *The Cadet and his Sister*.

Paul Coldwell compares Paula's method to that of a stage-director, which tallies with her own childhood delight with her toy theatre. And he confirms her always overriding interest in the story: 'The nursery rhyme becomes incidental. It's what's happening between the characters that interests Paula. The rhymes have become meaningless to us through repetition, but by

174 *The Rehearsal*, 1989. Acrylic on paper, 244 x 366 cm. Saatchi Collection.

175 *Boys and Girls Come Out to Play*, 1989.
Pen and watercolour, right panel 29.2 x 81.2 cm.,
left panel 29.2 x 40.7 cm.

taking the images by the scruff of the neck she returns them to the adult world.'

In order to make an etching the artist first uses a needle to draw on a metal plate coated with wax. The plate is then immersed in a tray of acid, and where the lines have exposed the metal beneath the wax the acid bites a mark. It is a tribute to Paula's skill that she destroyed only two plates during the entire production process. But as Coldwell says, 'the technique of etching can be learned in a day. It's the invention of the drawing that matters.' And drawing is indeed the probity of her art. 'It was a joy for me to work with her because her images are so strongly drawn', recalls Coldwell. 'At various points in the making of a print she insists on looking at it from a distance. That's another thing most artists don't do. They work with the print under their noses, and only see at the private view that the image is unreadable at anything over six inches.'

'Absolutely', confirms Rego, 'I wanted them to work biff-bang'. It hardly needs saying that they also contain some rollicking caricatures of her friends in the best eighteenth-century tradition of Rowlandson, whose pale colours she has consciously invoked in a few hand-tinted etchings of the *Rhymes*.

# TALES FROM
# THE NATIONAL GALLERY

In 1990 Paula was appointed the first Associate Artist at the National Gallery in London. She was given a studio on the premises and granted a stipend for a year, in return for which she was required to paint pictures directly related to those in the collection. It was not an appointment she entered into lightly and, to begin with, as is always the case when she moves into a new studio, she hated it:

I was very scared and a bit daunted! But to find one's way anywhere one has to find one's door, just like Alice, you see. You take too much of one thing and you get too big, then you take too much of another and you get too small. You've got to find your own doorway into things ... and I thought the only way you can get into things is, so to speak, through the basement ... which is exactly where my studio was, in the basement. So I could creep upstairs and snatch at things, and bring them down with me to the basement, where I could munch away at them. And what I brought down here from upstairs varied a lot, but I always brought something into my den.[37]

It is typical of Paula that, even in this account, she instinctively turns herself into an animal; as she once said of a painting, 'suddenly it's as if a dog were to tell its own story'.[38] But artists are like dogs. They scavenge art for ideas; as Lionel Trilling wrote: 'Immature artists imitate. Mature artists steal.'[39] Now, for Paula, one of the world's great art collections was laid before her like an open book. No wonder she was flummoxed, not least because of her avowed distaste for hierarchic distinctions.

She moved studio in January 1990. The timing was fortuitous, because it coincided with the expiry of the lease on the vacant button factory in Berry Street, where she had taken over a studio from Vic when he could no longer travel to work. This was a large warehouse space with no windows, though had there been windows Paula would have blanked them out, a symptom of her childhood agoraphobia, her need for a womb without a view. The Berry Street studio was wide and low. At the National Gallery she moved into an equally windowless space, but one with much higher walls. She felt trapped. The unsettling interim was negated by drawing.

When she arrived Paula had already embarked on a new series of paintings recalling a visit she and Vic had made to Madrid in 1957. The hotel had not been particularly memorable but the holiday had been a honeymoon of sorts, highlit in retrospect by a funny incident. One evening they had overheard a discussion about themselves: 'She's obviously a hooker, but

176   Previous page: Study for *Time - Past and Present*, 1990-91. Pencil and ink on paper, 53 x 48 cm.

a beautiful one, a good one, far too good for him. I can't figure out what's going on because clearly he can't afford her . . . ' was the gist of it. Thirty years later she picked up the thread of this gossip and decided to do a series of pictures of imaginary situations in the various rooms of the hotel – the powerful memory of her marriage itself a comfort in the aftermath of Vic's death.

In some ways the room series can be seen as a continuation of the 'departures', with youth being groomed by age in readiness for a first perilous meeting with destiny. *The Bullfighter's Godmother,* **179**, and *The Fitting,* **183**, the former finished and the ball-gown in the latter already completed by the time she arrived at the National Gallery, are both concerned with dressing. Because the young people depicted (João Penalva was the bullfighter, with Victoria – standing – and Caroline as his dressers), can be seen as sacrificial offerings in their different ways, it lends these pictures an aura of *memento mori.*

It was the red satin cloak of the bullfighter that triggered *The Fitting,* filling Paula with the desire 'to paint a huge blue satin skirt', which she did from a little model she made especially. The degree to which *The Fitting* is about the dress – formally and metaphorically – is only fully revealed when viewed from a distance. Then it fills the eye, the shine on its folds (she made numerous preparatory drawings) gleaming with vivid realism. In the confines of the studio the painting loomed much larger than when it was shown in Paula's winter exhibition in 1991-92 in the Sunley Room at the National Gallery, reminding one of the awesome size of many of the pictures in the Collection, designed as they were to make their mark in churches and palaces. From near and far the satin in *The Fitting* has the look of eddying and cascading water, redoubled by the figure of the dressmaker at its foot with her black boulder of a bottom.

In England, until 1959, it was the custom for the season's debutantes to be presented at Court. Subsequently their marital credentials would be displayed at a 'coming-out' ball. Although replete with poignancy as any good party is, there is no disguising the marketing aspect of the debutante ritual. Daughters, as Jane Austen so wittily wrote, 'are capital'. The debutante in the *The Fitting* – 'a socking great girl, being dolled-up for the meat market' – is truly like a fatted calf for the slaughter, an offering to be sacrificed on

177 Study for *The Bullfighter's Godmother*, 1990-91. Pencil and ink on paper, 48 x 51 cm.

178 Study for *The Bullfighter's Godmother*, 1990-91. Pencil and ink on paper, 26 x 31.1 cm.

179   *The Bullfighter's Godmother*, 1990-91. Acrylic on paper on canvas, 122 x 152.4 cm.

180  Study for *The Fitting*, 1990-91. Pencil and ink
on paper, 51 x 47 cm.

r81  (above right) Study for *The Fitting*, 1990-91.
Pencil and ink on paper, 49 x 49 cm.

182  (right) Study for *The Fitting*, 1990-91. Pencil and ink
on paper, 27.3 x 34.9 cm.

183  (opposite) *The Fitting*, 1990. Acrylic on paper
on canvas, 183 x 132 cm. Saatchi Collection, London.

the altar of marriage. Her waspish mother eyes the result like a calculating butcher with a prime piece of beef. But for Paula *The Fitting* has a redemptive message too, in that she sees the dress as a chrysalis from which the young girl emerges into the butterfly freedom of adult life. The dress-maker, by contrast, is socially disadvantaged: her daughter will never rise in the world. At first Paula intended to make this a literal disablement by locking the girl's legs in iron braces, but she decided this would look melodramatic and eventually chose to cast her as a doll-like Petrushka figure.

To 'cast' has a potent significance in this context, for as Paula says, 'I do cast. I plan things like a film director', an analogy enforced by her naturalis-tic work, as her son Nicholas, with his experience as a film director, readily agrees: 'She paints in technicolour; and the lighting is cinematic. The atmos-phere is cinematic.' This is borne out by the importance films have always had for Paula, perhaps the chief artistic stimulus of her visual imagination. Certainly, no painter has meant more to her development than have her beloved film-makers Disney and Buñuel. As with illustrators, extending the list would not necessarily throw any specific light on her visual develop-ment. Nicholas Roeg, for instance, is an English film director she particu-larly admires for his sumptuous visual style; but the connection between his films and her art is not immediately discernible, except, perhaps, in the lavish case of *The Fitting*. More to the point is her admiration – easily detectable in her recent paintings – for those two emphatically cinematic painters, Giorgio de Chirico and Edward Hopper.

Paula, as the National Gallery's Associate Artist, was duty bound to paint pictures directly related to works in the Collection – an awkward request to make of any artist. But, as always, she rose to the occasion. For *The Fitting* she took particular note of the girl's dress in Jan Steen's *The Effects of Intemperance*, even making a small copy of the picture; and the formal idea for the embossed doors of the cupboard was prompted by Mantegna's *Samson and Delilah*, a painting intended to look like a stone bas-relief. (Paula employed a similar pair of decorated doors in the shrine-like cabinet of *The Family* of 1988.) The story told on the cupboard doors in *The Fitting* is one of her own, but it parallels the drama of the main subject: a mother and her baby are threatened by Satan's wife, a ghastly creature with a devil's head

who is trying to snatch away the child – a parallel situation to the corruption of innocence personified by the victimized girl. The other picture within the picture has a more sentimental thrust. It depicts a Spanish woman in a mantilla and was copied from a postcard once sent to her by Vic. Paula chose to paint it like one of his 'visions', in that it could be a real scene in an adjoining room.

Her next painting, *Time – Past and Present*, **187**, concludes the departure theme. Its central character is an old sailor, a grandfather, contentedly babysitting while mulling over the voyage of his life. Not much tells us that he is an old tar, beyond the juxtaposition of his head, the picture of a sailor-boy and the model of the boat on the shelf. The picture above this boat has a nautical significance, though one would hardly guess it. It shows the extent to which Paula's paintings can contain stories within stories as well as pictures within pictures: 'It's a legend that I made up about a little girl from the sea, who eats up sailors. This St Jerome's brother was a sailor and was sacrificed to this girl from the sea by some nuns, who ran a school, and who were very strict.'

The reference to St Jerome explains the painting's inspiration – the National Gallery's *St Jerome in his Study* by Antonello da Messina:

> *St Jerome* by Antonello is the most magical painting – a house within a church with St Jerome sitting there and, inside the church but not quite inside his house, a little lion, running towards you from the distance. It's a magical painting. Anyway, I wanted to do this old friend of mine, Keith, as the Saint, sitting in the room with all his memories. Some of his memories are taken from pictures in the National Gallery, and some of them are made up.[40]

The pictures from which she quotes are Honthorst's *St Sebastian*, over the doorway; Zurbaran's *St Francis in Meditation* to its left and, below this, Memlinc's *St Anthony Abbot* from the back of the Donne triptych. The angel on the screen is an invention, though its proximity to the baby (her granddaughter Lola) endows it with an annunciatory air. It makes for an intense sub-plot when we learn that the model for the old man was Paula's and Vic's friend, Keith Sutton. Keith had been in the Navy before he became a painter and art critic; in 1966 he was responsible for the first article about Paula in the British press. It is, therefore, singularly appropriate that he should sit in a room full of pictures, and preside at the birth of new talent,

184 (above left) Study for *Time - Past and Present*, 1990-91. Pencil and ink on paper, 56 x 46 cm.

185 (left) Study for *Time - Past and Present*, 1990-91. Pencil and ink on paper, 61 x 46 cm.

186 (above) Study for *Time - Past and Present*, 1990-91. Pencil and ink on paper, 46 x 45 cm.

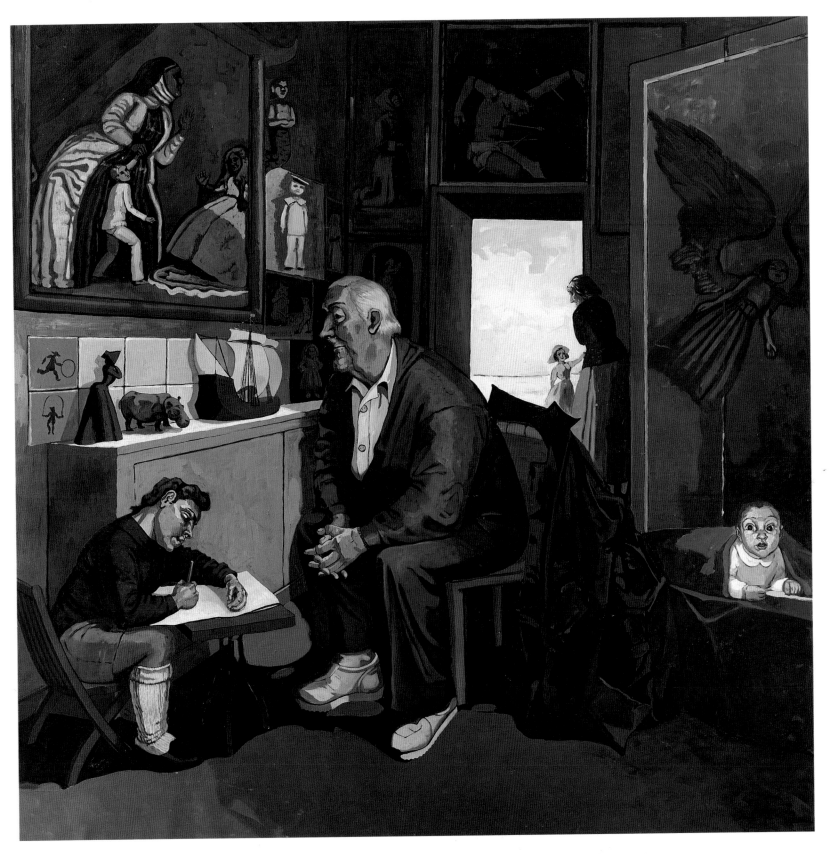

187  *Time - Past and Present*, 1990-91. Acrylic on paper on canvas, 183 x 183 cm.

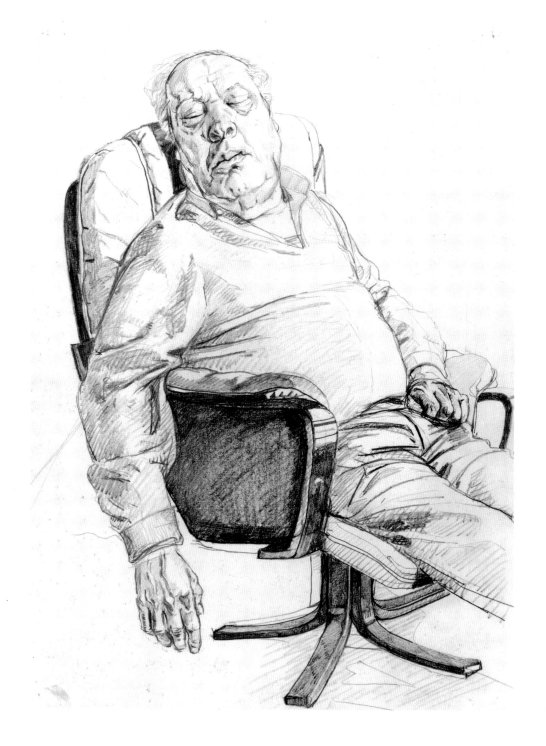

188 Study for *Joseph's Dream*, 1990.
Pencil on paper, 41.9 x 29.9 cm.

189 (opposite) *Joseph's Dream*, 1990.
Acrylic on paper on canvas, 183 x 122 cm.

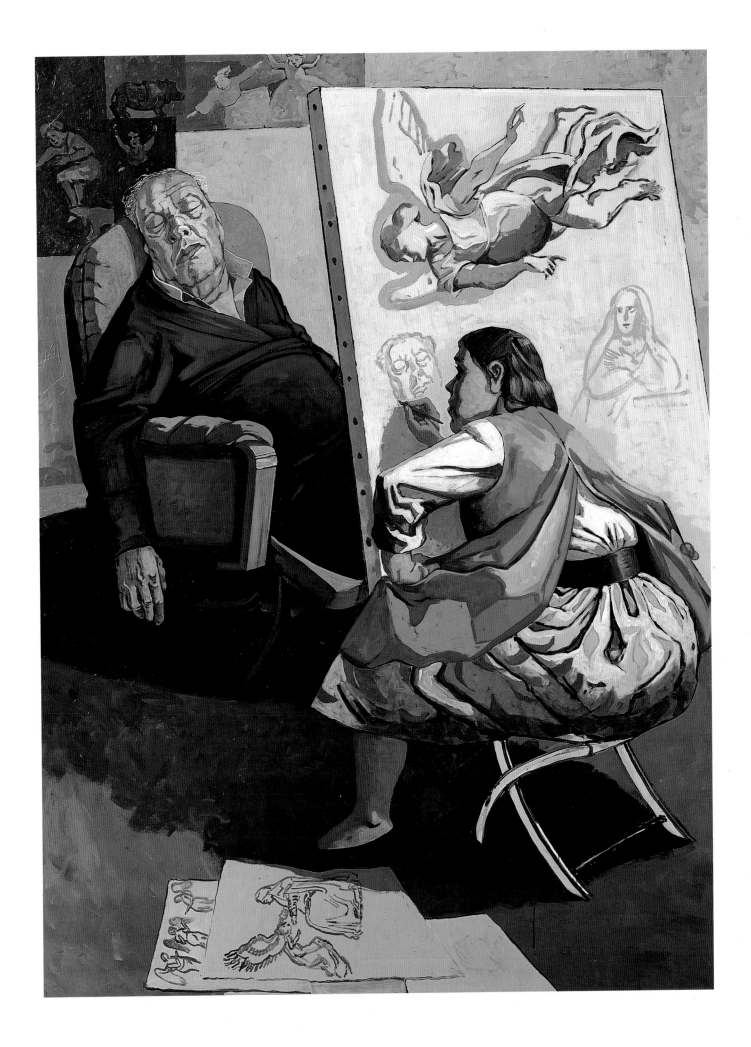

new life. Keith died in 1991, but not before he saw the finished picture. For Keith's friends *Time – Past and Present* will always be a fitting memorial to his own talents as a painter and writer.

At a late stage of painting *Time – Past and Present* Paula was still dissatisfied with the doorway, which gives onto a village street. One day she took a friend's advice and removed the pictorial clutter, opting instead for a far horizon. This served to complete the image as conclusively as the last jigsaw piece does in a puzzle. The perspective is gathered to a focal point; eye and imagination are released. The sailor's voyages are over, but the distant sea beckons for a new generation of adventurers.

The last picture in the sequence, *Joseph's Dream*, **189**, is the one most specifically indebted to the Collection, in that it shows a version of Philippe de Champaigne's *Vision of St Joseph*. The little girl making 'the secret drawing' in *Time – Past and Present* is now shown as an adult artist. She has grown into a hefty woman, very similar in bulk and shape to the rock-bottomed dress-maker in *The Fitting*, so much so, in fact, that one fears the precarious stool may collapse under her weight. She is shown painting a slumbering man, who models for the figure of Joseph in her, as yet only half-drawn, version of the de Champaigne painting. It is, therefore, not a picture within a picture, but a picture within a picture about the making of another picture based on a picture that is not in the picture! One could hardly ask for a more Borgesian puzzle. At the heart of this web of conceits lies Paula the artist herself, the painting neatly summarizing her own role as Associate Artist.

That Paula's talent has found fruition might be considered the celebratory sub-plot of *Joseph's Dream*. The obvious inference is that this is a self-portrait, by association if not in appearance, an interpretation supported by the fact that in *Time – Past and Present*, Luzia plays the part of the servant at the door; Paula is the little girl; and the curved frame of the picture recalls the line of the roof of the villa at Ericeira. *Time – Past and Present* also foreshadows *Crivelli's Garden*. The blue and white Portuguese tiles of the chimneypiece are of the same kind as those on which the colour-scheme of the mural is based; and the artist in the form of the little girl will reappear as the creative source of the entire design.

The classic 'Artist and Model' painting shows a man with a beautiful,

naked woman; but in *Joseph's Dream* Paula reverses this archetypal relationship with positively feminist relish:

> I wanted to do a girl drawing a man very much, because this role reversal is interesting . She's getting power from doing this you see. And then I went upstairs and I saw Philippe de Champaigne's picture, which I'd never seen before, and the two things fused in some peculiar manner. That picture is so solid, the angel is so solid, and Saint Joseph is so solid. It's wonderful.[41]

On the shelf in *Time – Past and Present* there stands a hippopotamus. And in one of the drawings behind the slumbering Joseph there is a comparable animal, a rhino – but one without a horn. In Africa today the conservationists deprive rhinos of their horns in order to make them valueless to poachers and therefore literally 'pointless' to kill. But in so doing they also render the rhino pointless. The sleeping man is equally deprived of his power. It is the artist, protected by her guardian angel, who has the upper hand.

# PETER PAN

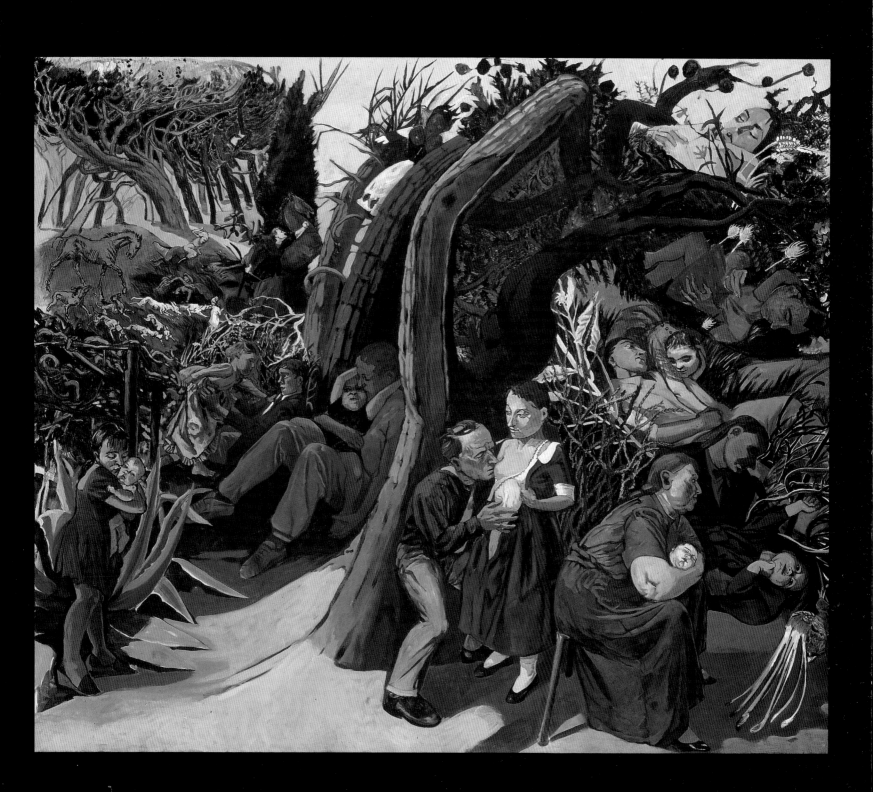

It was an inspired choice of the Folio Society to select Paula to illustrate a new edition of *Peter Pan*, published in 1992. The psychological complexities of J.M. Barrie's famous play, alternatively titled *The Boy Who Would Not Grow Up*, appealed to an artist adept at exposing the truth behind familiar stories.

*Peter Pan*, viewed psychologically, seethes with suggestions of the subconscious. For what do we mean by being 'grown-up'? And how many of us would want to be, even if we knew? Barrie himself recognized the darker sub-plot of the play. 'Long after writing P Pan its true meaning came to me – desperate attempt to grow up, but can't.'[42]

No one could have derived this insight from more bitter experience. For the first six years of his life Barrie lived in the shadow of his elder brother, David, the apple of their mother's eye. David died aged 13, and for the next 30 years Barrie consciously assumed his persona to shield his mother from the loss. So passionately did he identify with David that he even managed to stop growing at 13 and did not have to shave until his mid-20s. Nevertheless, reality could not be denied, and while his mother consoled herself with the thought that David, by dying young, remained a child forever, Barrie found lifelong inspiration in exploring 'the Never Land' between childhood and manhood. 'Perhaps Peter Pan was just a boy who died young,' Barrie wrote, 'and this is how the author conceived his subsequent adventures.'[43]

Never Land was reinforced by a childless marriage, which seems to have encouraged passionate friendships with children. Wendy, a name he invented, derived from the poet W.E. Henley's daughter calling him her 'fwendy'. The idea for the play was born of another friendship with a family he first met when walking his Nana-like dog in Kensington Gardens in London. It is to this family the play is dedicated: 'To Sylvia and Arthur Llewellyn Davies and their boys (my boys).'[44] The character of Peter formed, as Barrie wrote, 'by rubbing the five of you the Llewellyn Davies boys violently together, as savages with two sticks produce a flame'. It has often been said that Peter and Hook were subconsciously the two aspects of Barrie himself. 'All children grow up. That is their tragedy. Except Pan. That is his.'[45]

The bracketed afterthought in the dedication proved cruelly prophetic. The Llewellyn Davies parents died young, leaving Barrie as the legal

190   Previous page: *Caritas*, 1993–4. Acrylic on canvas, 200 x 240 cm.

191   *Captain Hook and the Lost Boy*, 1992. Colour etching and aquatint, 64 x 51 cm.

192 *Flying Children*, 1992.
Etching, 64 x 51 cm.

guardian of their sons. Tragedy continued. One son was killed in the First World War and Barrie's favourite, Michael, drowned when an undergraduate at Oxford, leaving Peter to survive into old age, ruing what he regarded as the curse imposed by 'that terrible masterpiece'.[46]

It is this murkier aspect of *Peter Pan* that Paula brings to light, making her the most disturbing of its many and distinguished illustrators. 'Mr Barrie is not that rare creature, a man of genius. He is something even more rare – a child who, by some divine grace, can express through an artistic medium the childishness that is in him,'[47] wrote Max Beerbohm. Paula, for all her late twentieth-century psychological sophistication, retains the same gift of innocence. She is particularly good at Captain Hook, in the words of the play 'that dark and fearful man'[48] who seems to embody the guiltiest of Barrie's secrets.

The most dramatic of the 15 coloured etchings is *The House under the Ground*, **194**, where Hook's gigantic, dramatically underlit face peers down on the unsuspecting and miniaturized children. The instruction in the play accompanying this incident is particularly revealing of Hook's complex character: 'In the aperture below, his face emerges and goes green as he glares at the sleeping child. Does no feeling of compassion disturb his sombre breast? The man is not wholly evil: he has a "Thesaurus" in his cabin, and is no mean performer on the flute. What really warps him is a presentiment that he is about to fail.'[49]

*The Never Land*, **193**, is another *tour de force,* with Hook as a spectre of Death, his face a skull sporting a plumed cavalier's hat, being dragged in a tumbril by his pirates rather than on the 'raft' of the original. He is silhouetted against the black outcrop of Marooners' rock, surrounded by Mermaids' Lagoon and its sinister traffic: 'Cruellest jewel in that dark setting is HOOK himself, cadaverous and blackavised, his hair dressed in long curls which look like black candles about to melt.'[50]

Hook is also portrayed as an ageing dandy holding Wendy's hand:

He is never more sinister than when he is most polite, and the elegance of his diction, the distinction of his demeanour, show him one of a different class from his crew, a solitary among uncultured companions. This courtliness impresses even his victims on the high seas, who note that he always says 'Sorry' when prodding them along the plank.[51]

193   *The Never Land*, 1992. Etching and aquatint, 57 x 72 cm.

194   (opposite) *The House under the Ground*, 1992. Etching and aquatint, 64 x 55 cm.

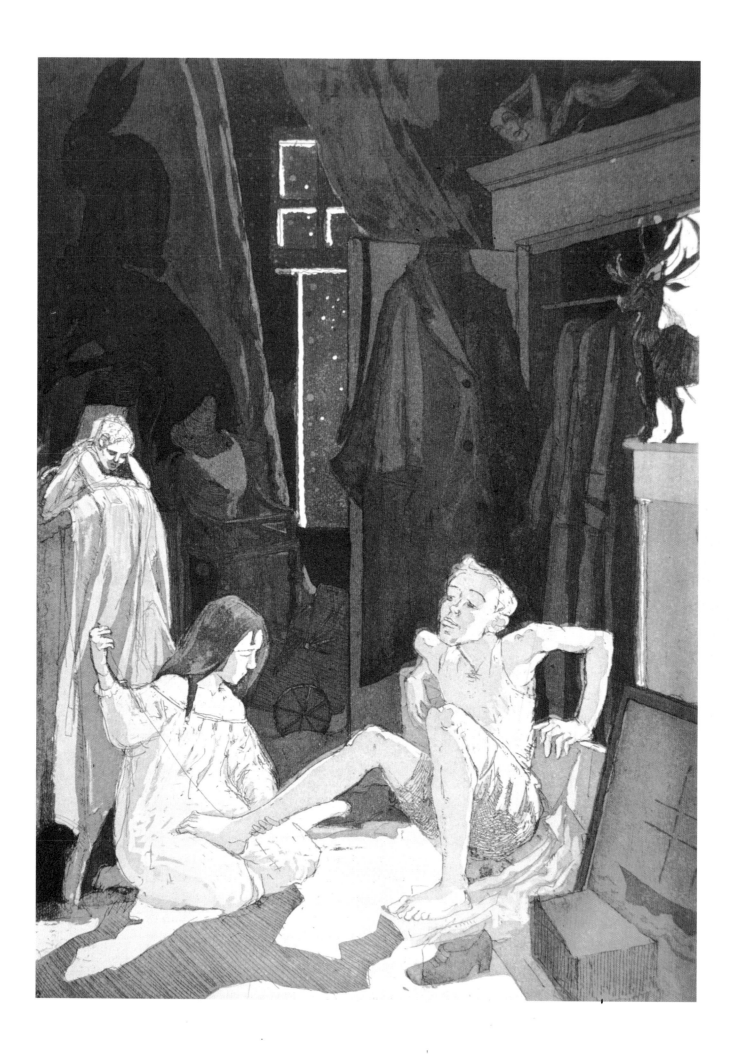

He might also be a potential paedophile as he sits, wigless, with Peter on his knee.

The sexuality of Peter and Wendy's relationship is Paula's other favoured subject. She gets Peter, modelled by David McEwen, to a T – not a sentimental sprite but a boy at that stage of dawning adolescence when football is still more important than sex. There is youthful arrogance in his languor, and joy in his physical power. Women are not his equal, yet all girls, most of all Wendy, are his mother. Poor Wendy, her calf-love for the innocently unaware Peter is the tenderest aspect of the play:

WENDY:*(knowing she ought not probe but driven to it by something within)*
What are your exact feelings for me, Peter?
PETER: *(in the classroom)* Those of a devoted son, Wendy.
WENDY: *(turning away)* I thought so.[52]

Is it the biological fate of women to be more grown-up than men?

Their relationship is touchingly described in *Wendy sewing on Peter's Shadow*, **195**. Wendy crouches subserviently at Peter's feet, tenderly holding his right leg by the ankle and letting his foot thrust suggestively against her thigh. Ostensibly sewing Peter's shadow to himself, her caressive pose suggests she feels she is sewing Peter to herself.

Many adults realize the relevance of Peter Pan's refusal to grow up. The androgynous pop star, Michael Jackson, at the height of his notorious career (when Paula was working on the illustrations), identifies so strongly with the character he even called his Hollywood mansion 'Neverland'.

Paula exposes the dire emotional conflicts at the heart of the 'terrible masterpiece' with her usual acuity and disdain of sentimentality. What Barrie would make of her interpretation one shudders to think, but Peter Llewellyn Davies would surely have approved.

Paula's work progresses by separate series, often arising from commissions. Completion usually leaves her casting about for a subject until the next feasible proposal locks her into a new cycle. The uneasy calm after the intensity of *Peter Pan* was not helped by the insecurity of having no fixed place to work. Having been forced to leave the button factory in Clerkenwell and after the year's residence at the National Gallery in London she took a short lease on a studio in Islington belonging to the sculptor Stephen Cox, a temporary and therefore unsettling solution.

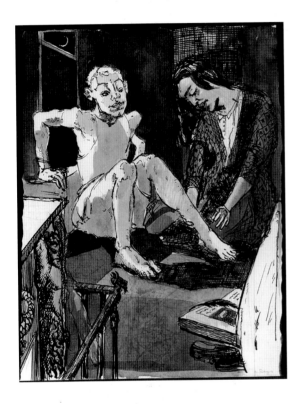

196 Study for *Wendy sewing on Peter's Shadow*, 1992. Watercolour and ink on paper, 28 x 22.8 cm.

195 (opposite) *Wendy sewing on Peter's Shadow*, 1992. Etching and aquatint, 64 x 51 cm.

Natalie Dower, a friend from Slade days, suggested she read Thomas Hardy's *The Return of the Native*. Paula was captivated by the book. She toured the Dorset countryside for inspiration but only found a landscape worthy of the desolation and majesty she was looking for when she stayed with a friend in Yorkshire. A large painting in watercolour and ink on paper, *The Return of the Native*, **198**, was the result, a romantic evocation full of wild undergrowth and long views. 'Like a scroll', it was 2.5 metres tall, differing from previous drawings by being vertical rather than horizontal in format.

Late summer as usual was spent in Portugal, where during August and September of 1992 she took advantage of the offer by the town council of Cascais to work in a 'studio', actually the kitchen in what had been a care-taker's cottage, in the town's public Carmona Park. The surroundings, famil-iar to her since childhood, fed the interest in landscape encouraged by reading Hardy.

The park was full of peacocks, cactuses and wind-twisted pine trees. The peacocks, symbols of bad luck with their mournful cries and tails of evil eyes, were like a troop of lost souls; a lugubrious contrast to the crowd of holiday-makers on the beach beyond. The locals dumped their litter in the park, an insalubrious feature also at odds with its idyllic purpose and the healthy outdoor activities of the swimmers and sunbathers. A series in ink and watercolour on paper about a ferry girl, **197**, is redolent of these sur-roundings: the alley cats, garbage, scavenging pigs and tribe of peacocks, trailing tails which are no longer sumptuous trains but rattling sheafs of featherless quills. Paula's cousin Manuela, portrayed behind the invalid man in *The Family*, **166**, is depicted as the girl. These works on paper were shown in the exhibition 'Peter Pan & Other Stories' at Marlborough Fine Art, London, in the winter of 1992–3.

In *Caritas* (charity), **190**, a barren Portuguese scrubland is peopled with fecund images of love, not least in the persons of Paula's children and growing family of grandchildren. An older man is suckling at the breast of a young woman in a traditional symbol of charity – mother's milk is here seen as an elixir of youth fed to wealthy old men as a panacea. The message is one of redemption. Also entirely Portuguese in feeling is *The First Mass in Brazil*, **199**, based on the interior of Luzia's cottage at Ericeira. The title is taken from the picture behind the girl, celebrating the Portuguese

197   *The Ferry Girl V*, 1992.
Watercolour and ink on paper, 77 x 51.5 cm.

198   (opposite) *The Return of the Native*, 1993.
Watercolour and ink on paper, 253 x 148 cm.

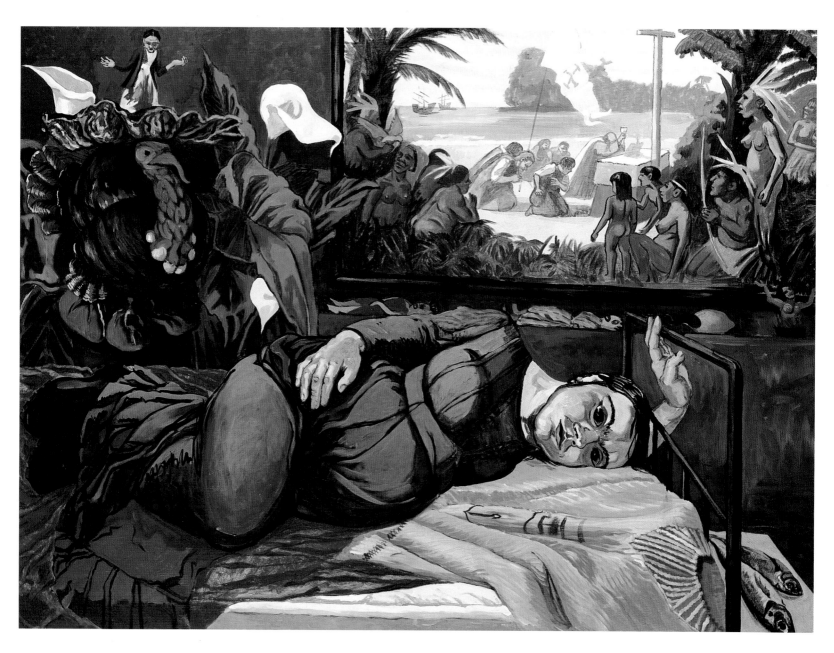

199  *The First Mass in Brazil*, 1993. Acrylic on paper laid on canvas, 130 x 180 cm.

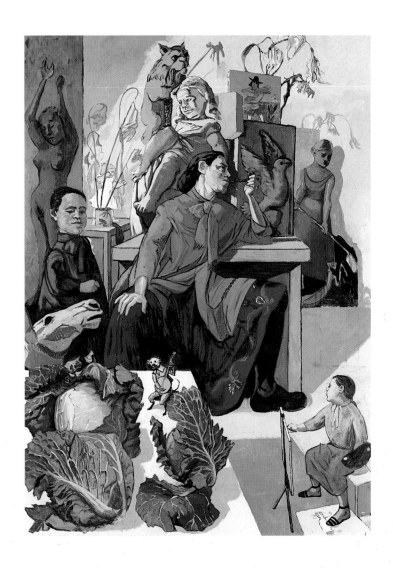

200  *The Artist in her Studio*, 1993. Acrylic on paper laid on canvas, 180 x 130 cm. Leeds City Art Gallery.

colonization of Brazil. The girl ponders her unwanted pregnancy and a tiny figure of Luzia can be seen above the china turkey-cock, her apron blood-stained from some farmyard foray. Country life has no time for squeamish-ness. The calla lilies signify death, the priest in the picture raises the chalice for the consecration, the holiest moment in the holy sacrifice of the Mass. This is a picture about sacrifice.

*The Artist in her Studio*, **200**, third of the large acrylic paintings done in the latter part of 1993, has links with *Time – Past and Present*, **187**, and *Joseph's Dream*, **189**. Here the artist smokes a pipe in emulation of that Victorian symbol of female independence, George Sand, and dreams, while her pupil (the diminutive size suggests she may be part of the dream – her younger self) confronts a still-life arrangement of cabbages. The cabbages were the most demanding aspect of the painting, as they had to be completed in three sessions before the leaves began to wilt. Cabbages are also prominent in *Still Life* (1994), featuring an oven-ready chicken but comically suggestive of an old bird well and truly stuffed in more than one sense. *Still Life*, *The Servant* (1994), her first large work in pastel, *Caritas*, **190**, *The First Mass in Brazil*, **199**, and *The Artist in her Studio*, **200**, lent weight to 'Unbound', an international survey of new trends in painting, mostly by artists under 40, commissioned by the South Bank Centre and shown at the Hayward Gallery, London, in spring 1994.

# DOG WOMEN

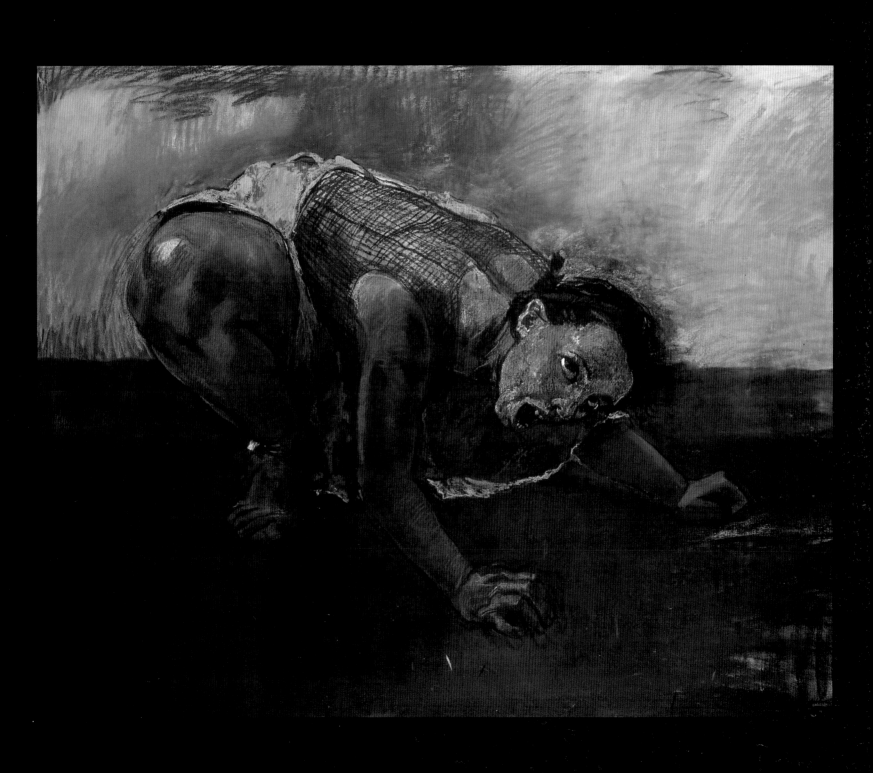

When Paula visited Chicago in 1993 she read a short story by Joyce Carol Oates called 'Haunted'. The story is about the friendship of two feckless teenage girls who play truant from school. One eventually gets a boyfriend which makes the other jealous so the girls drift apart. The jealous one discovers a deserted barn in the fields and while she is exploring it an old woman appears and gives her a savage beating. The old woman is a ghost. She vanishes, having sworn the girl to secrecy. Time passes and one day the other girl is found dead in the barn. Her boyfriend is arrested but no incriminating evidence can be found.

This tale of moody adolescence, heavy with sexual symbolism, is the subject of *The Barn*, **231**, a large painting which took six months to finish, an exceptionally long time for her. Dominated by a Friesian cow and full of magical goings-on, it shows the girl being beaten by two voodoo girls rather than the old woman in the story.

The derivation of the girls reaffirmed another old connection. They came from a picture of a doll by L.S. Lowry, whom Paula had always admired since his kindness to her as a visiting artist at the Slade. 'He was great. "I couldn't do that," he would say admiringly. He even wanted to buy one of my pictures but somehow nothing came of it.' The doll, which was sinister enough to have been an inflatable, had a bow, exposed breasts and a tiny waist. It struck her as so odd she did a drawing of it, initially incorporating it as a prop in a painting on the shelf behind the bed in *The First Mass in Brazil*, **199**.

After *The Barn* came *Dog Woman*, **201**. There is a connection, in that she toyed with the idea of placing a dog woman in the foreground of *The Barn*. As things transpired, this never happened. The familiar syndrome of complexity and catharsis is repeated. After the struggle with the larger painting, the ferocious *Dog Woman*, stripped of all detail and drawn in pastel, marks a fresh start – a renewal of spontaneous action.

*Dog Woman* originated in a rough, five-minute sketch of Lila done during the painting of *The Artist in her Studio*, **200**. The idea was triggered by a fairy story written for her by a Portuguese friend, who had heard it from her maid. The story, ferociously rustic in Portuguese style, is of an old lady who lives alone with her pets. The wind down the chimney assumes the voice of a wailing child, encouraging her to eat them, one by one. She duly performs

201   Previous page: *Dog Woman*, 1994. Pastel on canvas, 120 x 160 cm.

202   (opposite) *Baying*, 1994. Pastel on canvas, 100 x 176 cm.

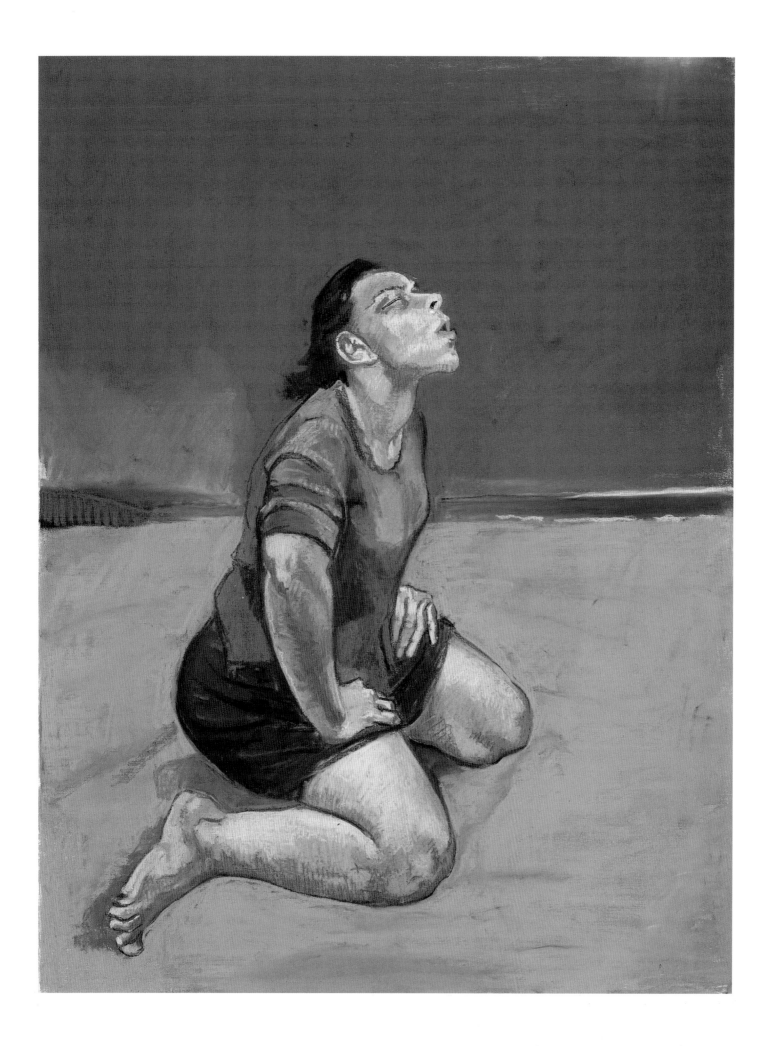

this grisly task. Paula asked Lila 'to crouch down and be a woman with her mouth open as if she's about to swallow something'.

For a while the result could have been described as a 'stray dog' of a drawing; but as soon as she readdressed it she realized it demanded its own space. Remembering a saying of the painter Walter Sickert's that by squaring up a sketch something of the original gets into the finished picture, she did the same for the first and only time in her life:

> And it's true what Sickert says, something of the spirit of the original does survive, don't ask me why. Sketches always have more vitality than paintings because you're finding things out through doing them, learning by your mistakes; whereas the whole point of a finished picture is that there is no uncertainty. To remind myself of the spirit of the original sketch I recreated Lila's pose in front of a mirror, squatting down and snarling, one foreshortened knee swelling out. I think the physicality of the picture came from my turning myself into an animal in this way; but I had to have a face, so I asked Lila to be the model.

203  *Grooming*, 1994. Pastel on canvas, 76 x 100 cm.

204  *Waiting for Food*, 1994.
Pastel on canvas, 120 x 160 cm.

She drew directly in pastel onto paper, backed with canvas and laminated onto a sheet of aluminium to give light but solid support. This was the first time she had attempted a finished picture by this spontaneous method, a significant leap in confidence, though not her first large-scale pastel, which was *The Servant* (1994), a costume drama of a butler comforting a vomiting maid, first shown in the 'Unbound' exhibition at the Hayward Gallery, London. Perhaps influentially *The Servant* was a violent subject but with *Dog Woman* she experienced an inner, animal force while she drew. It was like a fabulous and totally unexpected present. 'When the *Dog Woman* appeared it was a great day in my life, I can tell you,' she said.

The spontaneity of the method suited both the excitement of the moment and the ferocity of the subject. Once again she had arrived at the source of her inspiration, in touch with the unawareness 'of being a kid again' through drawing:

205 *Bad Dog*, 1994. Pastel on canvas, 120 x 160 cm.

With pastel you don't have the brush between you and the surface. Your hand is making the picture. It's almost like being a sculptor. You are actually making the person. It's very tactile. And lovely because it's very difficult, learning what colours to use together to make shadows and so on; and there's a lot of physical strength involved because it's overworked, masses and masses of layers changed all the time. It takes a lot of strength. But it's wonderful to do, to rub your hand over. It's so nice to use grey. You get these wonderful warm greys with pastel.

At the end of the day's work she looked like a coalminer, teeth and eyes the only visible features in her black face smudged by hours of pensive fingering. This delight in matter, of getting back to finger painting, also had a childlike freedom as her happy and mischievous smile would indicate.

*The Servant* has a remote connection with *Salazar vomiting the Homeland*, **56**; and the violent *Dog Woman* soon developed into a series on the relationship of dog and master, translated into human terms and, for her, with increasing pitilessness, into those of her own past. It is this intimacy which gives the pictures their universality, perhaps everyone is somebody's dog. In the anonymous words of the inscription on the collar of King Charles II's favourite spaniel:

I am his master's dog at Kew,
Pray, tell me sir, whose dog are you?

The *Dog Women* can be differentiated by their models. Lila Nunes, who sat for most of the pictures, drifts between a stray dog and a guard dog. She denotes wildness and ferocious protectiveness. Apart from *Dog Woman*, **201**, she modelled *Waiting for Food*, **204**, *Grooming*, **203**, *Baying*, **202**, *Sleeper*, **207**, *Scavengers*, **206**, *Bad Dog*, **205**, *Sit*, **212**, and *Watcher*. Victoria Willing played the part of the more domestic *Moth*, **208**, and *Bride*, **209**. And Flaminia Cinque, like Victoria a professional actress, is the prone *Lush*, **210**.

In *Scavengers* one figure is the shadow, the dark side, of the other. Its mood corresponds with those other shore dogs in *Waiting for Food* and *Baying*, where the dog woman howls for her daemon lover to the distant and nocturnal thunder of the sea. Stray dogs are not usual in England, the English often preferring animals to humans, but in Portugal there is no such emotional confusion. Dogs are inferior beings. Stray dogs are common and often well fed, even if they have three legs. Paula's *Dog Women* by the sea have the same restless character as these strays. Their shore-dog ances-

tors feature in one of the London National Gallery's most popular and intriguing pictures, Piero di Cosimo's *A Mythological Subject*. *Bad Dog*, **205**, a woman being kicked out of bed by a man, whose presence is implied but not described – as in so many of these pictures – places this ferocity in a domestic situation. Paula wanted the figure to be particularly animal in its powerful physicality:

206 *Scavengers*, 1994. Pastel on canvas, 120 x 160 cm.

To be a dog woman is not necessarily to be downtrodden; that has very little to do with it. In these pictures every woman's a dog woman, not downtrodden but powerful. To be bestial is good. It's physical. Eating, snarling, all activities to do with sensation are positive. To picture a woman as a dog is utterly believable. It emphasizes this physical side of her being. What is important is that the dog is the animal most like a human. A dog learns people's ways and behaves like a person; just as people do. Women learn from those they are with; they are trained to do certain things, but they are also part animal. They have independence of body, independence of spirit and their tastes can be quite gross.

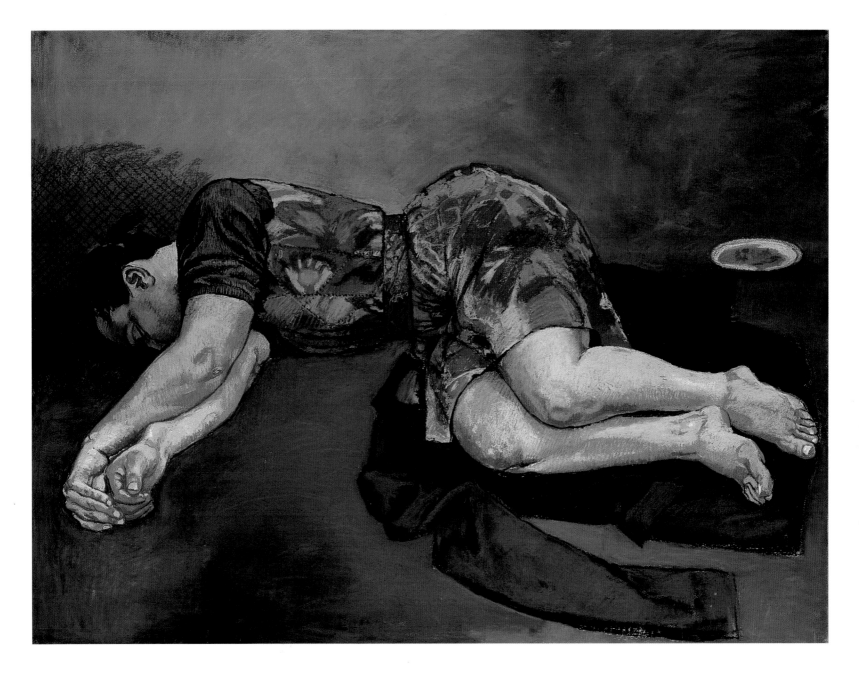

207 *Sleeper*, 1994. Pastel on canvas, 120 x 160 cm.

It is this animalism, as much as the vigorous use of pastel, which places this haptic work in the tradition of Edgar Degas, who used pastel, wax and even finger-painted in oils the better to get to grips with the physicality of his naked female subjects: 'I show them without their coquetry, in the state of animals cleaning themselves.'[53] Paula applauded this technique when interviewed about Degas' late work: 'He wanted to be a feminine animal sometimes. And there it is. It's honourable to women that he did them that way.'[54] She paints the *Dog Women* in the same spirit. ' I was going to clothe the back of *Bad Dog* but my mother said it was nice having it bare, and she was right. Not a totally nude figure – that would have been embarrassing; you have a nude and it becomes eternal or something.'

Animalism is emphasized in other ways, particularly by the foreshortening of legs and the swelling of knees and thighs, a device also used by the Scottish painter Jenny Saville in her exaggerated foreshortenings of the female nude in the early 1990s.[55] It is similar to the emphasis on flesh in

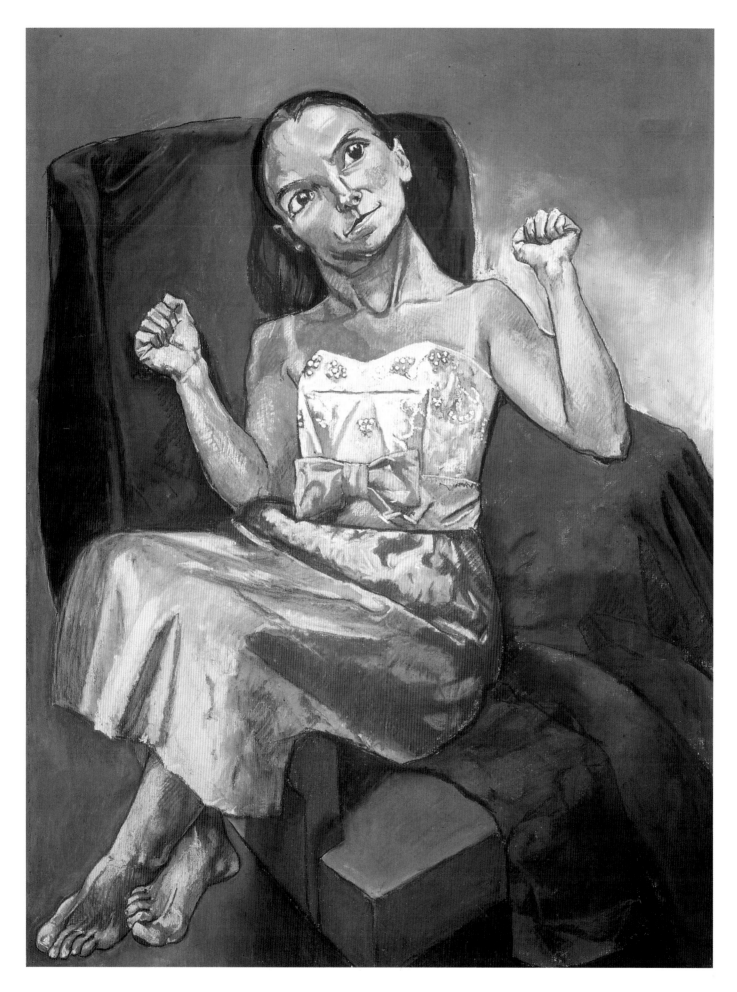

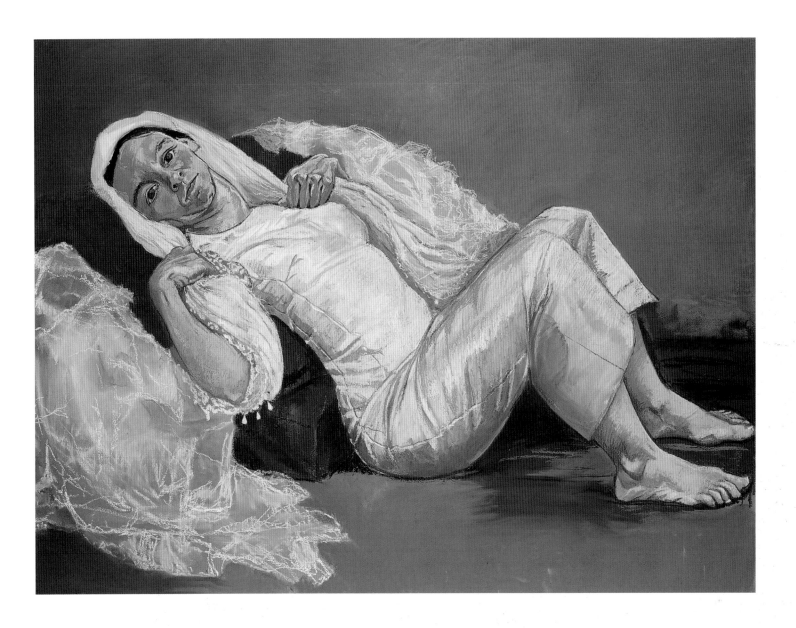

209  *Bride*, 1994. Pastel on canvas, 120 x 160 cm.
Tate Gallery, London.

Lucian Freud's later paintings, in which weight and muscularity are exposed by positions of animal freedom like in the late work of Degas. As Robert Flynn Johnson has written: 'Freud is clearly interested in the unusual emotional dynamics of bringing man and animal together in works of art in such a way that the two are infused with equal amounts of character and individuality.'[56] Some of Freud's best paintings have contained animals. He has even painted a man with a rat, and in his youth he abandoned art classes at Dartington Hall in order to ride. Paula particularly admires his paintings of whippets, and dog analogies with her work are singularly appropriate.

It was through painting the *Dog Women* that personal associations surfaced. In *Watcher* the tricycle is specifically one that belonged to her children and the location is the terrace at Ericeira. Early in the series she made a general acknowledgement of this autobiographical element by painting the entirely personal *Kennel*, **213**, a 'wink' of acknowledgement to Vic. It is not just the home of the dog but is done after a kennel made by her grandfather and later used by Vic's dog Bruno. Vic had an unfulfilled ambition to exhibit shelters or *aediculae*, places of contemplative retreat. *Kennel* mischievously trumps his

208  (opposite) *Moth*, 1994. Pastel on canvas, 160 x 120 cm.

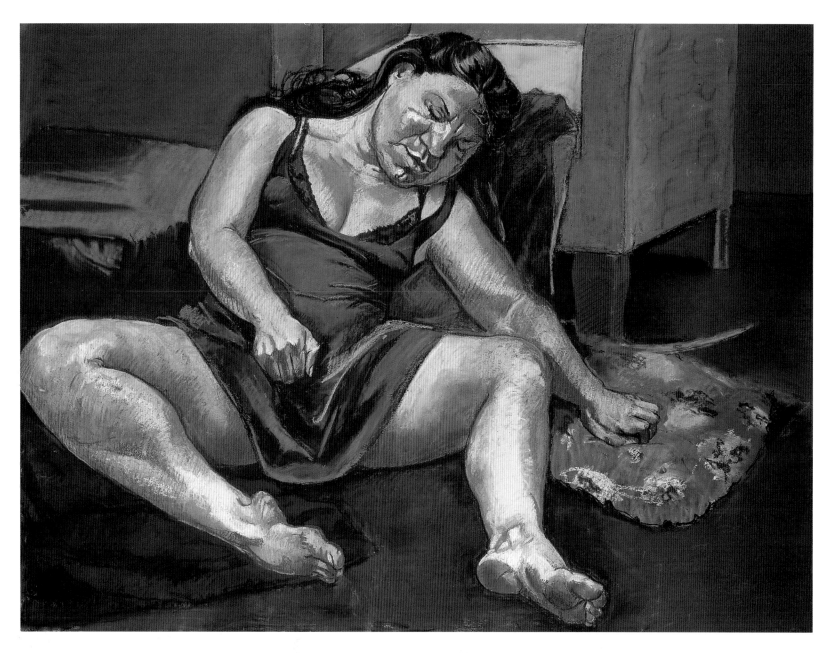

210  *Lush*, 1994. Pastel on canvas, 120 x 160 cm.

211  (opposite) *Target*, 1995. Pastel on canvas, 160 x 120 cm.

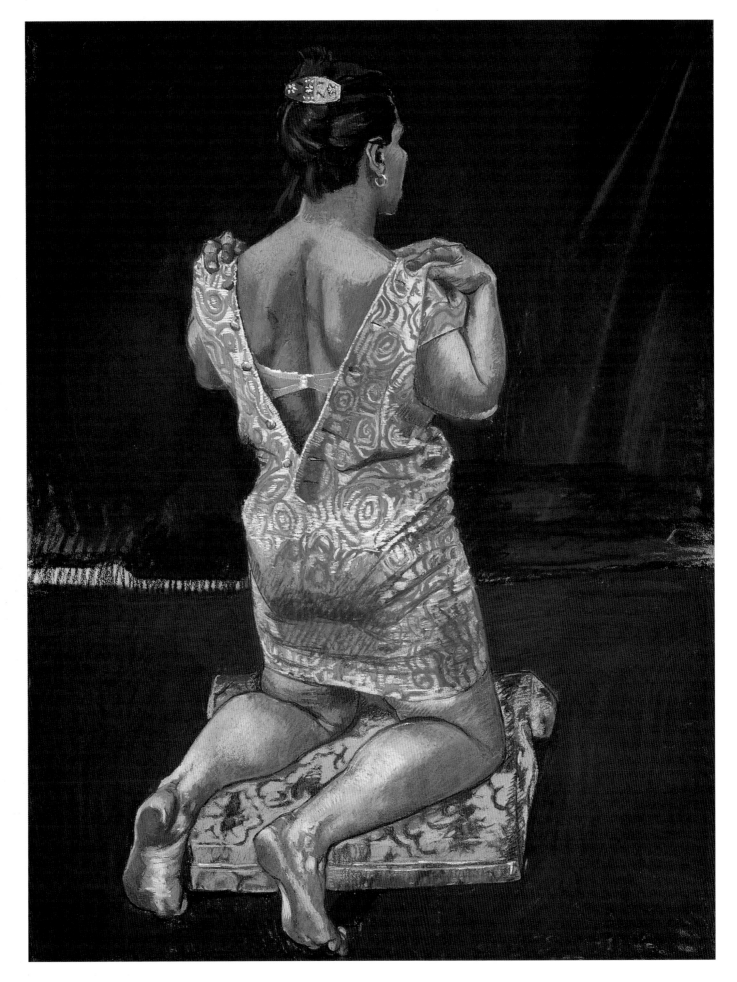

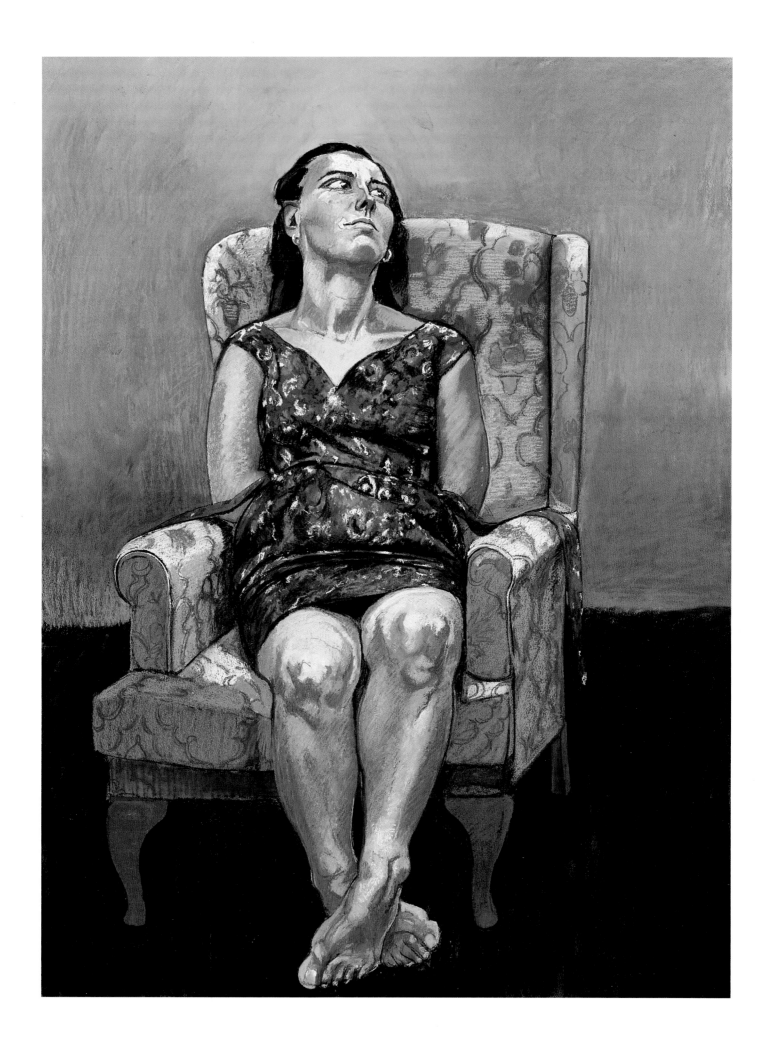

213 *Kennel*, 1994. Pastel on canvas, 160 x 120 cm.

212 (opposite) *Sit*, 1994. Pastel on canvas, 160 x 120 cm.

ambition but it is also a symbol of mysterious power – a talisman. She insisted on having it in the exhibition at Marlborough Fine Art in London in 1994.

The *Dog Women* were succeeded by pictures of women in more explicit social situations. *Sleeper*, **207**, can be seen as transitional – a dog woman sleeping, as dogs do, on her dead master's coat; but also a devoted wife using her husband's jacket as a comfort blanket.

*Moth*, **208**, was inspired by the poem of the same name by Blake Morrison,[57] 'which opened up a whole can of worms' to do with marriage. It shows a young girl in a formal, satin, 1950s party dress, in fact one belonging to Paula's mother, with her head cocked and her arms bent like paws in a pose of flirtatious and obedient dogginess:

> Like a little yelping Pekingese. She's an upper-class girl, well trained but vulnerable. She can't cope. He's coming towards her, maybe to rape her, but she's not concentrating on his advances. Maybe she's thinking of the next party, the next lighted candle. But she's on her own. It's about a marriage breaking up.

*Bride*, **209**, her second major work to be bought by the Tate Gallery in London, shows a similarly victimized girl, perhaps the same one, on her wedding day. She lies exhausted after the event, shoes off and with a look not of triumph or exhilaration, but resignation. Her naked feet, arms and neck are in crude contrast to the shimmering satin and lace of her dress; the bunched and divided veil forms wings at either shoulder, turning her into a fallen angel, which perhaps she is, or is about to become. The sense of the body breaking free of restriction, like a moth or butterfly from its pupa, also links it to *Moth*, and Morrison's poem.

*Sit*, **212**, completes the trio. A less helpless, more determined looking character, her crossed feet are a deliberate reference on Paula's part to a crucifixion. 'Lila said to me, "When you've done the feet crossed you'll know what the subject is", and she was right.' The woman originally had a baby strapped across her lap but without it the tension and ambiguity are greater. She is pregnant, her arms 'tied' in more ways than one.

What Paula describes as the 'girdle women', women in the intimate and sometimes humiliating position of taking off or putting on underwear, finish this increasingly harrowing series. The titles – *Target*, **211**, and *Compromised* – are fiercely to the point. Their mood was later resurrected in the pastels she made of Walt Disney's *Snow White*.

# THE OSTRICHES

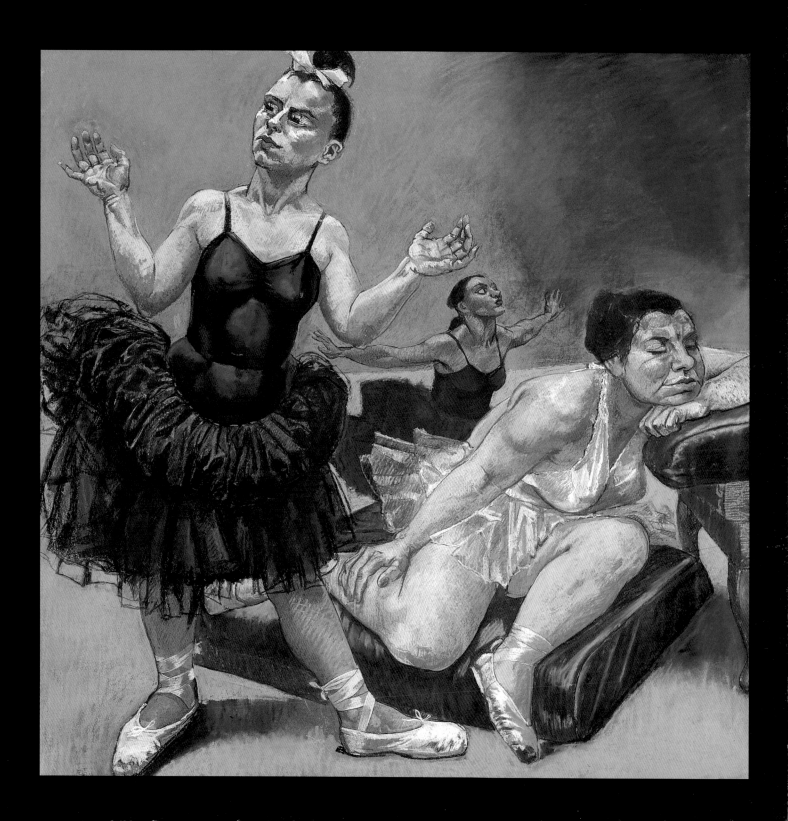

The 'Spellbound' exhibition at the Hayward Gallery in London in the spring of 1996 marked the centenary of the cinema in Britain by asking a selection of ten artists and film-makers to make new work displaying relationships between art and cinema. When Paula was invited she accepted with enthusiasm. Born in 1935, she was a child in the years when cinema, and particularly Hollywood, was at the zenith of its popularity; and she was as spellbound as anyone. In fact it has proved her most formative pictorial influence as an artist.

Her father had the first private cinema in Portugal – a source of singular wonderment – but an even greater treat was to go on an expedition to the local cinema with her grandmother and young nurse, Luzia. They would make a day of it, taking a box (as at the theatre) and bringing a picnic. In these blissful circumstances she saw her first Walt Disney film, *Snow White and the Seven Dwarfs*, an experience she describes as 'the discovery of a new world', followed by other Disney classics, notably *Pinocchio* and *Fantasia*. She found them awesomely real, often terrifying; a modern counterpart to her delight in the old fairy tales told to her by her aunt and others. Her mother remembers Disney books and comics supplementing her enthusiasm – a more constant and practical influence on her drawing than the films. To this day she acknowledges Disney as her ultimate artistic influence and regards him as the greatest pictorial genius of the twentieth century.

The idea of making some paintings on the subject of film immediately appealed to her when first suggested by Philip Dodd, editor of the British Film Institute's magazine *Sight and Sound* and a selector for 'Spellbound'. Dodd gave her a book of grotesques as a stimulant, and she took Lila Nunes to see some films for ideas – old childhood favourites from the war years. Her first notion was to do a picture about Carmen Miranda, the Brazilian actress famous for wearing headdresses of piles of fruit. But, having mistakenly sat through *Flying Down to Rio*, in which Miranda does not appear, some books on Disney drew her attention to *Fantasia* and in particular the 'Dance of the Ostriches'. In *Fantasia* Walt Disney set his animators the ultimate task of pictorially interpreting masterpieces of classical music. For 'Dance of the Hours', a ballet from the opera *La Gioconda* (*The Smiling One*) by Amilcare Ponchielli, first performed in 1876, they visualized the opening or 'Morning' scene as a herd of ostriches slowly waking and stirring them-

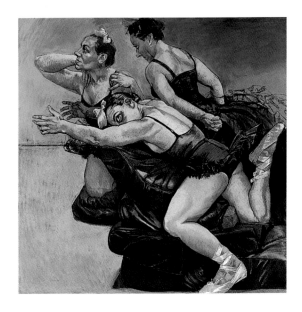

214  Previous page:
*Dancing Ostriches from Disney's 'Fantasia'*, 1995.
Pastel on paper mounted on aluminium, 150 x 150 cm.
Saatchi Collection, London.

215  (above) *Dancing Ostriches from Disney's 'Fantasia'*, 1995.
Pastel on paper mounted on aluminium, 150 x 150 cm.
Saatchi Collection, London.

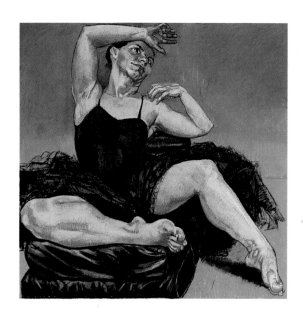

216  *Dancing Ostriches from Disney's 'Fantasia'*, 1995.
Pastel on paper mounted on aluminium, 150 x 150 cm.
Saatchi Collection, London.

selves to dance. This was not far from the truth, since ostriches are the most exotic and wildest dancers in the animal kingdom; but not to order. The Disney animators used women as models. After a hilarious morning selecting clothes at a specialist shop for ballet dancers, where the shopkeeper was puzzled by their ignorance of dress and shoe sizes, Rego and Nunes returned to the studio. 'This chair is always in the middle of the studio and I just sat on it and Paula asked me to put my arms up and she did a drawing', recalls Lila. From there, in Paula's words, 'the work took on a life of its own.'

*The Ostriches* became so engrossing Paula soon discarded preliminary studies to draw Lila directly. Awkward positions of neck, arms or legs were supported by cushions – props sometimes included in the picture. Lila is assimilated rather than portrayed. Sometimes her head is replaced by another; and one or two different characters creep in, particularly in the backgrounds. The ostrich women are made stockier, emphasizing their ludicrous attempts to defy age and gravity to 'fly'.

Paula purposely did not look at the film but relied on her memory and an occasional glance at John Cluhane's illustrated history of *Fantasia*; but her methods were surprisingly close to the original. Cluhane writes that in the first stages of animation, sketches were made of ballet dancers who were brought to the studio to perform positions and movements, 'the equivalent of a model's holding poses for an artist who draws still pictures'. The models were turned into birds, sometimes quite literally. As those present recalled there was 'a very tall, very ostrich-like girl, and she loved doing the burlesque of the ostrich for us … We put a few feathers on her costume where ostrich feathers should appear, and a bow on her head, and she performed the routines to perfection.' Rego reverses this process, turning the birds back into people.[58]

The commission was undertaken within a year of the exhibition, a very short time, but helped by the instinctive understanding between artist and model, which in this instance was even more improvisational than for the *Dog Women*. 'Lila has been living with my mother's fantasies for so many years that she can now add a little extra to them,' says Nicholas Willing, an award-winning animator and film director. 'Lila and she are very alike in their Portugueseness. It is a question of humour, a certain toughness and

blunt lack of sentimentality.' Using Lila for all the ostrich women turns the eight pictures into eight frames of one animated figure. To that extent the pictures tally with the film sequence, where the ostriches slowly wake and begin to dance. That is why the series only truly makes sense as one work – one woman displaying a range of emotions and positions but so transmogrified in the drawing that only those who know Lila well would recognize her. When Charles Saatchi purchased the series as one work for the Saatchi Collection it was a splendid piece of patronage, ensuring not only that the pictures would remain in their country of origin but together, as hoped, though not expected.

Nicholas Willing's first reaction was to burst out laughing: 'I thought they were the funniest things I'd ever seen. I laughed for a very long time and she laughed too – it was surprise and recognition all at once.' What he recognized was that world of make-believe, so often inspired by films, of the film fan wanting not just to act Snow White or James Bond, but to be them. The ostrich women are trying – repeatedly, exhaustingly – to be what they can never be. Even when they are together they act in isolation, doing their own thing. Some stalk in the distance, others flop or close their eyes and dream their dreams, waiting their turn.

217 Paula at work on *The Ostriches* in her studio. Photographer: John Haynes.

There is caustic, bucolic, peasant, even black humour in this; a fine line between comedy and tragedy. 'Ballet, of course, is an abstraction, in the way of movement, of story telling,' Cluhane quotes T. Hee, director of the 'Dance of the Hours' sequence. 'Chaplin often said that he walked a tightrope with comedy on one side and tragedy on the other; if he tipped to one side, it would be tragedy; if he tipped to the other side, it would be comedy'.[59] For Paula, the figures are grotesque, a word she is careful to distinguish from caricature. Caricature is mockery; grotesque, derived from grotto, describes the dark, secret, vulnerable side of the human character. But *The Ostriches* are also courageous. Like a middle-aged aerobics class they strive heroically against increasing odds. 'They are old fighters', which is why one falls not like the dying swan in the ballet but like the sculpture of the Gallic warrior in Rome; and why others form the heraldic prow of a ship, battling through the waves.

Part of their heroism and force is the way in which they admit to feelings. Lila says:

218 Paula at work on *The Ostriches* in her studio.
Photographer: John Haynes.

*The Ostriches* are founded in very deep feeling. They are the result of going through a lot of feelings and getting to the essence of them. I have these feelings but I'm younger and they're mixed up. Paula concentrates many feelings. It's all very connected. Maybe most people don't acknowledge certain feelings, maybe that's why they can become more difficult as they get older. Feelings almost too dark to speak of. I think women accept their feelings more than men. They're more open about them, they talk more about them with each other. A man will say: 'Everything's fine' when it isn't.

This may explain why the adverse criticism of Rego's pictures has come exclusively from men.[60]

'One thing's for sure', says Paula, '*The Ostriches* couldn't have been done if I hadn't been the age I am. A younger woman wouldn't know what it was like; longing for things that are not gone, because they're inside one, but that are inaccessible.'

For Paula there is something 'very ancient' about the ostrich women: 'very ancient in the storytelling sense. Like some Greek tragedies, it happened many centuries ago and still goes on. As animals they've been born knowing what to do, but they also have an animal's innocence.'

They are Harpies, Homer's personified storm winds who carry the unprepared into oblivion. In the *Dog Women* series there is always a story, a male presence implied though never seen. But with *The Ostriches* there is no story, no man (or child) present or implied. The ostrich women may tempt or pursue men, but these are pictures of states of mind rather than narration; the most 'abstract', in the imaginative sense, of her career so far. 'I don't think there's much happiness in these pictures', comments Lila who, being Portuguese, nevertheless understands their ferocity. 'Some of them would eat you up. They even go out looking. The sleeping one is the safest.' Even the light in them seems Portuguese, a storm light fit for Harpies, though they were drawn in her new Camden Town studio in London.

Ideally, the two drawings crowded with figures should be hung to make a doorway – a prelude to the rest. They can be interpreted equally as a chorus of ostrich women or one on her own displaying a range of postures and emotions. The left side of the diptych, **219**, describes spontaneous movement, with each figure using her dress as a drop, like improvising actors. One hides her head in shame, another holds her dress out like a net,

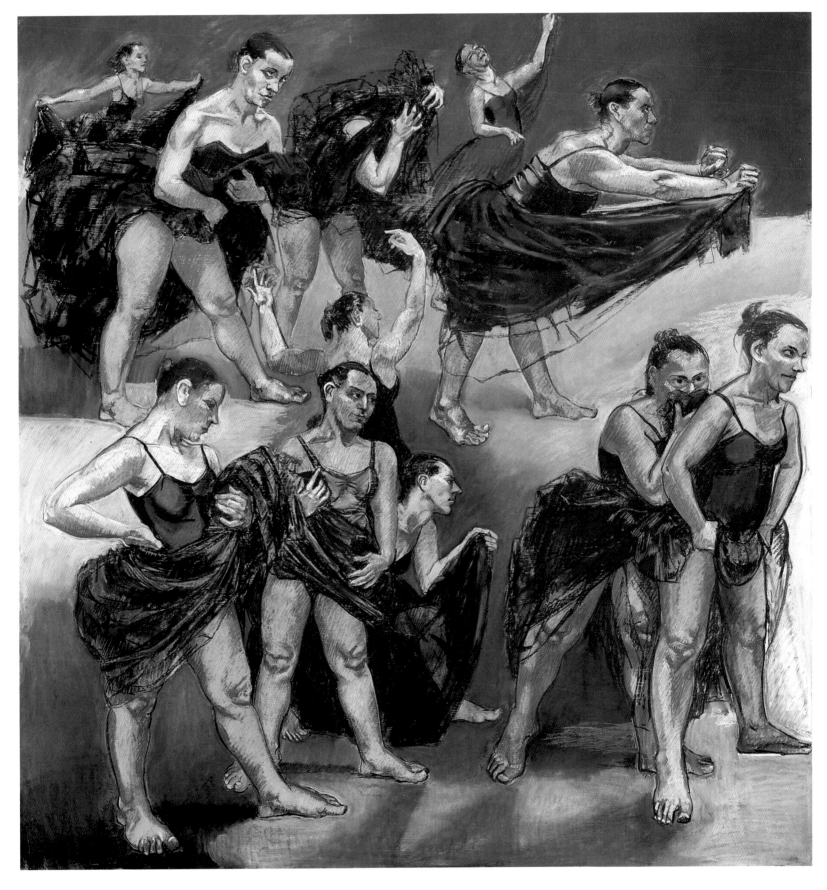

219 *Dancing Ostriches from Disney's 'Fantasia'*, 1995. Pastel on paper mounted on aluminium, 162 x 155 cm. Saatchi Collection, London.

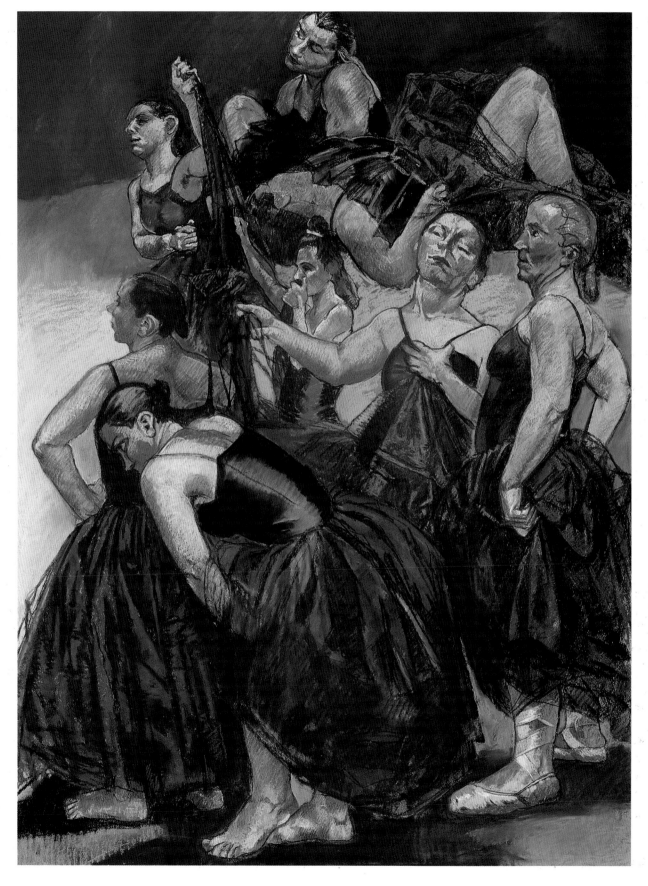

220  *Dancing Ostriches from Disney's 'Fantasia'*, 1995. Pastel on paper mounted on aluminium, 160 x 120 cm. Saatchi Collection, London.

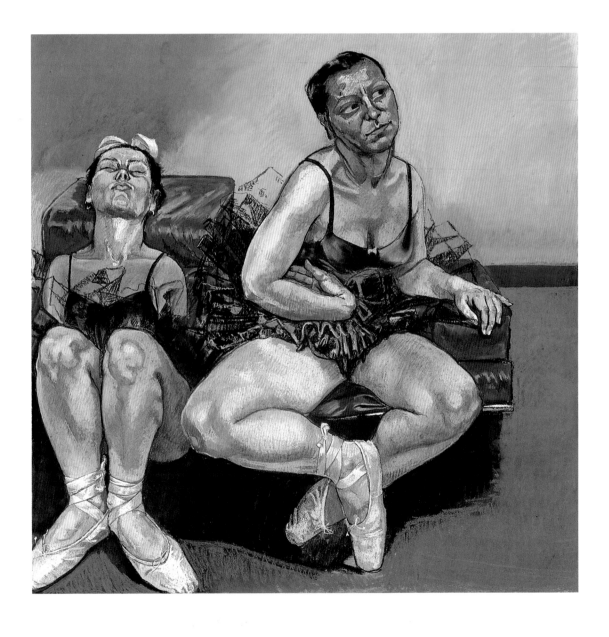

221  *Dancing Ostriches from Disney's 'Fantasia'*, 1995. Triptych, pastel on paper mounted on aluminium, each panel 150 x 150 cm. Saatchi Collection, London.

several cradle the folds into bouquets or babies, perhaps even a dead baby in one guilty case. In the corner a vulgar duo do not seem to act at all. One leans on her thighs while to her rear the other rudely uses her dress as a handkerchief, to hold or blow her nose.

In the second drawing, **220**, the mood is more subdued, with even a hint of nemesis or death, the rustling flock becalmed in various attitudes of exhausted anticipation. 'Is our time up?' asks one, through the wistful inclination of her head. 'Of course it is!' says her prostrate form. A manly figure on the right stands defiantly, a toreador about to face the bull – a contrast to the gesticulating lady, determined to go down in style, or the figure closest to the light source waiting in the wings, reminiscent of a Degas dancer.

'Duende' is a Spanish term which has no exact English equivalent. To say someone or something has 'duende' remains Paula's ultimate compliment. Can middle-aged women do ballet? A person who has 'duende' will do anything at any age, so a woman with 'duende' can dance anything at any time. Do the ostrich women have 'duende'? 'They have,' Paula says, grudgingly, 'now and again'. But *The Ostriches*, that is surely a masterpiece of 'duende'.

To broaden her coverage of Disney for the sake of the 'Spellbound' exhibition, Paula did further pictures on themes from *Snow White* and *Pinocchio* after she had finished *The Ostriches*. They are in marked contrast, as they are illustrations from the story, albeit psychologically interpreted, rather than balletic expressions of feeling in which 'lip-service did not have to be paid to the story'. And, in that sense, they are regressive.

In the *Snow White* series, especially, she returns to the subjected mood of the girdle women, in this case the battle between Snow White and her stepmother. As Marcia Pointon has written:

> Disney's saccharine anthropomorphism is filtered out through Rego's bold confrontation with the main theme: jealousy … In the struggle between them jealousy is explicitly sexual; they compete for the perfection of physical appearance that will win them the attention of men; of fathers and lovers. This is a deeply self-referential drama. The mirror on the wall eventually tells the stepmother that she must cede to the younger woman. To be no longer 'fairest of them all' is a problem of self-identity. The solution is murder.[61]

In *Snow White playing with her Father's Trophies*, **222**, the evil stepmother looks on in fury; while *Snow White and her Stepmother*, **224**, shows the older

222   *Snow White playing with her Father's Trophies*, 1995. Pastel on board, 170 x 150 cm.

223   (opposite) *Snow White Swallows the Poisoned Apple*, 1995. Pastel on board, 170 x 150 cm.

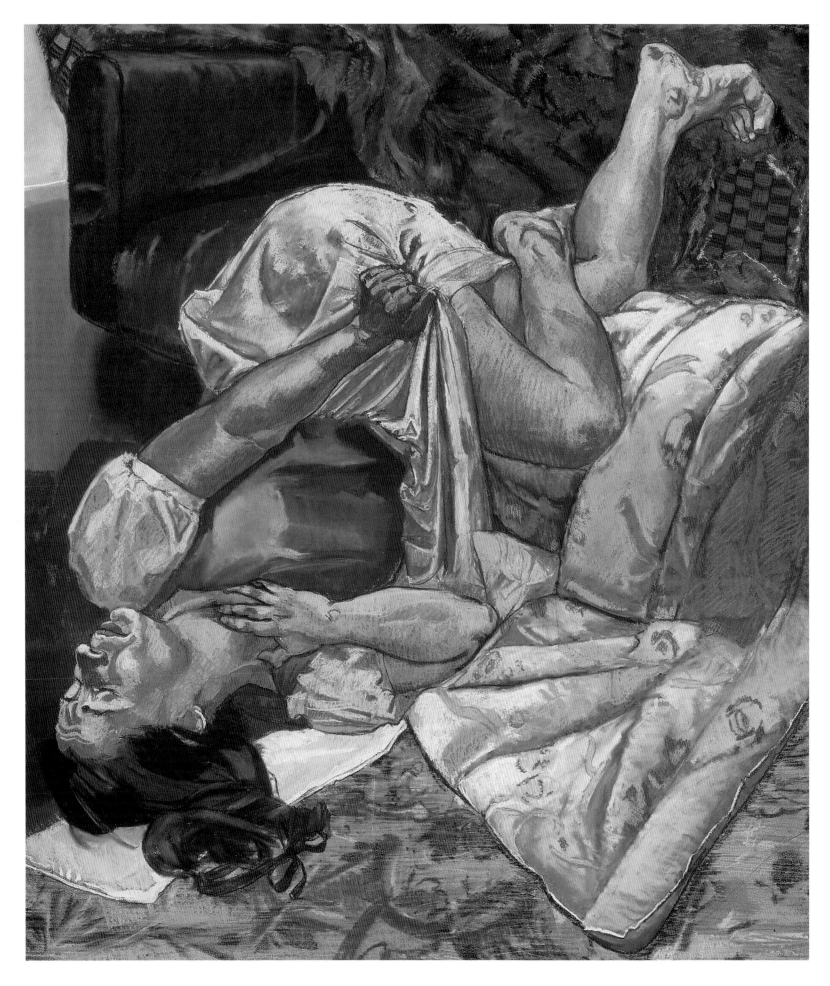

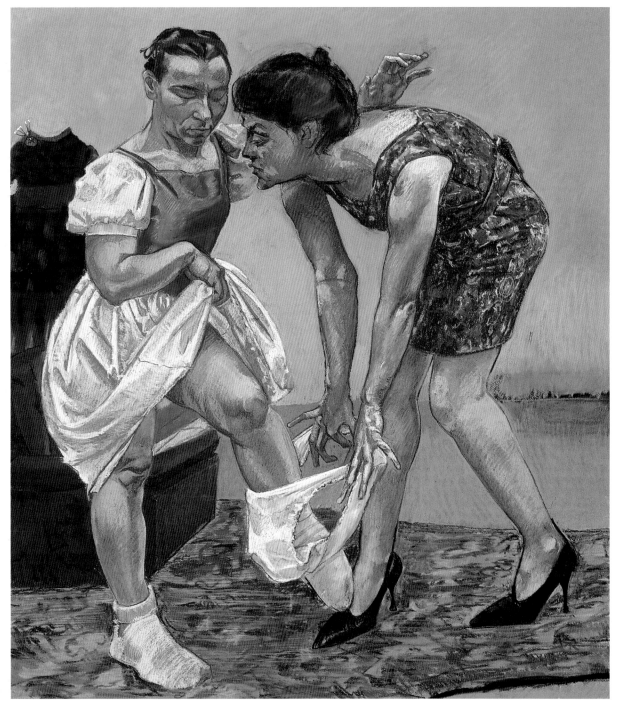

224  *Snow White and her Stepmother*, 1995. Pastel on paper mounted on aluminium, 170 x 150 cm.

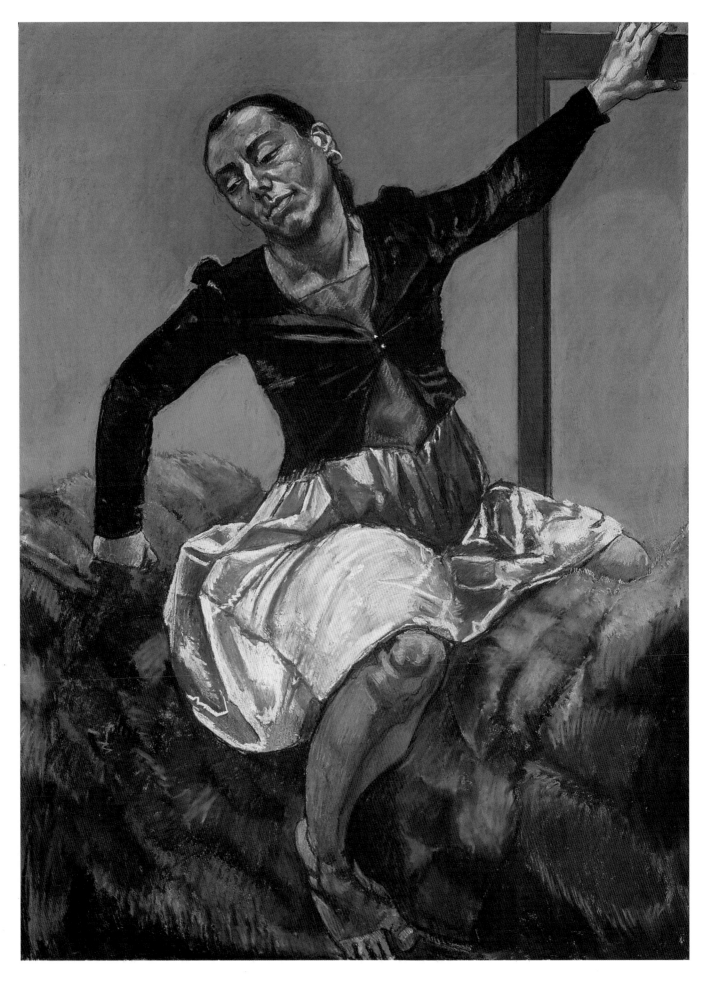

225 *Snow White on the Prince's Horse*, 1996. Pastel on paper mounted on aluminium, 160 x 120 cm.

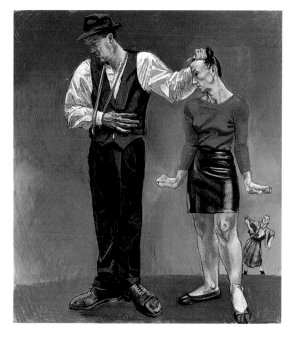

226  *Hey-diddley-dee – an Actor's Life for Me*, 1996.
Pastel on paper mounted on aluminium, 170 x 150 cm.

women subjecting the pubescent girl to an insultingly arm's length inspection of her knickers. Snow White's open hand declares her repugnance for her rival. She cannot bring herself to touch her. Even her dying gesture is of sexual modesty, as she pulls her dress over her thighs in *Snow White Swallows the Poisoned Apple*, **223**.

Lila modelled for Snow White and Josephine King for the stepmother. For her three pictures derived from *Pinocchio* she used her own family. Ron Mueck played Gepetto, the woodcarver who makes himself a son; Andy Smart the manipulative actor – a wolf in the film – and his partner, Victoria Willing, the Blue Fairy. The professions of Ron, a sculptor, and Andy, a comedian, corresponded to their roles. Ron even made the figure of Pinocchio, cast in plastic with real hair, which was exhibited alongside *Gepetto washing Pinocchio*, **228**. There is a suggestion of a *pietà*, of the dead Christ in the lap of His parent, a reference to religious iconography also seen in *Sit*, **212**, stimulated by an enthusiasm for José Ribera, a favourite painter of Vic's, rekindled by a major international exhibition of his work.

The figure also features in *The Blue Fairy Whispers to Pinocchio*, **227**. At Victoria Willing's suggestion it is depicted with its back to the viewer, a position made no less expressive by its gripped fists but leaving its presumably changing facial expressions to the imagination. The carpet curls at the edges, suggesting that it is magically floating on air.

*Hey-diddley-dee – an Actor's Life for Me*, **226**, posed by Andy and Victoria, originally had the man with his hand on the woman's shoulder. It was then felt more suitably dominating to have it placed on the head, the fist clenched to make it more round and paw-like. The effect is more sinister, as if he is pulling the woman's hair. Even unintentionally in Paula's work a sub-text comes through.

227  *The Blue Fairy Whispers to Pinocchio*, 1996.
Pastel on paper mounted on aluminium, 170 x 150 cm.

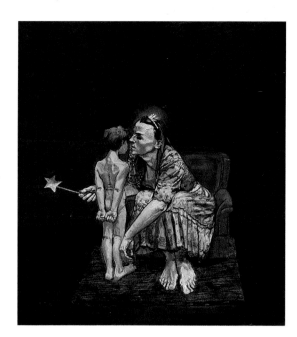

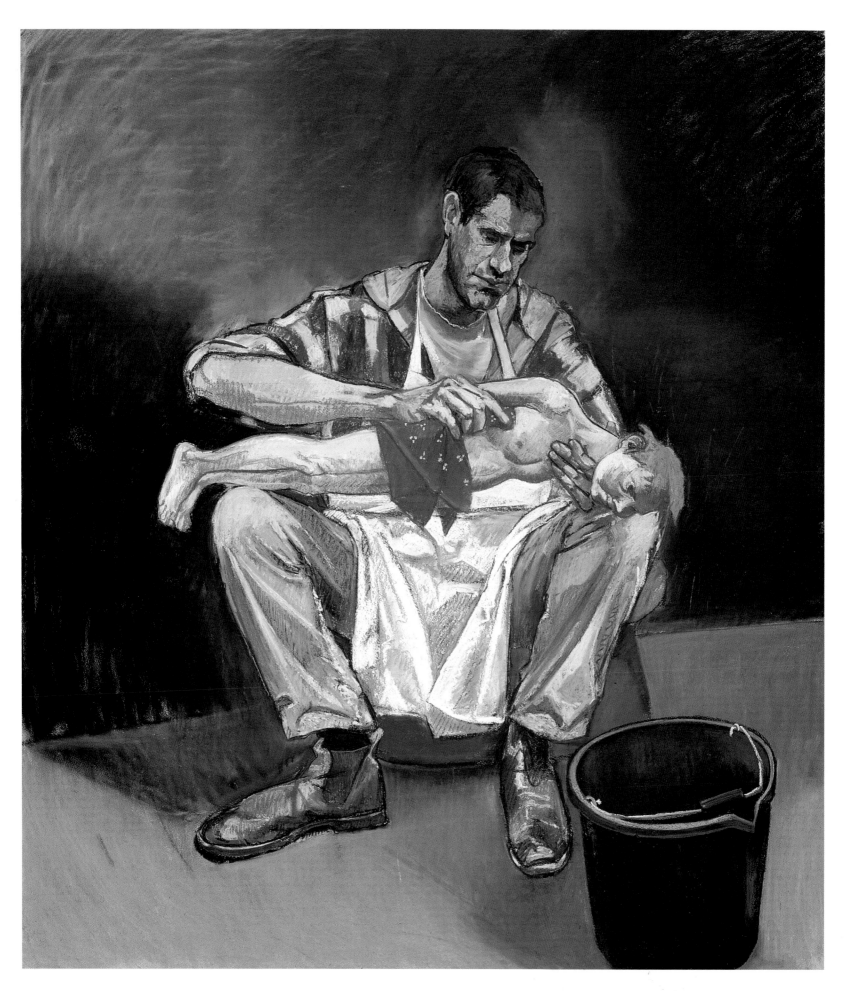

228 *Gepetto washing Pinocchio*, 1996. Pastel on paper mounted on aluminium, 170 x 150 cm.

# EVERY PICTURE TELLS HER STORY

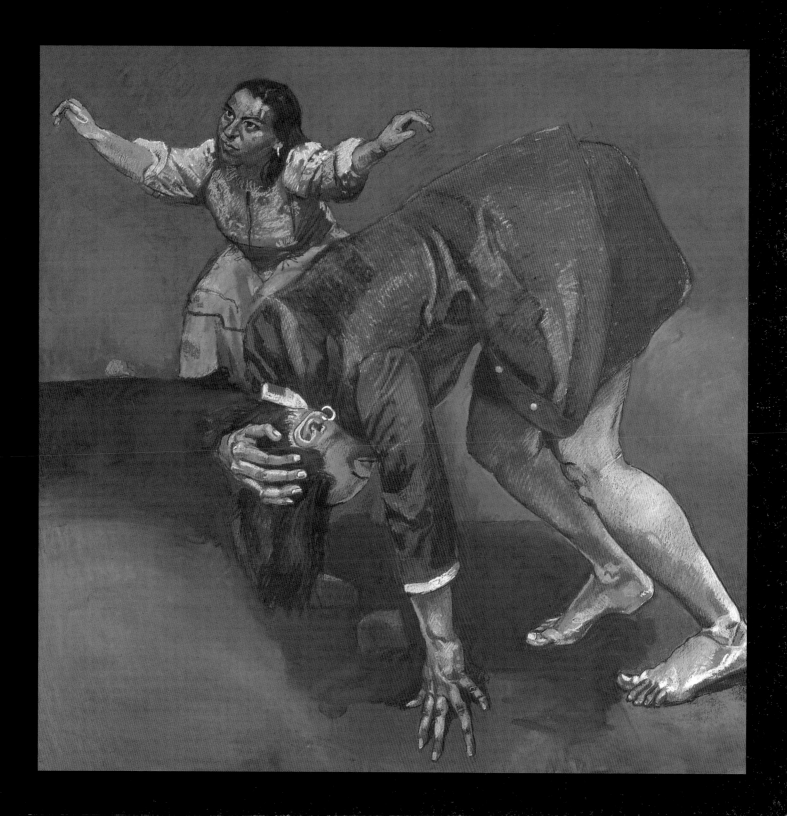

**P**aula's childhood passion for Walt Disney films has proved her greatest artistic experience. As the Disney art director Kendall O'Connor wrote to his colleague T. Hee on the subject of *Fantasia*.

229 Previous page: *Two Women being Stoned*, 1995. Pastel on canvas, 150 x 150 cm.

In case the complex witchery of other *Fantasia* sequences may lead you to feel that your 'Dance of the Hours' has the subtlety of a barn door, let me assure you that this is the art that conceals art. In fact, we concealed the art from almost a graphic league of nations. We concealed the art of France in the form of flat pattern à la Matisse, and Picassinine colour; and from Japan, architectural space division and block prints. From Africa we brought masks and weird proportions which we concealed along with the primitive instinct to dance. America and Greece contributed when a rash of dynamic symmetry broke out in the layout room … From Russia, Eisenstein's symphonic principles of handling graphic forms threatened to turn our pencils into batons.[62]

How indignant her more puritanical teachers at the Slade would have been to think of her 'wasting' afternoons at the cinema. Or perhaps they would not have cared. Art was man's work. Female students were regarded as no more than marriage fodder. 'I knew so many talented girls who sacrificed it all for a man.' To defy the odds required a struggle, the extent of which she only fully realized when she opened 'the can of worms' by painting *Moth*, **208**.

'Mum was very discriminated against. Dad was always considered a very important painter, but we'd go to private views and Mum would be asked if she was "still dabbling in that painting". There's great chauvinism in the art world,' recalls Nick Willing.[63] Paula was lucky to have her greatest critic in Victor Willing; but as one who escaped her 'deadly killer of a class' she speaks with the passionate conviction of a survivor when she tells students that their 'freedom, our freedom, is here; we have total freedom to paint exactly what we please'. In her case, she has not only won that right against great social, physical and psychological odds; she has practised it as a matter of moral principle.

As a child she preferred the hurly-burly downstairs to the restrictions upstairs, though it was only on holidays with her grandparents at Ericeira that she could pass the day in the kitchen. She recalls that she 'always identified with the people who worked there and also at the table and made the beds. I felt very protected by them and I always loved their company.' But it was only when she lived in Ericeira as a married woman that she fully appreciated the hardships endured by the local people.

230 Paula in her studio.
Photographer: Jane Bown.

During the winter they were destitute. If the sea was too bad they did not fish. The wives were sometimes so poor they hadn't got money to give medicine to their kids; and, as the church forbade contraception, they were always getting pregnant. They gave birth constantly or they had abortions, which were illegal. They suffered a great deal, a great great deal, and I felt for them a great deal.

It was this sense of outrage that inspired Paula to paint her politically vehement pictures of the 1960s, when the military dictatorship of Salazar was still in power. Collage, a pictorial equivalent of graffiti, suited their caustic protest.

In the years that followed, ushered in by the death of her father and followed closely by the onset of Vic's illness, personal problems could occasionally make her too depressed to paint. It was in 1973 that she began the Jungian analysis she still practises. The year 1975 marked a nadir. It was a much harder time financially than she ever admitted, the family business subject to a workers' takeover in the Portuguese political revolution which, ironically, she supported. To earn money, as well as to take artistic stock, she approached the Gulbenkian Foundation for a research grant to study illustrated children's books and fairy tales. This was to have far-reaching consequences for her art, quite unforeseen at the time.

The break did her good. It restored her powers of storytelling which is her imaginative instinct. As Alfred Neuman wrote of his friend Marc Chagall: 'Artists are artists – rarely are they learned people. Their talent is imaginative insight, not the intellect.'[64] Paula agrees. 'My daughters understand the psychology of my paintings because they're women, but Nick knows how they're done. Nobody else does.'[65] She has experienced the inspiration of this primal emotion at long but regular intervals, beginning with the Dubuffet-inspired 'doodles', and most recently with *The Ostriches*.

These outbursts have been consolidated by a flow of ever more considered and considerable works, in a strangely similar pattern. In the 1960s it culminated with the collages she showed at her first solo show, at the Sociedade Nacional de Belas Artes, Lisbon, in 1966; in the 1980s, with the 'Girl and Dog' exhibition at the Edward Totah Gallery, London, in 1987. Both triumphs were followed by nemesis: the death of her father in 1966 and Vic in 1988. As John Mills, Vic's most long-standing friend, said of Paula's paintings in the late 1980s: 'they are full of farewells.' This mood

reached its bittersweet climax in *The Dance*, **167**. 'How did she know!' Paula exclaimed when she read Elspeth Barker's story inspired by the picture; at the time she had not met the writer.[66] This melancholy sense of departure even lingers in some corners of *Crivelli's Garden*.

The shadows and colour of paintings like *The Family*, **166**, or *Time – Past and Present*, **187**, reveal her enthusiasm for the work of the Swiss artist Felix Valloton, especially his moody interiors done at the turn of the century. Her children were adults, grandchildren were arriving, and her paintings express deeper feelings born of experience and age; of maternal loss and hope; of emotion recalled in tranquillity. The National Gallery appointment came at a fortuitous time. She had the strength to confront and understand the high art behind popular art. 'I'm able to see a tiny bit more now – because it's all there, it's just that we can't see it.' But she has seen it, more than most.

'It is not often given to women to recognize themselves in painting, still less to see their private world, their dreams, the insides of their heads, projected on such a scale and so immediately, with such depth and colour,' wrote Germaine Greer.[67] In 1995 Paula accepted to paint a portrait of her admirer for the National Portrait Gallery in London, **232**. This was her first portrait commission and to begin with she found it inhibiting. The necessary informality was eventually arrived at by having Greer tell her the stories of Wagner's *Ring*. The result, both commanding and informal, is an admirable likeness.

Women recognize themselves in Paula's work, their coquetry, duplicity and cruelty as much as the sterling qualities more often cited in their praise, compassion, stoicism and bravery. It perplexes her that students invariably ask her why her painting has changed. It has not. Representational drawing has always underpinned it, and the bold figuration of her more recent work was there 40 years ago in *The Birthday Party*, **37**. That early promise has been abundantly fulfilled. It owes much to her parents' faith and encouragement, most of all to Vic's selfless support and intuitive criticism, and now to her family, of which Lila, much more than a model, can be counted a part. But the struggle is never over.

That is why it is so appropriate she chose to celebrate the courage of women in *Crivelli's Garden*, the female saints and their mythological equivalents. She knows their unsung and living counterparts – the working,

231 *The Barn*, 1994. Acrylic on canvas, 270 x 190 cm.
Berardo Collection, Sintra Museum of Modern Art.

practical women of Portugal who inspired her as a child and always will. To see Paula in her element is to watch her sitting in the shade of Luzia's cottage, murmuring chickens at the door. 'Most women in my pictures are Portuguese. I use Portuguese models, simply because I identify with them very very closely, and I do have a profound admiration for these particular women. They are so brave. I mean they endure such a hard life. They are very very brave people.'

Where Paula has been a pioneer, she is now part of an unprecedented movement of female art in the West. In England 70% of people who have become professional artists since the mid-1980s have been women. Art lies beyond age, race or gender, but is nonetheless affected by them. The rise of women artists is the greatest artistic revolution of the second half of the twentieth century. Heroines emerge – the women who have made this possible, who have worked throughout to achieve greater acclaim in old age than at any time in their career. In England there is Prunella Clough, her abstract paintings like a succession of secret confidences; in America Louise Bourgeois, whose sculpture can be both startlingly physical and menacingly melancholy. Both are as feminine in their way as Paula, but their art is more oblique. Perhaps of all contemporary artists, the American Cindy Sherman, fantasist and role-player, a storyteller in photographs, comes closest to her in spirit. For Paula too, every picture can tell a story, but the story will change every time she tells it. This perpetual uncertainty is all that is certain; that, and her right to fame.

232 *Germaine Greer*, 1995. Pastel on paper mounted on canvas, 120 x 110 cm. National Portrait Gallery, London.

233   *Love*, 1995. Pastel on paper mounted on aluminium, 120 x 160 cm.

# CRIVELLI'S GARDEN

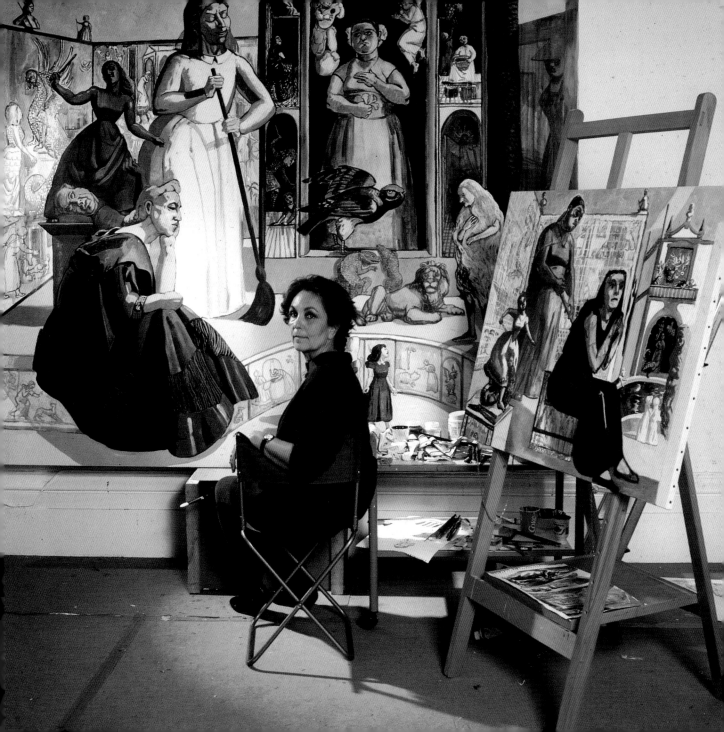

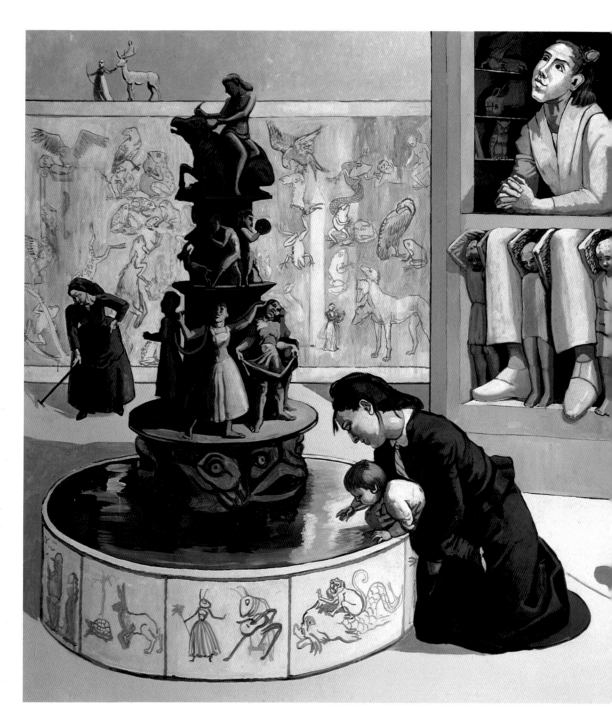

234  Previous page: Paula Rego at work on *Crivelli's Garden*, at the National Gallery, London, 1990.

235  *Crivelli's Garden*, 1990-91. Acrylic on paper on canvas. Left panel 190 x 240 cm., right panel (overleaf) 190 x 260 cm. Sainsbury Wing (brasserie), National Gallery, London.

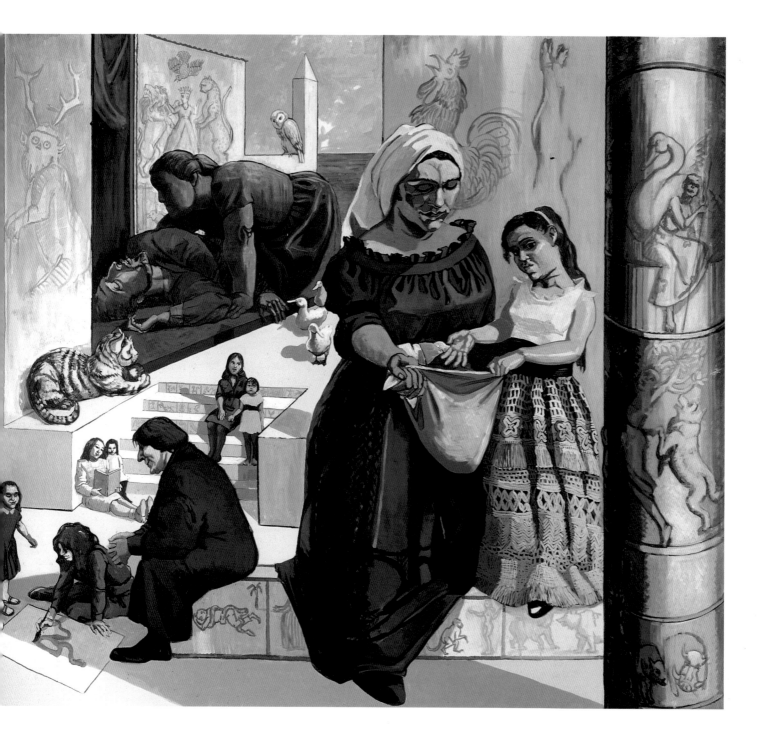

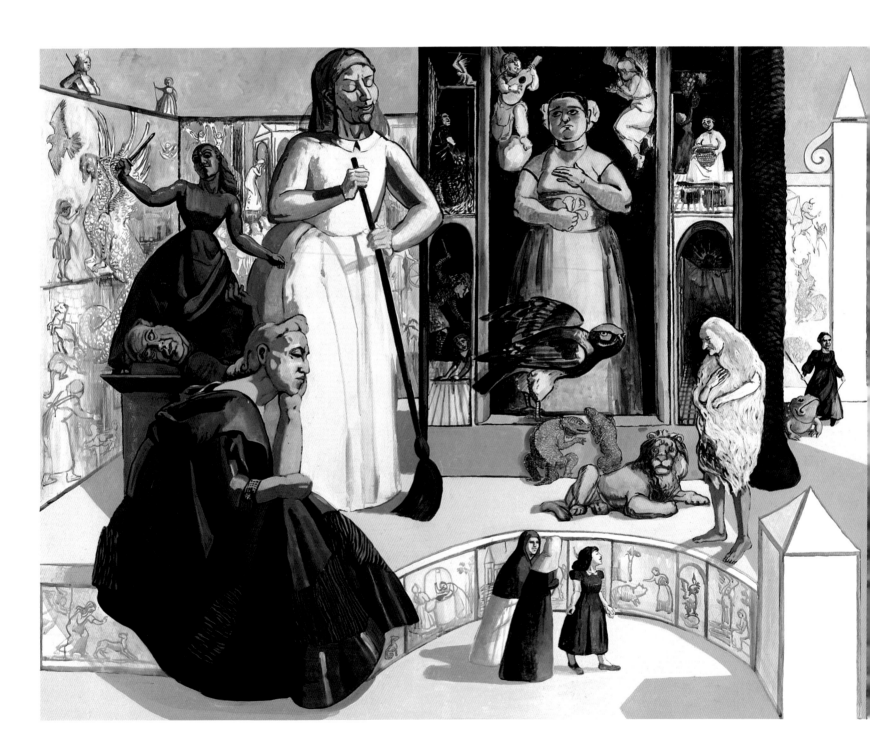

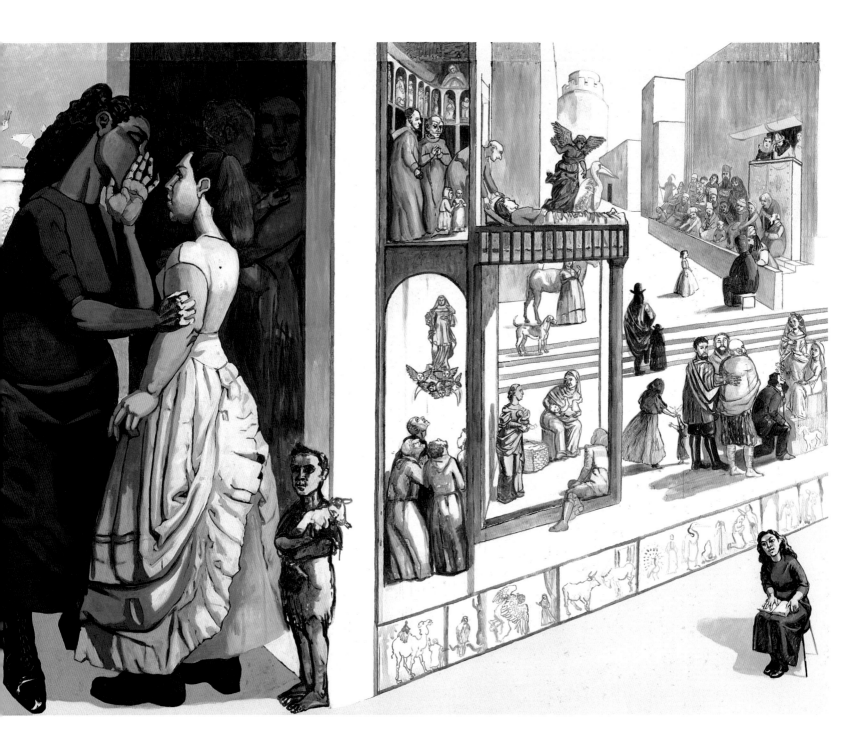

*Crivelli's Garden, the mural in the Brasserie in the National Gallery's Sainsbury Wing, was commissioned from Paula Rego by the Trustees of the National Gallery in 1990. Paula began work on it in June 1990, by making some preparatory drawings. She was still adding finishing touches to the paintings* in situ *in July 1991.*

*The Sainsbury Wing was officially opened to the public by Her Majesty Queen Elizabeth II on 10 July 1991.*

**John McEwen:** *You took up your appointment as the first National Gallery Associate Artist at the beginning of 1990 with the specific requirement of producing work 'directly related to paintings in the Collection' – hence the mural for the restaurant in the Sainsbury Wing.*

**Paula Rego:** Yes. I took up the appointment on 2 January 1990 and I did a lot of pictures in my studio in the basement of the old National Gallery before Caryl Hubbard, one of the Trustees, took me along one day to see this wall and said: 'How about doing something?' So it was thanks to her. Curiously enough I'd already done a drawing showing various key incidents in the life of the Virgin Mary all in one picture, and this became the right-hand canvas of the mural triptych almost unchanged. Then Colin Wiggins, who lectures on the pictures in the Collection, took me to see Crivelli's *Madonna della Rondine* and pointed out the predella. 'You can see what Crivelli's garden was like', he said, 'from the glimpses you get of it in these backgrounds to the lives of the saints.' And he was right. There are these little paintings at the foot of the big

painting and in each one of them there is a glimpse of the garden. So I decided to do a garden, *Crivelli's Garden.*

**JM:** *And not just Crivelli's but yours as well – a garden full of references, personal and pictorial; nevertheless we're standing in front of the painting now and to me these backgrounds seem more to do with a town than a garden.*

**PR:** I agree it can look more like a fortress but bits of garden can be seen – a walled garden. Anyway, that was Colin's story and I thought: 'What a fantastic idea. I'll make the mural a view of Crivelli's garden from high up and fill it with saints from *The Golden Legend.*'

**JM:** *Could you explain about* The Golden Legend?

**PR:** *The Golden Legend* was the first book on the lives of the saints and was much used by Renaissance artists as a source of subjects for pictures. On my first studio open day Erica Langmuir, Head of the Education Department, said it might interest me because it was to do with stories; and she gave me a photocopy of

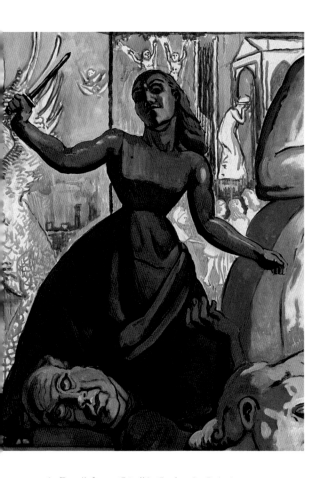

236 Detail from *Crivelli's Garden. St Catherine.*

the pages dealing with 'The Temptations of St Anthony'. So then I read the whole book and was fascinated. It tells what's supposed to be the historical truth and also the legends. It's a marvellous book, very alive. That was the way I connected with the Collection, through the stories. Obviously there are so many saints only a fraction could be fitted into *Crivelli's Garden.* I decided to include only the women saints that appear in pictures in the National Gallery Collection. I preferred to paint women; and it was also a homage to them, their steadfastness and courage – the way they never gave up their Faith despite being put to the rack or whatever.

**JM:** *Even so you must have had more than enough to choose from.*

**PR:** No, you'd be surprised; there aren't that many women saints. The only one that appears in the *Madonna della Rondine* and the mural is St Catherine.

**JM:** *So how did you go about the selection?*

**PR:** In the first instance they

had to be in pictures in the National Gallery – and in *The Golden Legend,* so I could read about them. That was the beginning and it developed from there to include mythological characters and so on – equivalents or forebears of the Christian heroines. Then the next thing was how to cast these roles. Real people became the saints, because I used real people as models. For instance, I even chose to include St Cecilia because I loved the look of a woman called Cecilia who works for my mother in Portugal.

**JM:** *And it has a Portuguese air, even the quinta at Ericeira where you spent your summer holidays appears.*

**PR:** Absolutely. The mural's title may be *Crivelli's Garden* but of course it's really my garden, a Portuguese garden. In my bedroom at Ericeira there were tiles from floor to ceiling, arabesques in cobalt blue – the same colour I've used for the tiles I've painted on the walls at the lower level of the mural. In the drawing-room at Ericeira there were tiles of hunting scenes specially commissioned by my

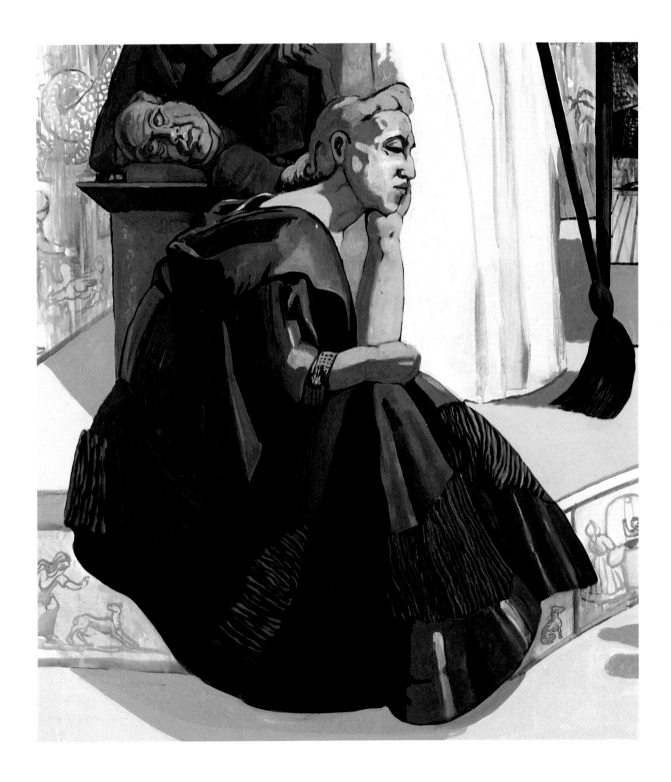

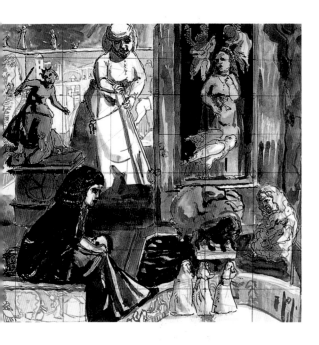

237 (opposite) Detail from *Crivelli's Garden*. *Mary Magdalene*.

238 Study for *Crivelli's Garden*, 1990-91. Pencil and ink on paper, 50 x 60 cm.

grandfather; and on the outside wall of the house there was a tiled panel devoted to St Gertrude.

**JM:** *You thought of it as a personal picture and also about storytelling.*

**PR:** About stories, like in *The Golden Legend*. It was an exciting connection to find myself using the same book for the painting as so many great artists had used for theirs all those years ago – extraordinary really. So it is a tribute in a way – although of course the figures have turned out differently because they portray people who are alive today. I didn't know the Collection well. Colin and Erica showed me where to find the women saints. None of the figures are copied from paintings; they duplicate them, that's the point.

**JM:** *How would you like us to look at the mural?*

**PR:** It starts in the middle because that's where the core of *The Golden Legend* is – the centre and the right-hand canvas.

**JM:** *Can you run through who everyone is.*

**PR:** Mary Magdalene is in mourning in the black ball-gown – my mother's opera dress in fact – as an older woman, so she is thoughtful, day-dreaming. St Catherine is the brown figure wielding the sword, treading on the man who humiliated her. He was a Roman emperor and had her tortured and then put to death on the wheel, from which the firework takes its name. She hasn't really killed him; it's just to symbolize the triumph of the spirit.

**JM:** *She's a statue – your son Nick described the big figures as being 'rather delicious, as if carved out of butter'.*

**PR:** That's right. The little people are the real ones.

**JM:** *And the big ones are dummies.*

**PR:** I think of them more like the clothed figures in 'The Stations of The Cross' that adorn the walls of Catholic churches. At Braga in Portugal there's a staircase and on every landing a little chapel and inside each chapel there is a 'Station of The Cross', incredibly alive. That made a great impression on me. But

they could be dolls. It's a sort of tableau with living people, the little people, moving through it.

**JM:** *It's appropriate the saints are huge because of their nature; they are larger than life characters, heroic examples.*

**PR:** Precisely. They were huge people. Saints are interesting. They were people who knew their own minds and they did what they intended to do and no threat or torture was going to deter them. So they are admirable human beings, marvellous.

**JM:** *Who are the other saints depicted in the central canvas?*

**PR:** St Martha sweeps the floor. She is the patron saint of housewives. In each case the tiled wall nearby tells the story of the nearest saint. For instance, in the alcove in the middle St Cecilia is surrounded with scenes of her torture and death. She was a plucky girl. They first tried to boil her alive and then hacked off her head three times. In front of her with the long hair is St Mary of Egypt. She is often confused with St Mary Magdalene because they

were both prostitutes and both did penance by going into the desert. St Mary of Egypt stayed there as a hermit and was buried by a friendly lion when she died. I've placed him next to her and also a hawk as a sign of her nobility. The Devil appeared to her in the shape of a dragon and swallowed her up but she burst out of his tummy, so she's also the patron saint of women in labour. Afterwards she tamed the dragon, which I've painted on a lead as a slithy toad. The lizards are just slag-bags, sinister things, but they were lovely to draw.

**JM:** *And the little people down below?*

**PR:** The little people came at the end, after I'd finished the rest of the painting. They were children in my original drawings and then they became small figures. One of them is a girl who lectures at the National Gallery, Ailsa Turner. I think of her being initiated to the mysteries herself, really. She is the little girl in black. I think of her as a girl brought up by nuns so she may be a budding saint herself.

239 Detail from *Crivelli's Garden. St Martha.*

240 Detail from *Crivelli's Garden. St Mary of Egypt and St Cecilia.*

**JM:**   *What about the right-hand canvas?*

**PR:**   Well, as I've said, before I was asked to do the mural I had done a drawing of the Virgin Mary fitted into an architectural scheme; so I used that drawing to make the blue tile picture on the side of the building and then I added the two large figures, representing 'The Visitation' – the meeting of Mary and her older cousin Elisabeth. Elisabeth is in brown and announces that, despite her age, she is expecting a baby. The baby will be John the Baptist, so I have included him as the boy holding the lamb – the lamb being the symbol for Jesus whom John would one day baptize. It is a glimpse of the future, if you like. Time is all muddled up in the mural.

**JM:**   *And he also happens to be a portrait of a Portuguese art critic.*

**PR:**   Yes, a friend of mine, but that's just a bit of private fun. Most of the characters in the wall picture – the mural within the mural – represent people I know as well as scenes from the life of the Virgin, including her

241 (opposite) Detail from *Crivelli's Garden. Elisabeth and Mary, and St John the Baptist.*

242 Study for *Crivelli's Garden.* 1990-91. Pencil and ink on paper, 50 x 60 cm.

243 Detail from *Crivelli's Garden. The Reader.*

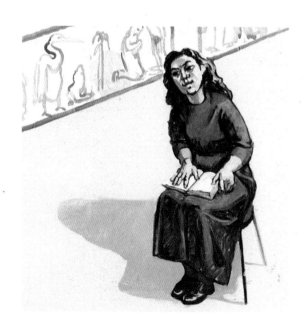

Assumption into Heaven.

**JM:** *And is that you sitting on the stool at the foot of the wall?*

**PR:** No, that's Ailsa again. She pops up all over the place because she also posed for the large figure of the Virgin and the artist drawing the snake in the left-hand panel. But here, at the foot of the wall, she's the reader.

**JM:** *So the whole painting could represent what's going through her mind as she reads the book – the equivalent of a thought bubble in a cartoon strip.*

**PR:** Maybe it's a thought bubble, yes. It could be. As the reader she is certainly the start of it all, really; the anchor figure. You see I also see myself as all the characters. Casting is quite important because it's part of my stimulus as a painter. For many artists this would not apply, but it's important in my case.

**JM:** *So it's like a film.*

**PR:** A drama, a theatre – more a theatre than a film.

**JM:** *Artists have quite frightening power, don't they – almost like witch doctors. I mean they can get their own back in a picture. For instance you've got someone you didn't like at the*

*National Gallery being strangled by a serpent, so I'm told.*

**PR:**  Would I do a nasty thing like that?·

**JM:**  *So I'm told.*

**PR:**  Well I have actually. I think the person knows who it is.

**JM:**  *Let's turn to the left-hand canvas?*

**PR:**  Here the dominant figures are Judith and her maid. The maid's covering up for her in the way maids sometimes do for rich girls.

**JM:**  *What's she covering up?*

**PR:**  Judith's cut off a head and the maid's hiding it in her apron. It's a secret, a bond, between them.

**JM:**  *So this tells the story of Judith and Holofernes.*

**PR:**  Yes, Judith had to cut off his head to save her people. She didn't know him very well. It was just something she had to do; but she didn't like it. So she was a heroine. And I think the maid helped her. She is the strong one, the big one; while Judith herself is not so sure. Judith was the most difficult to paint of all the characters in the mural. I must have tried about fifteen different expressions. I just couldn't get the right gesture, the right look on her face. I've made her into a young girl, you see, who's just practising for the future. I don't mean it to be Holofernes's head in the apron, it's something else's – maybe a dog's.

**JM:**  *Not one of your beloved pigs, that's for sure.*

**PR:**  Oh no, not a pig's. Pigs are far too cosy. So this terrible thing she has to do is still in front of her. She is disgusted at the thought. She doesn't want to do it and yet she is destined to, like all the saints; at the same time she's pleased she's succeeded so far. I don't know the things I want until I've done them; but it pleases me the way she finally came out. It looks right.

**JM:**  *Is that her in the background actually attacking Holofernes?*

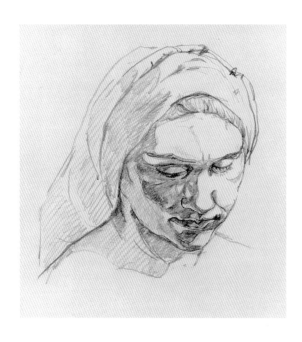

244 Study for *Crivelli's Garden. Judith's Maid.* 1990-91.
Pencil and ink on paper, 19 x 20.3 cm.

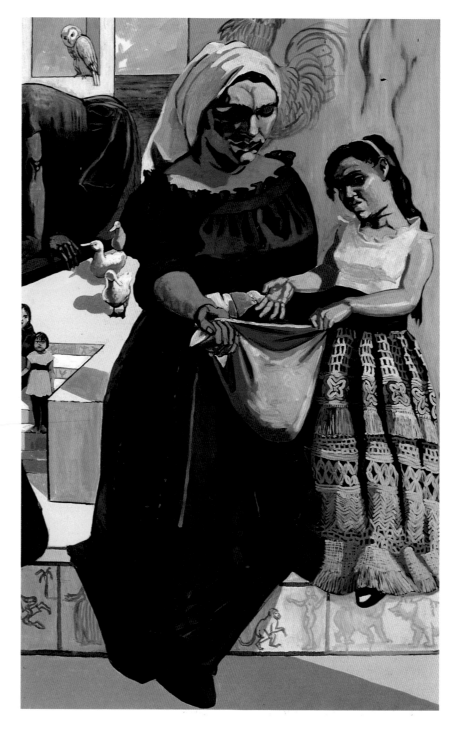

245 Detail from *Crivelli's Garden. Judith and her Maid.*

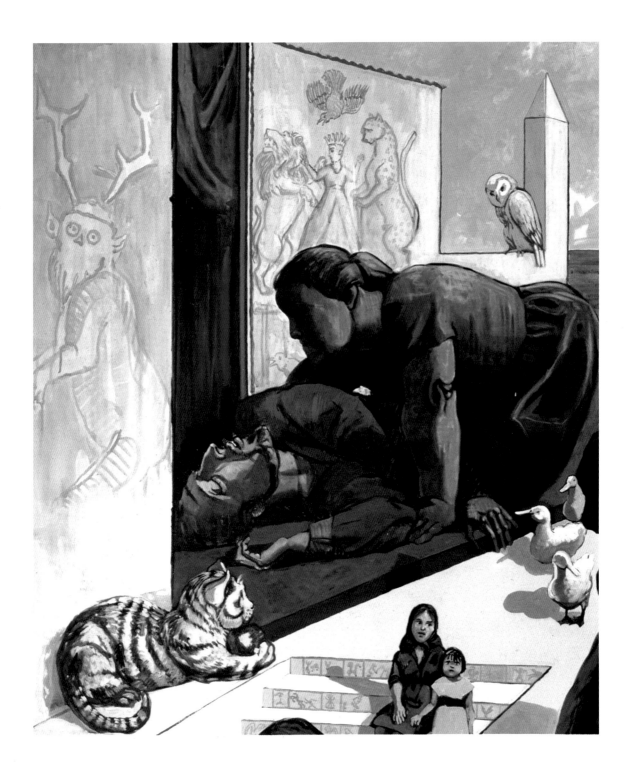

247 Study for *Crivelli's Garden*. 1990-91. Pencil and ink on paper, 20.6 x 37.5 cm.

246 (opposite) Detail from *Crivelli's Garden. Samson and Delilah, and Diana and Actaeon.*

**PR:** At first I did mean it to be her but now I think of it as Delilah; an older but similar story. Delilah loved Samson, she didn't want to betray him to his enemies but like Judith it's her fate to do so – and like Holofernes Samson is vulnerable, asleep.

**JM:** *He's her prey – is the cat there because it's a stealthy, stalking, animal?*

**PR:** Yes – and Diana the Goddess changed into a cat. The owl is a witch-like character, watching over everything; and the ducks are simply to create space. They lead you to the sea. I was worried about introducing the sea. I thought it might be too kitsch.

**JM:** *How do you define 'kitsch'?*

**PR:** If you make art with feeling, if you are emotionally involved, it can't be kitsch. Kitsch is empty of feeling.

**JM:** *This side of the mural is not just about Christian saints – that's the big difference.*

**PR:** I'm not sure what it's about really – except that it brings in mythology and earlier examples of powerful women, forerunners of the saints, because from legend through to history the same characters turn up in different guises. For instance, behind Delilah in the tile picture you get the Lady of the Beasts, who is one of the earliest goddesses; and behind the cat is Actaeon wearing the antlers. Actaeon was a great hunter and one day he came across Artemis (Diana in Latin), daughter of Zeus father of the gods, bathing with her nymphs; whereupon Artemis, the virgin goddess, turned Actaeon into a stag and had him devoured by his hounds. It's meant to look faded, one of those wall-paintings that's been weathered.

**JM:** *But you have also reintroduced Mary Magdalene.*

**PR:** Yes, she's the stone statue sitting in her *aedicula* or box. In the other panel she's matronly and pensive; but here she's a young

249 Study for *Crivelli's Garden. Mary Magdalene.* 1990-91. Pencil on paper, 35.6 x 20.3 cm.

248 (opposite) Detail from *Crivelli's Garden. Mary Magdalene.*

girl and a bit of a white witch, a good witch. I wanted the angels to come out between her legs – because you know they take her up for a meal in Heaven; oh yes, because she only eats up there. She can live on earth without eating anything because she has all her meals in Heaven thanks to the angels.

**JM:**     *When did this happen?*

**PR:**     When nobody was looking. When she went into the desert and when she went to France – they took her up. But I like this idea of the angels pressing up from between her legs, with the arms as wings.

**JM:**     *They're going to shoot her up the lift-shaft.*

**PR:**     Exactly – wooosh. It's sexy, that kind of thing. The model was Lizzie Barker, who's a lecturer at the National Gallery. And then there's the fountain, which depicts Bacchic and Dionysian rites. The Dionysian rites through Orphic worship bring you right into Christianity – God controlling Man's creativity and instinctive nature; as opposed to Apollo who

stood for society, duty and rules. So I made up this fountain to portray stories of instinct and that's very important, with the child playing with the water – because that's where the ideas come from. The child is being taught to play by her teacher – who happen to be my daughter Vicky and my granddaughter and her niece Lola.

**JM:**     *So they and the fountain represent the source of knowledge.*

**PR:**     Exactly. It all begins with learning to drink. That is the first skill. In fact the story of the mural could begin here I suppose, just as well as with the reader on the opposite side.

**JM:**     *And another sweeping figure also appears.*

**PR:**     Not a housewife this time but a sweeping gardener to represent the reaper, the spirit of death, because growth and death go together, just as innocence and experience do. The little people too all represent various aspects of learning and teaching. The storyteller is Erica Langmuir, who told me about the stories,

and she watches while the girl, the budding artist, draws the snake – a powerful symbol of creativity and healing all over the world; in Chinese philosophy even the very world itself, the core of the earth. But the storyteller could equally well be my Aunt Ludgera. You see everything I know is in this picture; even my old nanny, Luzia, comes into it as the old lady with the chickens on the wall in the central panel. And then you have my other granddaughter Carmen with the pruning-fork – they're all learning something you see in their different ways. It's a picture all about stories, as we said, but also about how stories and learning are passed from generation to generation. Somebody called it a picture of 'initiation rites' the other day. I suppose it is, really, but I didn't think of it like that while I was painting it.

**JM:** *What about the painting of it, the formal side. To begin with it's not a true mural, is it – because it's painted on three canvases and not directly on the wall?*

**PR:** That's right. I painted most of it in my studio in the bowels of

250 (opposite) Detail from
*Crivelli's Garden. The Fountain.*

251 Study for *Crivelli's Garden.*
1990-91. Pencil and ink on
paper, 29.2 x 29.2 cm.

the National Gallery without any reference to the colour-scheme of the restaurant, but when I brought the paintings there for the first time they matched the decor – an incredible coincidence. I mean the grey of my shadows was exactly the grey of the dado; and the walls and carpets are blue and grey. Well I did it in blue and brown because I thought it would be in better taste to have it a bit subdued – posh wallpaper really. Once I saw it *in situ* I altered very little. I put in the column and toned down the background wall on the left of the middle canvas, that was all.

**JM:** *And the composition offers us a way out – down the street on the right or to the sea on the left.*

**PR:** It was important there was a way out of this garden – which brings me to another thing I've used in this painting and never before in my work, and that is perspective. Nicholas, my son, gave me some lessons in that, which was a great help because it was very important I got it right. The perspective of the horizon line is constant. There are several vanishing-points but they

are all at the same height. Also I hope the floor of the picture, which is the same throughout, will unify it – which is pretty tricky to achieve because it's so wide, 9 x 2 metres. It's one floor but on two levels; and all the figures had to be on the same ground, to have their feet firmly planted on the same ground, to add to the drama. If they hadn't they'd have been floating about like balloons. As a result it's my most three-dimensional picture, my most illusionistic – which I think stems from being in the Gallery, from looking at the pictures upstairs.

**JM:** *You used books as well.*

**PR:** I used one book in particular, called *Animals*. It was published by Dover and it's an archive of animal illustrations from the nineteenth century. I've used it over and over again, not just for *Crivelli's Garden* but before it for the *Nursery Rhymes* as well. The other book I used was *Gardens of Portugal* by Patrick Bowe, with photographs by Nicholas Sapieha. It's a Portuguese book published by Quezal. I didn't copy anything out of it,

but it kept the ambiance in my
head.

**JM:**   *What was the formal purpose of
mixing the scale of the figures?*

**PR:**   The big figures are so they
can be seen from a distance and
the little ones are to give you
something to look at when you're
close to – so it's always enter-
taining. Thank God I made the
'Visitation' figures of Elisabeth
and Mary so big. They carry the
whole thing. But the thrill when
I'd done the big figures was to
put in the little ones. It turned the
whole thing off balance.

**JM:**   *Did doing it teach you a lot
about the pictures in the National
Gallery?*

**PR:**   I think it did. I'm able to
see a tiny bit more now – because
it's all there, it's just that we can't
see it. We CAN NOT see it. This
is the problem with art education.
It does not teach us how to see.

**JM:**   *What sort of things? Formal
things?*

**PR:**   Formal things, yes, but
things of character, psychological

things – how good they are, how
complex, how interesting. It's like
getting to know a person – the
better you know them the more
interesting they become because
you begin to see the contra-
dictions, the complications. And
you see this with pictures – the
more you look the more you see,
but it takes so long. Still, it's nice
to see things better; so you feel as
if you know more about treasure
– because by anybody's standards
they are treasure. But they are also
so deep, so profound.

**JM:**   *Is that because they are products
of Faith?*

**PR:**   The artists were unques-
tioning in their Faith, certainly.

**JM:**   *And are you?*

**PR:**   Yes, I am – in that I believe
in these women. I know they
exist. They exist as part of stories
and stories are just as important
as if they existed in reality; it
makes no difference.

**JM:**   *So it has been a good experience.*

**PR:**   I have loved doing it. I've
never enjoyed anything so much.

# Appendix 1

## UNTITLED

*Published anonymously in the catalogue to the exhibition
'Six Painters', Institute of Contemporary Arts, London, 1966.*

The time of day in that place, of that climate, has the presence of an animal. A heavy, uneasy, sun-baked thing which twitters and whines in one's ear. One must tease it, humiliate it, gouge it, pity it. The picture becomes its face. If it can be described it can be forgiven for being what it is and made lovable even. Such creatures (fawning, lethargic, elusive) rush about or wander, lost, singly and even in packs. For Paula, painting is trapping them, breaking them, putting on brands and hanging them, groomed and pampered, on the wall.

## PAULA REGO

*Foreword by Victor Willing to the catalogue of the exhibition 'Paula Rego.
Paintings 1982-83', held at the Edward Totah Gallery, London, 1983.*

The São Carlos Opera House in Lisbon, before the Revolution was a stage on both sides of the footlights, as an opera house should be. The audience dressed up, stared and paraded against the gilt and grey velvet, the President sat floating amidst camellias, new darlings were discovered and reputations hung in the balance. During the intervals the gentlemen rushed to the bar and swapped political jokes, making nonsense of press censorship. On the way home, the Presidential Cadillac would overtake us on the coast road to Estoril, passing the fort where, one day, the old dictator's folding chair folded unexpectedly, ending his rule. This appealed to the national sense of the ridiculous. The Portuguese are keenly aware of the fragility of hierarchies and the comedy which derives from their disruption. On stage and in the auditorium the tragi-comedy crashed on at full stretch. The orchestra wheezed and thumped while Di Stefano and Callas vibrated the perfumed air.

Every winter since childhood Paula had been sharing her father's passion for Italian opera. Wagner's dramas of the subconscious were too insubstantial, the *Commedia dell'Arte* and its human stories of love and villainy had a reassuring solidity. We can best project particular attitudes by embodying the masks which we assume concentrate our entire presence in one role; the theatre reinforcing the archetype. Human individuality is so complex that projected in its entirety it would be inexpressive.

The Popular Tale or Fairy Tale (full of 'masked' characters) transcend the banal and sentimental by evoking images which are universally recognized. Before Opera and the *Commedia dell'Arte* there were the Roman plays. So in spite of its grandeur opera's foundations are popular; the emotions simple.

A strong verbal tradition continues in Portugal where Paula's childhood imagination responded to the endless storytelling of a great-aunt. When the tale is well launched the language itself can become incantatory and hypnotic; the words thicken in the mouth and acquire substance, pushing and pulling through the rhythms of the sentences they add their own excitement and glamour to the images; speaker and listener locked in motionless frenzy.

The painter's reflections are too solitary and prolonged for this degree of intensity, but we must all remember from childhood the magic when a drawn line 'became' an object, car, dog, horse or whatever. However bizarre the drawing, this line was an exact fit. You could taste your satisfaction as the object appeared before your eyes, first-time excitement palpable in the drawn line. Just so, for the adult, 'the thought made in the mouth' determines the speed of its expression, the speed of the drawn line.

Misdemeanours are more engaging than good behaviour, and even more so, our own indignation, so the caricaturist points at hypocrisy, avarice and pomposity, not at good works. Before she knew Rowlandson and Gillray, Paula knew Benjamin Rabier and the caricatures of *Pluma y Lapis*, still treasured Spanish magazines from the beginning of the century. Urban riff-raff in bowler hats and tight suits cavorted in constant monkey-tricks in the sea-food taverns and alleys of Madrid. Their laughter is frequently malicious but the artist loves their love of life. Deliberate cruelty can have its tender moments while on the other hand, in spite of good intentions lovers are sometimes clumsy. All the time, in Paula's pictorial dramas things are going wrong. The accumulating disasters add up to a somehow survival. If that sounds like soap-opera, the difference is one of style, the pictorial style that is the visual equivalent of those words that become substance in the mouth. Because it is not, after all, the stories that arouse our curiosity (however important they are to the artist), it's the way that she has transmuted them visually; the object has become a line, one fitting the other, and this line records her fluctuating hope and dismay; her amusement or rage. Perhaps it's more true to say that the line becomes an object. We would be wrong to suppose that, because Paula's work contains nameable creatures in familiar antics that she is illustrating a story, one which she has visualized and is describing graphically. More simply, marks are floated, or seem to float themselves across the paper and particular gestures are formed because their appearance lends itself to the mark. They are suggested by the marks and found appropriate. The desire to make sense makes these creatures engage before long in a game of consequences which shapes their actions.

Certainly the animals in whose form those actions find their embodiment are appropriate metaphors. Donkeys are stupid, chickens are timid; we make the analogies without premeditation. These beasts then become the masks of the artist's graphic dramas, the drama of events and the marks in turn taking the lead as the pictures evolve.

'Life is full of men making a grand gesture and falling on their arse.' Her exasperation with male vainglory extends beyond our heroics and the hierarchies of Art. Even if we sometimes escape with our dignity intact our lofty intentions arouse her impatience. She insists that, though her paintings sometimes end up big, they are not 'grand'. They are not intended to impose nor to improve us. Nor do they contain those felicities on which the self-esteem of so many artists depends, those 'turns of phrase' by which an artist tries to secure his position in the pecking order, exuding a self-conscious 'authority' described as 'a respect for permanent values'. Such crutches she has no use for, not from naiveté but disdain. Lorca in his essay on the *duende* describes a flamenco singer who got rid of the 'scaffolding of the song' and 'impoverished her skills and aids' in order to achieve her aim. This is the necessary sacrifice. Paula felt the paradox when she confessed that 'by not trying to do art I get better at what I do'. She had better look out, people are beginning to think that this is Art.

## INEVITABLE PROHIBITIONS

*Essay by Victor Willing for the catalogue of the retrospective of Paula Rego at the Gulbenkian Foundation, Lisbon, 1988, reproduced in the catalogue of the exhibition 'Paula Rego', Serpentine Gallery, London, 1988.*

Even if you cannot immediately recall *The Virgin spanking the Infant Jesus* by Ernst, it will be no surprise to find that it is not paint in search of a subject. Evidently what it is about matters. But this title does give rise to uneasy speculation. In what circumstances could Jesus have deserved chastisement? Could Mary be unjust, or domineering? Ernst's own unease (real or assumed) is apparent in the style which reminds us of the Roman Mannerists, their snooping perspective, sinuous silhouettes, air of menace and always, through disrupted hierarchies, the rumour of plots.

Childhood was full of moments when adult behaviour was perplexing. Were we witness to an act of love or murder? As witness, and not participant, we felt excluded and therefore suspicious. The Mannerist's vision evokes the child's worst fears – looming menace, incomprehensible events, isolation, falling, sudden clamour and broken rules.

However strong our means of outrage in the face of unfairness we knew we were guilty of something – probably curiosity. Innocence is an adult's attribution and refers, surely, to the child's lack of knowledge not its lack of guilt. So just as curiosity may have been the first sin, so forbidden knowledge was the most avidly acquired and difficult to forget. We longed to lose that innocence. Secrets and prying were wrapped in excitement. With heart pounding in open mouth they preceded sexual experience, where an intimation of its turmoil and, possibly, of other experiences for which we were also unprepared – alarming things like scaling heights, winning prizes and addressing an audience. Yet usually these weren't forbidden even. Erotic ecstasy came later and required, for its achievement, a widespread conspiracy in the prevalent culture to prepare us, yearning for we knew not what as yet unrealized possibility which, then perceived and within grasp, was forbidden.

For those whose education makes little distinction between ethics and etiquette, their imperatives being of equal weight, the world is dangerous. The exemplary young ladies of the Comtesse de Ségur were prepared for an exemplary society and might fall victim – voluptuous and compliant victim – to a latter-day de Valmont.

The romantic is made not born. Made by storytelling, by the precious brevity of life, by wiles and coquetry, by tension and drama – by Art. The limits of experience are not reached by doing what comes naturally. Paula's childhood was well filled with stories and probably she discovered early that humour can disarm the pompous and insincere, leaving the genuinely serious unaffected. Early alarm at the highfalutin' has made her faithful to the world of the popular tale – the versions told before polite society contrived something 'suitable for the children' – which meant the unsophisticated – and told to her by people unaware of Perrault (though very knowing). Of course, 'children' will listen with wide-eyed delight to tales of blood and guts.

Regarding humour, she disappointed some admirers who wanted more, when she decided that some things are not a laughing matter. Wit handles serious matters with a light touch – from a certain fastidiousness perhaps – but that is in the tone of voice, the heart of the matter may be heavy and though nothing can be improved by a long face, even so, to insist always on finding reasons to laugh would betray embarrassment about life's dark side. She has none.

The problem we all have, when confronting those presences emerging from the darkness in our lives, is how to describe them. The truth to which some may be asked to testify, banal facts about rapine and slaughter, are simple by comparison. This more shady truth is complicated by our need to make sense of what we perceive – to give it a form which we ourselves are satisfied is true, which form in turn may even make sense to others – that would be a bonus, but the priority is always our own understanding. Testimony is secondary and if a painter is asked what he means – what he *really* means, by a painting, his answer, if he made one, might still leave us unsatisfied. His understanding is unlikely to have reached an explicable form – in so many words, and may never do so, but a sense of unease has been confronted, which the image has encapsulated, leaving him or her with the feeling that the matter has been settled.

The matter for Paula often concerns domination, or rebellion and domination; or freedom and repression; suffocation and escape. In these dramas her sympathy for the protagonists is ambivalent and wavering – as when she watched a child prostitute in a fairground whose father stood by as the leering bumpkins sidled past. Who was victim, who exploiter, whore, pimp, or client?

Later in life, the child's games/mimicry are bent to adult purposes, but maturity never obliterates our childhood. The image of the child can be that of the 'father of the man' or it may presage an as yet unrealized possibility within us. Paula's girls are both a memory and presentiment.

Ours is a generation which has found it difficult to believe in the inevitability of progress or, consequently, to identify progressives amongst us. The liberal ideal, long central to our values, has been under threat from 'realities', so we have seen *Sturm und Drang*, nostalgia, primitivisms and revivals. The progressive development of the formal means by an avant-garde has paused – any way, it seems, could be forward. The representation of the figure has been a particular embarrassment. Voice of harmony and optimism, the figure does not easily become the imagery of a generation bereft of ideals and making the best of it – guided by expediency, whim and opportunism, not principle.

Paula's search for 'a way to do it' is quickly disappointed by renewed dissatisfaction when the image fails to fit the feeling. At an age when most artists advance confidently, building on achievement, she starts again. In her latest dramas the figures emerge from sullen paint coercing an awkward naturalism; which failure, paradoxically, leads to an uneasy success when after all, this is not prosaic but Gothic in feeling. A lifetime of courting disaster turned around at the last moment – snatching chestnuts from the fire – produces a note of hilarious triumph. It defies the pain.

# Notes

**1** The visit gave rise to a large collage, *The Firemen of Alijo*, **72**, of 1966, recently discovered in store at Kingston Polytechnic having been bought, probably from a London Group show, in the late 1960s.

**2** Many of the tributes paid to the writer Angela Carter (1940–92) could equally well be applied to Paula. For instance: '… through her daring, vertiginous plots, her precise yet wild imagery, her gallery of wonderful bad-good girls, beasts, rogues and other creatures, she causes readers to hold their breath as a mood of heroic optimism forms against the odds.' Marina Warner, 'Angela Carter' (obituary), *Independent,* 18 February 1992.

Paula admired Carter's stories but they only met once: 'We talked about the cats in Venice – the disgusting things they get up to and the smallness of their heads. I was thrilled by the vividness of her conversation.'

**3** Paula Rego interviewed for TV by Melissa Raimes, 'The South Bank Show', London Weekend Television, 23 February 1992, P/N 80520, p 46.

**4** Victor Willing, foreword to *Paula Rego: Paintings 1982-83*, Edward Totah Gallery, London, 1983. Edward Totah died suddenly in 1995, aged 46.

**5** 'The South Bank Show', op. cit., p 22.

**6** *A Catechism of Christian Doctrine*, Catholic Truth Society, 1989.

**7** In German they are called 'Berliners'. When President John F. Kennedy made his ungrammatical but well-received statement, '*Ich bin ein Berliner*' on a visit to the Berlin Wall on 26 June 1963, what he actually said was, 'I am a doughnut'!

**8** 'Third Ear', BBC Radio 3, 21 October 1988.

**9** 'The South Bank Show', op. cit., p 42.

**10** Keith Sutton, 'Paula Rego: Every Picture Tells a Story', *london life,* 19 March 1966, p 14.

**11** Alberto de Lacerda, review of 'Portuguese Art since 1910' at the Royal Academy, London, *Art Monthly*, no. 20, October 1978, p 12.

**12** Evelyn Waugh, 6 July 1953, in *The Letters of Evelyn Waugh*, Penguin, Harmondsworth, 1980.

**13** Sutton, op. cit., p 14.

**14** 'Drawing is signs for Pasmore, but that doesn't work for knuckles,' she said ruefully when painting *Crivelli's Garden*.

**15** *Paula Rego*, exhibition catalogue, Serpentine Gallery, London, 1988, p 45.

**16** ibid., p 46.

**17** Victor Willing, *Victor Willing: A Retrospective Exhibition 1952-85*, exhibition catalogue, Whitechapel Art Gallery, London, p 21.

**18** *Paula Rego*, op. cit., p 45.

**19** In *Outsiders*, Victor Musgrave Outsider Trust.

**20** *David Hockney by David Hockney*, London, 1976, p 67.

**21** Sutton, op. cit., p 15.

**22** *Nineteen Eighty-Four*, exhibition catalogue, Camden Arts Centre, London, 1984, p 45.

**23** Victor Willing, 'The "Imagiconography" of Paula Rego', *Colóquio*, April 1971, p 45.

**24** Lacerda, op. cit., p 12.

**25** Hellmut Wohl, *Portuguese Art since 1910*, exhibition catalogue, Royal Academy of Arts, London, 1978, p 18.

**26** ibid., p 24.
Like most artists Paula does not encourage categorization. She is also consistently contradictory in her opinions, not least with regard to her own work. It is perhaps worth including here the virtual admission of her Surrealistic debt given to Alberto de Lacerda in 1965 in the interview quoted on p 72:

AL: *From what I know of your work and personality and even from some of the things you have just been telling me – I find in you strong Surrealist elements. Is it a chance encounter; or would you say that the Surrealist movement influenced your development?*

PR: *I would say, a chance encounter, a coincidence. I never tried to be Surrealistic. For instance, I never read the texts. But I admire painters like Max Ernst and Miró.*

AL: *Which goes to prove that there exist in you the instinctive elements of a Surrealist, therefore the most pure ones. Similar elements make you admire Henry Miller. What above all attracts you in this writer?*

PR: *The erotic frankness, the tumult of his torrential style.*

On the basis of this response, and remembering that she did *cadavre exquis* drawings with the three Surrealists Cruzeiro Seixas, Mário Botas and Raul Perez, one would say, 'Game, set and match to Lacerda'.

**27** José Orozco in the foreword to a booklet on his murals, Dartington Hall School, 1934.

**28** 'In 1930 Vieira – as the French call her – married the Hungarian painter Arpad Szenes, later a leading member of the École de Paris. They both became French citizens in 1956. He was a subtle mentor to his wife. I find a moving parallel with the case of Victor Willing who, with supreme tact, was mentor to his wife, Paula Rego. Two intensely strong women with the grace to know how to take advice at difficult turns.' Alberto de Lacerda, 'Vieira da Silva' (obituary), *Independent,* 9 March 1992.

**29** Barbara Laszczak, 'Paula Rego: Fantasy and Figuration', April 1985, unpublished MS, p 25.

**30** ibid., p 27.

**31** Gaston Bachelard, *The Poetics of Reverie*, Boston, 1971, p 100.

**32** *Paula Rego,* op. cit., p 48.

**33** *World of Interiors*, October 1988, p 267.

**34** *Paula Rego,* op. cit., p 20.

**35** ibid., p 8.

**36** Dr Mills, a schoolfriend of Vic's, went on to become Head of the Scientific Department at the National Gallery, London; he delivered the address at Vic's funeral.

**37** *Paula Rego: Tales from the National Gallery,* National Gallery Publications, London, 1990, p 21.

**38** Marina Warner, foreword to *Paula Rego: Nursery Rhymes,* exhibition catalogue, Marlborough Fine Art, London, 1989, pp 2–3.

**39** Augarde ed., *Oxford Dictionary of Modern Quotations,* Oxford, 1991, p 220.

**40** *Paula Rego: Tales from the National Gallery,* op. cit., p 23.

**41** ibid., p 11.

**42** Andrew Birkin, introduction to *Peter Pan* by J. M. Barrie, illustrated by Paula Rego, Folio Society, London, 1992, p x.

**43** ibid., p XXVII.

**44** ibid., p XIII.

**45** ibid., p x.

**46** ibid., p XXVII.

**47** ibid.

**48** *Peter Pan,* op. cit., p 46.

**49** ibid., p 81.

**50** ibid., p 47.

**51** ibid.

**52** ibid., p 74.

**53** *Degas by Himself,* edited by Richard Kendall, MacDonald Orbis, London, 1987, p 299.

**54** Robert McNab and Misha Scorer, *Degas: The Old Man Mad About Art,* 'Omnibus', BBC1, 20 May 1996.

**55** This style of exaggerated foreshortening was introduced by her fellow student at Glasgow School of Art, Paul McPhail.

**56** Robert Flynn Johnson, *Lucian Freud: Works on Paper,* Thames & Hudson, London, 1988, p 23.

**57** *This chip of cedarwood*
*with the linsey-woolsey face*
*is furred like the ermine*
*it stole inside one Christmas*
*while she lay, splay-winged,*
*beneath my weight.*

*Our last hunt ball*
*before the child came!*
*She'd been a tease that night,*
*fluttering round Molphey*
*and the colonel: this curt fuck*
*was how I paid her back.*

*Something came, daddy,*
*something flied into the light*
*screamed my flu-hot son*
*half a decade later.*
*She was God knows where*
*gallivanting. I couldn't cope.*

*Orange dots on the back*
*of a cabbage leaf:*

*magnified, they are melons,*
*peardrops, basketweaves,*
*ribbed like a water-butt*
*or pocked as a golf ball.*

*And these become the pupa,*
*the puppet dolls,*
*spinning their sex silks*
*and waggling their tails*
*towards some chandeliered*
*apartment of light.*

*The stuff she came out with!*
*That tale of a moth kept warm*
*overnight in her bosom*
*then rising at breakfast*
*from its chrysalis –*
*I mean, for Christ's sake,*

*look where it landed us,*
*balmed and tattered*
*as this ghost of the wardrobe*
*which lies in my palm*
*like her old diary*
*with marbled covers and spine.*

Blake Morrison, 'Moth', from *The Ballad of the Yorkshire Ripper,* Chatto Poetry, London, 1987, p 37.

**58** John Cluhane, *Walt Disney's Fantasia,* Abradale Press/Harry N. Abrams Inc., New York, 1983, p 171.

**59** ibid., p 166.

**60** For example: 'Two of the most (financially) successful painters at the moment are Paula Rego and Peter Howson. They both practise a kind of lumpen realism with emblematic overtones, a style not far removed from Guttuso's', Tim Hilton, 'The peasants are revolting', *Independent on Sunday,* 24 May 1996. A female reader took violent

exception to this: 'But Rego's a fantasist!' she exclaimed.

**61** Marcia Pointon, *Spellbound: Art and Film,* exhibition catalogue, Hayward Gallery, London, 1996, pp 113 and 115.

**62** Cluhane, op. cit., p 168.

**63** Ann McFerran, 'Relative Values', *Sunday Times Magazine,* 6 February 1994.

**64** Alfred Neuman, *The Record of Friendship,* exhibition catalogue, Leo Baeck College, London, May/June 1996, p 5.

**65** McFerran, op. cit.

**66** 'Then the music stopped, the dance was over. Amicia lurched to the table. The feral cats were scrabbling among the lobsters. "Fucking bloody cats," she yelled. "Disgusting. Where's the music?"' Elspeth Barker, 'The Dance', from *Writing on the Wall: Women Writers on Art,* Weidenfeld & Nicolson, London, 1993. Reprinted in the *Independent on Sunday,* 10 October 1993.

**67** Germaine Greer, 'Paula Rego', *Modern Painters,* Autumn 1988, p 34.

# Chronology

**1935**
26 January. Maria Paula Figueiroa Rego born in Lisbon, the first and only child of José Fernandes and Maria de S. José Avanti Quaresma Paiva Figueiroa Rego.

**1937**
Her parents in England, where her father works in Chelmsford, Essex, for Marconi. Paula left in Lisbon with her surviving paternal grand-parents, whom she loved, and her mother's aunt, whom she did not. She considers this disruptive experience of great significance to her subversive tendencies as an artist.

**1938**
Diagnosed as having incipient tuberculosis. Family moves to the seaside resort of Estoril, north of Lisbon.

**1940–2**
Attends local primary school in Estoril.

**1943–5**
Tutored at home by local teacher, Dona Violeta.

**1945–51**
Attends St Julian's Anglican School, Carcavelos, the only English school in Portugal. Her talent for art is first noted and she gains an English School Certificate.

**1951–2**
Attends The Grove, Sevenoaks, Kent, a finishing-school for girls, from which she discharges herself.

**1952–6**
Attends the Slade School of Art, London, as an outside pupil. Shares first prize with David Storey, later famous as a novelist and dramatist, for her 1954 summer project painting, *Under Milk Wood*. Meets and falls in love with Victor Willing, who is married.

**1956**
Birth of Caroline. Returns to Portugal.

**1957**
Settles in Ericeira with Victor Willing and Caroline.

**1959**
Victor Willing having gained a divorce, they marry. Birth of Victoria in London. While in London is spurred to renewed efforts as a painter by seeing Dubuffet exhibition.

**1961**
Their third child, Nicholas, is born. Starts working in collage and has three collage pictures accepted for 'Segunda Exposição de Artes Plásticas', Calouste Gulbenkian Foundation, Lisbon.

**1962**
Awarded two-year scholarship by Gulbenkian Foundation. Her works are shown for the first time in an exhibition of the London Group, then under the enterprising presidency of the painter Claude Rogers. Hockney, Andrews and Auerbach are among the fellow exhibitors. She and Vic buy terraced house in Albert Street, London NW1. Time now divided between London and Portugal.

**1965**
Chosen by Roland Penrose for 'Six Artists' exhibition at the prestigious Institute of Contemporary Arts, London. First solo show, held at the Galeria de Arte Moderna in the Sociedade Nacional de Belas Artes, Lisbon, invited by its director, Fernando Pernes. It was Paula Rego's first major public success.

**1966**
Death of her father.

**1967**
Vic diagnosed as having multiple sclerosis, a progressive disease of the nervous system.

**1969**
Chosen to represent Portugal in the XI Bienal de São Paulo, Brazil.

**1975**
Family electronic business is expropriated by workers as a result of the Portuguese revolution. Lengthy litigation with regard to compensation follows restoration of democracy and the return of law and order.

**1976**
Establishes her permanent residence in London, travelling to Portugal only for holidays. Represents Portugal at XIII Bienal de São Paulo, Brazil. Takes time off painting to study children's illustration in British Museum, funded by a grant from the Gulbenkian Foundation.

**1978**
Has eleven paintings in 'Portuguese Art since 1910' held at the Royal Academy of Arts, London. First solo show with Galeria III, Lisbon.

**1979**
For economic reasons she is forced to sell the much loved *quinta* at Ericeira, which she always considered to be her true home.

**1981**
First solo exhibition in London at the state-sponsored AIR Gallery. Rejects collage in favour of painting, with her *Red Monkey* series.

**1982**
Exhibits at the Edward Totah Gallery, her first solo exhibition at a private gallery in London.

**1983**
Visiting Lecturer in Painting at the Slade School of Art. Work shown in USA for the first time: 'Eight in the Eighties' and 'Marathon 83', both in New York. 'Paula Rego: Paintings 1982-83' (including *Opera* series) exhibited in London (Edward Totah), Bristol (Arnolfini) and Milan (Studio Marconi).

**1984**
Exhibits *The Proles' Wall* commissioned for '1984 – An Exhibition' at Camden Arts Centre, London, in celebration of George Orwell's novel.

**1985**

Represents Great Britain at XVIII Bienal de São Paulo, with Stuart Brisley, Patrick Caulfield and John Davies. Attends opening in Brazil. *Vivian Girl* series. First painting, *Nanny, Small Bears and Bogeyman*, 1983, enters collection of the Tate Gallery, London. First solo show in the USA, held at The Art Palace, New York.

**1987**

'Selected work 1981-1986', a touring exhibition shown at Aberystwyth Arts Centre, Wales, and elsewhere in the UK. *Girl and Dog* series exhibited at the Edward Totah Gallery. Birth of Carmen Mueck, her first grandchild. Paints *The Maids*.

**1988**

Death of Victor Willing. Retrospective exhibition at the Gulbenkian Foundation, Lisbon and the Serpentine Gallery, London. Is the subject of a television documentary 'The Artist's Eye', directed by Jake Auerbach (BBC Television).

**1989**

First solo show with Marlborough Fine Art, London: *Paula Rego: Nursery Rhymes*, printed by Paul Coldwell and first designed as a birthday present for Carmen. *The Dance* (1988) purchased by Friends of the Tate Gallery, London, for the permanent collection. Appointed Senior Fellow of the Royal College of Art.

**1990**

Appointed first Associate Artist of the National Gallery, London. 'Nursery Rhymes' exhibition toured nationally by the South Bank Centre. Birth of Lola Mueck.

**1991**

*Crivelli's Garden* mural unveiled as wall decoration in the brasserie of the new Sainsbury Wing, National Gallery, London, making her the only living artist with a work on permanent display there. 'Tales from the National Gallery' opens its nationwide tour at Plymouth City Museum and Art Gallery.

**1992**

'Tales from the National Gallery' concludes nationwide tour at the National Gallery, London. Television documentary by Melissa Raimes, *Paula Rego*, 'The South Bank Show', London Weekend Television. Presented with Honorary Degree by Winchester School of Art. Produces illustrations for a new edition of *Peter Pan*. *Paula Rego* by John McEwen, the first monograph, published by Phaidon.

**1994**

Shows works in the 'Unbound – Possibilities in Painting' exhibition at the Hayward Gallery, London. 'Dog Woman' exhibition at Marlborough Fine Art, London.

**1996**

One of ten artists selected to produce work for the 'Spellbound: Art and Film' exhibition at the Hayward Gallery, London, to celebrate the centenary of the cinema in Britain.

# List of Exhibitions

## SOLO EXHIBITIONS

**1965–6**
Sociedade Nacional de Belas Artes,
Lisbon

**1971**
Galeria São Mamede, Lisbon

**1972**
Galeria Alvarez, Oporto

**1974**
Galeria da Emenda, Lisbon

**1975**
Módulo, Centro Difusor da Arte,
Lisbon

**1977**
Módulo, Centro Difusor da Arte,
Porto

**1978**
Galeria III, Lisbon

**1981**
AIR Gallery, London

**1982**
Galeria III, Lisbon
Edward Totah Gallery, London

**1983**
Arnolfini, Bristol
Galerie Espace, Amsterdam

**1984**
South Hill Park Arts Centre,
Bracknell Midland Group,
Nottingham
Edward Totah Gallery, Zurich
Art Fair

**1985**
The Art Palace, New York
Edward Totah Gallery, London

**1987**
*'Selected Work 1981–1986'*, Aberystwyth
Arts Centre and UK tour
Edward Totah Gallery, London

**1988**
Retrospective exhibition at the
Fundação Calouste Gulbenkian,
Lisbon, Casa de Serralves, Oporto,
and the Serpentine Gallery, London

**1989**
*'Paula Rego: Nursery Rhymes'*,
Marlborough Graphics Gallery,
London
Galeria III, ARCO, Madrid
Galeria III, Lisbon

**1990**
*'Nursery Rhymes'*, Galeria III, Lisbon
*'Nursery Rhymes'*, Galeria Zen, Oporto

**1990–1**
*'Nursery Rhymes'*, South Bank
Centre travelling exhibition: Bridport
Arts Centre, Dorset; Rufford Craft
Centre, Nottinghamshire; Hove
Museum and Art Gallery; Vicarage
Gallery, North Shields
*'Nursery Rhymes'*, British Council
travelling exhibition in Europe

**1991–2**
*'Tales from the National Gallery'*,
travelling exhibition: Plymouth City
Museum and Art Gallery;
Middlesborough Art Gallery;
Whitworth Art Gallery, Manchester;
Cooper Art Gallery, Barnsley;
National Gallery, London; Laing Art
Gallery, Newcastle; Calouste
Gulbenkian Foundation, Lisbon

**1992–3**
*'Paula Rego: Peter Pan & Other Stories'*,
Marlborough Fine Art, London
*'Paula Rego: Peter Pan – a suite of
15 etchings and aquatints'*, Marlborough
Graphics, London

**1993**
*'Nursery Rhymes'*, Cheltenham Literary
Festival

**1994**
*'Paula Rego: Dog Women'*, Marlborough
Fine Art, London; Art Gallery of
Greater Victoria, Victoria BC, Canada

**1995**
*'Nursery Rhymes'*, Ty Llen, Cardiff
Literature Festival (May–July)
*'Nursery Rhymes and Peter Pan'*,
Annandale Galleries, Sydney,
Australia; Charles Nodrum Gallery,
Melbourne

**1996**
*'Nursery Rhymes'*, University Gallery,
University of Northumbria at
Newcastle

## GROUP EXHIBITIONS

**1955**
*'Young Contemporaries'*, London

**1961**
*'Segunda Exposição de Artes Plásticas'*,
Fundação Calouste Gulbenkian,
Lisbon

**1965**
*'Six Artists'*, Institute of
Contemporary Arts, London

**1967**
Bienal de Tokyo; *'Novas Iconologias'*,
Lisbon
*'Art Portugais – Peinture et sculpture
du naturalisme à nos jours'*, Brussels,
Paris, Madrid

**1969**
Represented Portugal in the XI
Bienal de São Paulo, Brazil
*'Gravure portugaise contemporaine'*, Paris

**1970**
*'Novos Sintomas na pintura portuguesa'*,
Galeria Judite Dacruz, Lisbon

**1973**
*'Pintura portuguesa de hoje – abstractos e
neo-figurativos'*, Lisbon, Salamanca,
Barcelona
*'26 Artistas de Hoje'*, Lisbon
*'Exposição de Artistas Modernos
Portugueses'*, Galeria Quadrum, Lisbon

**1974**
Expo AICA, SNBA

**1975**
XIII Bienal de São Paulo
*'Figuração Hoje'*, Lisbon

**1976**
*'Arte portugués contemporanea'*, Galeria
Nazionale d'Arte Moderna, Rome
*'Art portugais contemporain'*, Musée
d'Art Moderne de la Ville de Paris
*'Exposiçao de Arte Moderna Portuguesa'*,
SNBA, Lisbon

**1977**
*'Artistas Portugueses en Madrid – Pintura
e Escultura Contemporâneas'*, Madrid

**1978**
*'Portuguese Art since 1910'*, Royal
Academy of Arts, London
*'Exposição individual'*, Galeria III,
Lisbon

**1979**
*'Femina'*, UNESCO, Paris

**1981**
*'Artists in Camden'*, Camden Arts
Centre, London
*'Ante-visão do Centro de Arte Moderna'*,
Fundação Calouste Gulbenkian,
Lisbon
*'The Subjective Eye'*, Midland Group,
Nottingham

**1982**
*'Three Women'*, Edward Totah
Gallery, London
*'Inner Worlds'*, Midland Group,
Nottingham
*'Pintura portuguesa contemporânea'*,

Museu Luis de Camões, Macao
'Hayward Annual', London
'John Moores Exhibition', Liverpool

**1983**
'Third Biennale of Graphic Arts', Baden-Baden
'Eight in the Eighties', New York
'Marathon 83', New York

**1984**
'1984 – an Exhibition', Camden Arts Centre, London
'Os Novos Primitivos', Cooperative Arvore, Oporto

**1985**
'The British Art Show', Ikon Gallery, Birmingham
'Diálogo sobre arte contemporânea', Centro de Arte Moderna; Fundação Calouste Gulbenkian, Lisbon
Bienal de Paris
'Animals', Edward Totah Gallery, London
'Exposição Diálogo', Fundação Calouste Gulbenkian, Lisbon
'John Moores Exhibition', Liverpool
Bienal de São Paulo (representing Britain)
'Passion and Power', La Mama and Gracie Mansion, New York

**1986**
'A primeira década', Módulo-Centro Difusor da Arte, Lisbon
'Le XXè au Portugal', Centre Albert Borchette, Brussels
'Terceira Exposição de Artes Plásticas', Fundação Calouste Gulbenkian, Lisbon.
AICA-PHILAE, SNBA, Lisbon
'Love Sacred and Profane', Plymouth
'The Human Zoo', Castle Museum, Nottingham
'Contemporary British and Malaysian Art', National Gallery, Kuala Lumpur
'Nove – Nine Portuguese Painters', John Hansard Gallery, Southampton

**1987**
'Arte Contemporáneo Portugués', Madrid
'Current Affairs – British Painting and Sculpture in the 1980s', Museum of Modern Art, Oxford, Hungary, Poland and Czechoslovakia
'70–80: Arte Portuguesa', Brasilia, São Paulo, Rio de Janeiro
'Alberto de Lacerda – O Mundo de um poeta', Fundação Calouste Gulbenkian, Lisbon
'30 Obras de Arte União de Bancos Portugueses', Casa de Serralves, Oporto
'Feira do Circo', Forum Picoas, Lisbon
'Exposição Amadeo Souza-Cardoso', Casa de Serralves, Oporto
'Obras de uma Colecção Particular', Casa de Serralves, Oporto

**1988**
'Works on Paper by Contemporary Artists', Marlborough Fine Art, London
'35 Pinturas de Colecção do Banco Portugues da Atlantico', Casa de Serralves, Oporto
'Cries and Whispers', British Council travelling exhibition, Australia
'Narrative Paintings', Castlefield Gallery, Manchester
'Objects and Image: Aspects of British Art in the 1980s', Stoke-on-Trent Art Gallery

**1989**
'Inês de Castro', Richard Demarco Gallery, Edinburgh

**1989–90**
'Picturing People: Figurative Art in Britain 1945–1989', British Council travelling exhibition: National Gallery, Kuala Lumpur; Hong Kong Museum of Art; National Gallery of Zimbabwe, Harare

**1990**
'Now for the Future', Hayward Gallery, London; Mappin Art Gallery, Sheffield
'Great Britain/ USSR', British Council travelling exhibition, Kiev and Moscow
'Did You Ever See Such A Thing In Your Life', Leeds City Art Gallery

**1990–1**
'British Art Now: A Subjective View', British Council travelling exhibition, Japan
'The Great British Art Exhibition', Glasgow
Eleventh International Print Biennale, Bradford

**1991**
'Modern Painters – A Memorial Exhibition for Peter Fuller', City Art Galleries, Manchester
'Triptico', Museum van Hedendaagse Kunst, Ghent

**1991–2**
'From Bacon to Now – The Outsider in British Figuration', Palazzo Vecchio, Florence
'The Primacy of Drawing – An Artist's View', South Bank Centre travelling exhibition: Bristol Museum and Art Gallery; Stoke-on-Trent Art Gallery; Graves Art Gallery, Sheffield

**1992**
'Myth, Dream and Fable', Angel Row Gallery, Nottingham

**1992–3**
'Innocence and Experience', Manchester City Art Galleries and South Bank Centre travelling exhibition: Ferens Art Gallery, Hull; Castle Museum, Nottingham; Kelvingrove Art Gallery and Museum, Glasgow

**1992–3**
'Life into Paint: British Figurative Painting of the 20th Century', Israel Museum, Jerusalem

**1993–4**
'Writing on the Wall – Women Writers on Women Artists', Tate Gallery, London; Norwich Castle Museum; Arnolfini Gallery, Bristol

**1994**
'Unbound – Possibilities in Painting', Hayward Gallery, London
'Waves of Influence' (Nursery Rhymes and Peter Pan graphics), Snug Harbour Cultural Center, Statton Island, New York
'Here and Now', Serpentine Gallery, London
'John Murphy, Avis Newman, Paula Rego', Saatchi Gallery, London; Contemporary Arts Society Art Market, Festival Hall, London

**1994–5**
'An American Passion – the Summer Collection of Contemporary British Painting', McLellan Galleries, Glasgow; Royal College of Art, London

**1995**
'Open Studio', The Florence Trust, London
'Summer Exhibition', Marlborough Fine Art, London
'Peep', Brighton Museum, in collaboration with the Institute of International Visual Art
'New Acquisitions', National Portrait Gallery, London

**1996**
'David Hockney: Six Fairy Tales from the Brothers Grimm; Paula Rego: Nursery Rhymes', University Museum, Long Beach, California
'Spellbound: Art and Film', Hayward Gallery, London

# Bibliography

## CATALOGUES

**1961**
*Il Exposiçao de Artes Plásticas,* Fundação Calouste Gulbenkian, Lisbon
*Paula Rego,* Fundação Calouste Gulbenkian, Lisbon

**1965**
Alberto de Lacerda, 'Fragmentos de um poema intitulado Paula Rego', *Paula Rego,* SNBA, Lisbon
Victor Willing, *Six Artists,* Institute of Contemporary Art, London

**1967**
*Art Portugais – Peinture et Sculpture du Naturalisme à nos jours,* Brussels

**1971**
*Paula Rego,* Galeria São Mamede, Lisbon

**1972**
*Exposição Colectiva,* Galeria São Mamede, Lisbon

**1974**
Salette Tavares, 'A Estrutura Semântica na obra de Paula Rego', *Expo AICA,* SNBA, Lisbon

**1978**
Hellmut Wohl, *Portuguese Art since 1910,* Royal Academy of Arts, London

**1983**
Victor Willing, 'Paula Rego', *Paula Rego: Paintings 1982–83,* Arnolfini Gallery, Bristol; Galerie Espace, Amsterdam

**1984**
Deanna Petherbridge, 'Nineteen Eighty-Four in 1984', *1984 – An Exhibition,* Camden Arts Centre, London

**1985**
Lynne Cooke, 'Paula Rego', *Paula Rego: Paintings 1984–5,* Edward Totah Gallery, London
Alexander Moffat, 'Retrieving the Image', *The British Art Show,* Arts Council of Great Britain

**1986**
Alistair Hicks, 'Paula Rego', *Paula Rego: Selected Work 1981–1986,* Aberystwyth Arts Centre
*Nine Portuguese Painters,* John Hansard Gallery, Southampton

**1987**
*70–80 Arte portuguesa,* Brasilia, São Paulo, Rio de Janeiro
Lewis Biggs and David Elliott, *Current Affairs,* Museum of Modern Art, Oxford
*Feira do Circo,* Forum Picoas, Lisbon
*Paula Rego: Girl and Dog,* Edward Totah Gallery, London

**1988**
*Works on Paper by Contemporary Artists,* Marlborough Fine Art, London
*Paula Rego,* Fundação Calouste Gulbenkian, Lisbon and the Serpentine Gallery, London. With texts by Victor Willing, Ruth Rosengarten, John McEwen and Bernardo Pinto de Almeida
*Cries and Whispers,* British Council

**1989**
Marina Warner, essay in *Nursery Rhymes,* Marlborough Graphics Gallery, London

**1990**
John McEwen, *Paula Rego: The Nursery Rhymes,* South Bank Centre travelling exhibition

**1991**
Keith Patrick and Maité Lores, *From Bacon to Now – The Outsider in British Figuration,* Palazzo Vecchio, Florence
Germaine Greer and Colin Wiggins, essays for *Tales from the National Gallery,* National Gallery, London
Deanna Petherbridge, *The Primacy of Drawing – An Artist's View,* South Bank Centre travelling exhibition

**1993**
*Peter Pan & Other Stories,* Marlborough Fine Art, London
*Peter Pan – a suite of 15 etchings and aquatints,* Marlborough Graphics, London
Judith Collins and Elspeth Linder, eds, *Writing on the Wall – Women Writers on Women Artists,* Tate Gallery, London

**1994**
Adrian Searle, *Unbound – Possibilities in Painting,* Hayward Gallery, London

**1994–5**
Patricia Seligman, ed., *An American Passion – The Susan Kasen Summer and Robert D. Summer Collection of Contemporary British Painting,* exhibition curated by Susie Allen, Royal College of Art, and Stefan van Raay, Glasgow Museums

**1996**
Marcia Pointon, 'Familiarity, Fear and the Boundaries of the Body in Paula Rego's Dialogue with Disney', *Spellbound: Art and Film,* Hayward Gallery, London
Sarah Kent, 'Mutton Dressed as Lamb: Paula Rego's Ostrich Women', and John McEwen, 'The Ostriches: A Tribe of Bird Women on the Edge of the Sea', *Paula Rego Dancing Ostriches,* Saatchi Gallery, London

## ARTICLES

**1961**
Andrew Forge, 'The Slade – To the Present Day', *MOTIF Magazine,* spring

**1965**
Alberto de Lacerda, 'Paula Rego nas belas Artes', *Diário de Notícias,* Lisbon, 25 December
Nelson di Maggio, 'O Medo Criador', *Jornal de Letras e Artes,* 29 December

**1966**
Fernando Pernes, 'Entrevista com Paula Rego': 'A minha pintura nao é neo-dádá', *Jornal de Letras e Artes,* Lisbon, 5 January
Salette Tavares, 'Excerto do poema em três tempos de Pedro Sete – para Paula Figueiroa Rego', *Diário de Notícias,* 10 February
Keith Sutton, 'Paula Rego: Every Picture Tells a Story', *london life,* 19 March

**1971**
Victor Willing, 'The imagiconography of Paula Rego', *Colóquio Artes,* April, pp 43–9
Eurico Gonçalves, 'Paula Rego: Não é a cola que faz a colagem', *Flamma,* 4 June

**1974**
Salette Tavares, 'Dados para uma leitura de Paula Rego', *Expresso,* 2 July

**1981**

John McEwen, 'Telling Tales', *Spectator*, 30 May

Waldemar Januszczak, 'Paula Rego/ Ronald Boyd', *Guardian*, 2 June

John McEwen, 'Paula Rego', *Colóquio Artes*, September, pp 58–9

**1982**

José Luís Porfírio, 'Os monstros no castelo da pureza', *Expresso*, 3 April

Waldemar Januszczak, 'Hammering the Nail on the Head', *Guardian*, 8 May

Sarah Kent, *Time Out*, 10–16 September

John McEwen, 'Triangles', *Spectator*, 11 September

Richard Cork, 'The Beast in Us All', *Evening Standard*, 16 September

Andrea Hill, 'Paula Rego', *Artscribe*, no. 37, October, pp 33–7

**1983**

John McEwen, 'Rego/Willing', *Art in America*, February

Bernardo Pinto de Almeida, 'Vida e Operas de Paula Rego', *Jornal de Letras e Artes*, 26 April

John Russell, 'Eight in the Eighties', *New York Times*, 20 May

**1984**

Caroline Collier, 'Paula Rego: Art from Inside', *Studio International*, vol. 197, no. 1007, p 56

**1985**

Susan Gill, 'Paula Rego', *Artnews*, October

Alistair Hicks, 'Mischief in Paradise', *Spectator*, 7 September

William Feaver, 'Quack, quack here', *Observer*, 15 September

Mary Rose Beaumont, 'Paula Rego', *Arts Review*, 27 September

**1987**

Mary Rose Beaumont, 'Paula Rego', *Arts Review*, March

William Packer, 'Current British Artists Show their Strengths', *Financial Times*, 3 March

Sarah Kent, *Time Out*, 11–18 March

Michael Phillipson, 'Paula Rego', *Artscribe International*

William Feaver, 'Shy Venus, Earth Mother', *Observer*, 22 March

Lynne Cooke, 'Paula Rego', *Flash Art*, no. 134, May

Alexandre Melo and João Pinharanda, 'Paula Rego: Tudo o que pinto vem de Portugal', *Jornal de Letras e Artes*, 15 June

John McEwen, 'Paula Rego at Totah', *Art in America*, July, pp 37–48

Andrew Graham-Dixon, 'Painters for the Eighties', *Independent*, 1 July

Pamela Kessler, 'The View from Portugal', *Washington Post*, 16 October

**1988**

Judith Higgins, 'Painted Dreams', *American Art News*, vol. 87, no. 2, February

Alexandre Melo, 'O Mundo Mágico de Paula Rego', *Expresso*, 7 May

João Pinharanda, 'Paula Rego: Las Meninas Exemplares', *J.L.*, 10 May

José Luís Porfírio, 'Paula Rego – A distância do medo', *Expresso*, 21 May

Jill Joliffe, 'Shades of Youth', *Guardian*, 30 May

Germaine Greer, 'Paula Rego', *Modern Painters*, vol. 1, no. 3, autumn

William Feaver, 'Lolitas in Revolt', *Observer*, 2 October

John McEwen, 'Telling Tales Out of School', *Sunday Times Magazine*, 16 October

Sarah Kent, 'Heroic Handmaidens', *Time Out*, 19–26 October

William Packer, 'Surreal Images from a Winsome Wonderland', *Financial Times*, 28 October

Amanda Sebestyen, 'Female Potency', *New Statesman and Society*, 28 October

Linda Talbot, 'A Look Past the Shadow', *Hampstead and Highgate Express*, 28 October

Giles Auty, 'Paula Rego, Serpentine Gallery', *Spectator*, 29 October

Richard Dorment, 'Images of the Affluent Society', *Weekend Telegraph*, 29 October

Mel Gooding, 'Paula Rego', *Art Monthly*, November

William Feaver, 'Rego Wonderland', *Vogue*, November

John Russell Taylor, 'A Brush with the Sinister', *The Times*, 1 November

Andrew Graham-Dixon, 'Heroine Addiction', *Independent*, 1 November

Richard Cork, 'Focus Puller', *Listener*, 3 November

Brian Sewell, 'Obsession on a Grand Scale', *Evening Standard*, 3 November

Mary Rose Beaumont, 'Paula Rego, Serpentine Gallery', *Arts Review*, 4 November

Michael Shepherd, 'A Book of Black Anger', *Sunday Telegraph*, 6 November

**1989**

Sarah Kent, 'Rego's Girls', *Art in America*, June

Clare Henry, 'Gruesome Melodrama on a Set within a Set', *Glasgow Herald*, 14 July

Georgina Montagu, 'A Life in the Day of Paula Rego', *Sunday Times Magazine*, 15 October

Guy Burn, 'Prints', *Arts Review*, 20 October

John McEwen, 'Rhymes of Innocence and Experience', *Independent Magazine*, 18 November

Peter Fuller, 'Careful with the Mud in the Morning-Room', *Sunday Telegraph*, 26 November

James Burr, review of Paula Rego's exhibition at Marlborough Graphics, *Apollo*, December

'Paula Rego, Nursery Rhymes', *The Artist*, December

Sylvia Fuller, Jesse Jacobson and Joe Painter, 'Paula Rego's Nursery Rhymes', *Modern Painters*, vol. 2, no. 4, Winter 1989–90

Alberto de Lacerda, 'Paula Rego e Londres', *Colóquio Artes*, Lisbon, December

**1990**

Marina Warner talks to Paula Rego, 'Shame of Secrets', *New Statesman and Society*, 26 January

Peter Fuller, 'Rego's Interior Designs', *Daily Telegraph*, 27 January

Bernardo Pinto de Almeida, 'Familiar Restlessness', *Lapiz*, no. 67, April

James Biglan, 'Paula Rego', *A Journal of Art*, Cornell University, May

**1991**

John McEwen, 'Paula Rego's Tales from the National Gallery', *Sunday Telegraph*, 28 April

Andrew Lambirth, 'Cross Reference', *Royal Academy Magazine*, no. 39, spring

Graham Hughes, 'News', *Arts Review*, 5 April

Rebecca Fortnum interviews, 'Paula Rego Tales from the National Gallery', *Woman's Art Magazine*

Tom Lubbock, 'New Tales from the Old Master Stories', *Independent on Sunday*, 28 April

Jo Hughes, 'Out of the Doll's House', *Everywoman*, June

Juliette Berkhout interview with Paula Rego, *Avenue Magazine*, June
Paula Rego talks to John McEwen, 'Saints hanging Round the Servery', *Sunday Telegraph*, 7 July
Alistair Hicks, 'Women Take Over the Garden', *Sunday Times*, 7 July
Teresa Guerreiro in London, 'Paula Rego: Histórias Inglesas', *Expresso*, 6 July
Clare Henry, 'News from Scotland', *Arts Review*, 12 July
'Paula Charms, or Threatens', *Manchester Evening News*, 1 August
John McEwen, 'Paula Rego: Every Picture Tells a Story', *The Green Book*, vol. III, no. 9, autumn
Bill Moss, 'Cooper Pulls Off Another Notable Coup', *Barnsley Chronicle*, 25 October
George Szirtes, 'Paula Rego: The Actors in the Playhouse', *Modern Painters*, vol. 4, no. 4, winter
Juliet Hacking, 'Past and Present – An Interview with Paula Rego', *Blunt, Courtauld Institute Magazine*, December
Alison Beckett, 'The Mistress of the Old Masters', *Evening Standard Magazine*, 5 December
William Packer, 'An Expatriate Grows Up', *Financial Times Weekend*, 14–15 December

**1992**
Alistair Hicks, 'A Painter Retaliates', *Antique and New Art Magazine*, New Year
Tom Lubbock, 'Every Picture Tells a Story – Paula Rego's Artful Tales', *Harpers & Queen*, January
Richard Cork, 'Fearless Poacher is Captured by her Prey', *The Times*, 3 January
John McEwen, 'Limelight', *Telegraph Magazine*, 18 January
David Whetstone, 'A Shy Celebrity

Guaranteed to Sell', *The Journal*, 28 March
Charles Hall, 'Myth, Dream and Fable', *Arts Review*, April
Bruce Bernard, 'A Spirited Woman', *Independent Magazine*, 17 October
Martin Gayford, *Sunday Telegraph*, 15 November
Linda Talbot, 'Fired by the Scars of Childhood', *Hampstead and Highgate Express*, 4 December
William Packer, 'Fairy Tales in Unexpected Terms', *Financial Times*, 5 December
William Feaver, 'Peter Pan for Psychotics', *Observer*, 13 December
Tracy Brower, 'Nursery Crimes', *Antique Collector*, December
Sister Wendy Beckett, 'Peter Panned', *Modern Painters*, winter

**1993**
Anna Greva, 'Munching in her Presence Feels Like Sacrilege', *Literary Review*, January
Charles Hall, 'Jung at Heart', *Arts Review*, January
Will Eaves, 'Fly Away, Peter', *Times Literary Supplement*, 9 January
John McEwen, 'Lifting the Stones to Expose the Worms, *Sunday Telegraph*, 10 January
Julian Bell, 'Strong-limed Girls in Hefty Skirts', *Times Literary Supplement*, 5 February
Andrew Lambirth, 'Reinventing Peter Pan', *Artists and Illustrators Magazine*, June
Elspeth Barker, 'The Dance', *Independent on Sunday*, 10 October
Sudi Piggott, 'Spring Clear', *Everywoman*, November
Richard Cork, 'Patrons of Rare Vision', *The Times*, 21 December

**1994**
Ann McFerran, 'Relative Values',

*Sunday Times Magazine*, 6 February
Antony Thorncroft, 'Lisbon Takes the Laurels', *Financial Times*, 5 March
Tim Hilton, 'Every Which Way But Forwards', *Independent on Sunday*, 6 March
John McEwen, 'A Brat's Brilliant Slide into Paranoia', *Sunday Telegraph*, 6 March
Richard Cork, 'Painting is Back in the Picture', *The Times*, 7 March
David Lillington, 'Zeitgeist', *Time Out*, 9–16 March
Waldemar Januszczak, 'A State of Confusion', *Sunday Times*, 13 March
William Packer, 'Hidebound by Rhetoric', *Financial Times*, 15 March
'Strange Brew on a Rego Trip', *Hampstead and Highgate Express*, 18 March
Ian McKay, 'Back to Basics?' *What's On In London*, 23–30 March
'Etcetera', *Royal Academy Magazine*, spring
'Writing on the Wall' at Castle Museum, *Eastern Daily Press*, 31 May
'Works by Women Selected by Women', *Eastern Daily Press*, 13 June
William Packer, 'The Acceptable Face of Avant-garde', *Financial Times*, 14 June
Joanna Gibbon, 'Appeals', *Independent*, 30 July
Edward Lucie-Smith, 'Critic's Diary', *Art Review*, July
Clifford Myerson, 'On Painting I', *Art Monthly*, September
Simon Henwood, 'Magnificent Regression', *Print Magazine*, Maryland, USA, vol. XLVIII:V, September–October
John Walsh, 'Dream Team – Paula Rego and Marina Warner', *Independent Magazine*, 29 October
Joanna Pitman, 'Dogged Woman', *The Times Magazine*, 29 October
William Feaver, 'See How They

Run', *Vogue*, November
Richard Dorment, 'Her Majesty's Pleasure', *Daily Telegraph*, 2 November
Sarah Kent, 'Life's a Bitch', *Time Out*, 2–9 November
'Dog Women Chasing Dreams', *Hampstead and Highgate Express*, 4 November
William Packer, 'Furtive Families and Flurries of Activity', *Financial Times*, 8 November
Neil Philip and William Feaver, 'Enchanted by Beastly Tales', *Times Educational Supplement*, 11 November
Sarah Staughton, 'Dream On', *Independent Magazine*, 12 November
William Feaver, 'Lying Doggo', *Observer*, 13 November
Noel Malcolm, 'The Fairy Stories of a Feminist', *Sunday Telegraph*, 14 November
*What's On in London*, 16–23 November
Sarah Kent, 'Hits and Myths', *Time Out*, 16–23 November
John McEwen, 'Every Dog Has her Day', *Sunday Telegraph*, 21 November
AP, 'Paula Rego: Dog Woman', *Big Issue*, 21–27 November
Alison Pearson, 'Left on the Hook', *Evening Standard*, 22 November
John Russell Taylor, 'Around the Galleries', *The Times*, 22 November
Martin Gayford, 'The Mysterious World of Nursery Art', *Daily Telegraph*, 23 November
Filipa Melo, 'Paula Rego Novos Encantamento – Para descobrir o encantamento', *Jornal de Letras, Artes e Ideias*, Lisbon, 23 November – 6 December, No. 629
Rachel Barnes, 'Family Values', *Guardian*, 24 November
Richard Cork, 'Galleries', *The Times*, 26 November
Tom Lubbock, 'Portrait of the

Artist as a Little Dog', *Independent* (Section Two), 29 November
Ruth Rosengarten, 'Eis a Mulher-câo', interview with Paula Rego, *Visão*, 30 November–6 December, No. 89
*Cosmopolitan*, December
Christina Hardyment, 'The Frog's Strangled Warbling', *Independent*, 3 December
Rachel Barnes, 'Fearful Families', *Guardian Weekly*, 4 December
Richard Cork, 'Thoroughly Modern Saatchi', *The Times*, 6 December
Rosanna Negrotti, 'Paula Rego', *What's On in London*, 14–21 December
Estelle Lovatt, 'Paula Rego: Dog', *Southern Cross*, December
'Paula Rego: Mujer Perro, 1994', *El Punto de las Artes*, Madrid, December
Alexandre Melo, 'A Mulher Safa-se per câo', *Revista*, No. 1155, 17 December

**1995**
Emmanuel Cooper, 'Undermining Myths', *Tribune*, 13 January
John Windsor, 'How They Bring the Good News from Ghent', *Independent on Sunday*, 15 January
David Wootton, 'Paula Rego, Saatchi and Saatchi Gallery', *What's On in London*, 18–25 January
'Decisions, Decisions', *Independent*, 3 February
Christina Duarte/Mano Silva, 'Paula Rego Ericeira No coraçâo', *Regiâo Saloia*, No. 47, 12 April
Robin Turner, 'Nightmare Nursery Rhymes', *Western Mail*, 18 May
Ruiko Harada, 'Paula Rego, Contemporary Artists Review', *Bijutsu Techo*, Tokyo, No. 18, summer
Andrew Billen, 'Art and Soul', *Observer Life Magazine*, 23 July

Kiki Morris, 'The Art of the Female', *Everywoman*, July
William Packer, 'A Sense of Discovery', *Financial Times*, 31 October
John Russell Taylor, 'The Art of the Feast', *Art Quarterly*, winter

**1996**
Iain Gale, 'The Secret Life of Snow White', *Independent* (Section Two), 30 January
Clifford Bishop, 'Spellbound', *London Magazine*, February
Philip Hensher, 'Flick Witted', *Mail on Sunday* (Night and Day Magazine), 25 February
*Evening Standard Diary*, 26 February
Craig F. Ferris, 'The Rage of Innocents', *The Sciences*, New York, March–April
John McEwen, 'To the Beat of a Poptastical Drum', *Sunday Telegraph*, 25 February
Adam Mars-Jones, 'Affairs of the Art', *Independent*, 27 February
Sarah Kent on Spellbound, 'Reel to Real', *Time Out*, February 28–6 March
Elizabeth Lebovici, 'Le Cinéma, l'art au trousses', *Libération*, 5 March
Richard Cork, 'Beyond the Silver Screen', *The Times*, 5 March

**BOOKS**

**1974**
José-Augusto França, *Pintura portuguesa no século XX*, Livraria Bertrand, Lisbon, 1974, 1986

**1984**
Rui Mário Gonçalves, *Pintura e escultura em Portugal, 1940–1980*, Instituto de Cultura, Lisbon

**1986**
Alexandre Melo e João Pinharanda, *Arte contemporânea portuguesa*, Lisbon
Bernardo Pinto de Almeida, *Breve introdução à pintura portuguesa no século XX*, Edição do Autor, Oporto

**1991**
Hector Obalk, *Paula Rego*, Art Random, Kyoto Shoin International Co. Ltd, Kyoto

**1992**
John McEwen, *Paula Rego*, 1st edition, Phaidon Press Ltd, London

**1993**
*International Women's Art Diary*, 1993
*The Art Book*, Phaidon Press Ltd, London

**1994**
Marina Warner, *Wonder Tales*, Chatto & Windus, London
*A Portfolio – Nine London Birds*, Byam Shaw School of Art, London, introduction by John McEwen

**1995**
Diana Eccles and Barbara Putt, eds, *British Council Collection Catalogue*, Volume II

**OTHER**

**1992**
Margaret Walters, interview for 'Meridian', BBC World Service, February
John McEwen, lecture at the National Gallery, London, 11 February
Melissa Raimes, *Paula Rego*, 'The South Bank Show', London Weekend Television, 23 February

**1994**
Sue Aron, 'The Art': 'The Art of Living Things', BBC Schools Programme, 8 February and 20 October
Reiner Moritz, 'Masterworks', German TV, Munich and RTP Portugal
Elizabeth Levy, 'Little Angels, Little Devils', Wall to Wall Television Ltd for Channel 4, 10 May
Sue Aron, 'Art Show': 'The Art Show', BBC Schools Programme, summer and November
Steve Grant, 'The Late Show', BBC2, 17 November

**1995**
Paula Rego, lecture at the Art Institute of Chicago, USA
'Decisions', one-day conference at the Tate Gallery, London

**1996**
Tim Marlowe, 'Kaleidoscope', BBC Radio 3, 23 February

# Index of Works

# Index

WITHDRAWN